THE SUNDAY TIMES

A Life in the Day

edited by
Richard Woods

Published by Times Books

An imprint of HarperCollins Publishers
Westerhill Road
Bishopbriggs
Glasgow G64 2QT
times.books@harpercollins.co.uk

HarperCollins Publishers
1st Floor, Watermarque Building,
Ringsend Road, Dublin 4, Ireland

First edition 2021

This compilation © Times Newspapers
Ltd 2021

The Times® is a registered trademark of
Times Newspapers Ltd

All rights reserved. No part of this
publication may be reproduced, stored in a
retrieval system, or transmitted, in any
form or by any means, electronic,
mechanical, photocopying, recording or
otherwise without the prior written
permission of the publisher and copyright
owners.

The contents of this publication are
believed correct at the time of printing.
Nevertheless the publisher can accept no
responsibility for errors or omissions,
changes in the detail given or for any
expense or loss thereby caused.
HarperCollins does not warrant that any
website mentioned in this title will
be provided uninterrupted, that any
website will be error free, that defects will
be corrected, or that the website or the
server that makes it available are free
of viruses or bugs. For full terms and
conditions please refer to the site
terms provided on the website.

A catalogue record for this book is
available from the British Library

ISBN 978-0-00-848539-9

10 9 8 7 6 5 4 3 2 1

Printed and bound in the UK using 100%
Renewable Electricity at CPI Group (UK)
Ltd

For image credits please see
acknowledgements on page 378

Our thanks go to Lily Cox and Joanne
Lovey at News Syndication and, at
HarperCollins, Gerry Breslin, Lauren
Murray and Kevin Robbins.

MIX
Paper from
responsible sources

FSC
www.fsc.org
FSC® C007454

This book is produced from independently
certified FSC™ paper to ensure responsible
forest management.

For more information visit:
www.harpercollins.co.uk/green

Contents

Introduction

Two words, one simple switch – and a legend was born. The old phrase A Day in the Life became the altogether more intriguing A Life in the Day. It was 1977 and The Sunday Times was searching for a new feature to enliven its colour magazine. After a couple of unsuccessful forays, the then editor of the magazine, Hunter Davies, revived an idea he'd tried as a student journalist.

"I suggested we did a series on real lives, famous and non-famous people," he later explained, "but concentrating only on the non-working part of their day: the mundane, domestic, trivial – the stuff we can all identify with, such as what time do you get up, do you have tea or coffee, do you leave your clothes out the night before?"

Sceptics dismissed the concept as dull. What could possibly be interesting about the humdrum inanities of waking up, of having breakfast, lunch and dinner, of being unfamous behind closed doors – even if you were a celebrity the rest of the time?

So Davies conducted a test, asking members of the magazine's staff how they began their day, in particular how they chose what to wear. "I consult my diary," answered one Patrick Nicholson, who was then the magazine's chief sub-editor. It turned out that Nicholson regularly kept a note in his diary of what he had worn each day to avoid repeating it too soon.

"That was it," Davies later recorded. "If Patrick had this little ritual that no one knew about, imagine what gems we might dig out of Famous People."

He was right, and A Life in the Day began. The style of the interview was unthreatening: this was no thumb-screw inquisition or confrontation. Tell us about your everyday habits as well as your broader life, that was the pitch. The subjects felt relaxed and often opened up in ways that revealed sides to their character rarely seen.

Here are film stars, politicians, sports champions and more – all illuminated through the routines, the bric-a-brac, and the occasional upheavals of their daily lives. In this selection of interviews, some people start their day with prayer; the Dalai Lama

is perhaps no surprise, but there is also, for example, Little Richard, one of the founders of rock'n'roll. Interviewed in 1999, when he was in his 60s, Little Richard gives thanks to God each day just for letting him get out of bed again.

Many subjects prefer to put their faith in coffee – though none more so than ABBA songwriter Bjorn Ulvaeus. He gets through up to 20 cups a day. Quite a number are also strong believers in the power of porridge – and it's worth noting that Captain Tom Moore had a bowl of the gloopy sludge every day for 50 years and lived to be 100.

Others, though, have more challenging morning routines. In California, Orlando Bloom is juggling "brain octane oil" and "collagen powders", just as any normal elf would. Over on another planet, Eric Cantona, the former footballer with a philosophical bent, likes to stand up and sing at breakfast while his family tuck into crostini. "To me," he says, "control is boring".

At the same time, however, the format of A Life in the Day also allows insight into more serious themes. Oprah Winfrey speaks about how she suffered abuse in childhood from some of those close to her; the supremely fit athlete Michael Johnson talks about the physical and mental shock of having a stroke in his 50s; and the footballer Raheem Sterling extols his mother's determination to make a better life for him after his father was murdered when he was a child.

With others you have to read between the lines as they give glimpses of their personal traits and troubles. The songwriter Nile Rogers says he can't work unless he has the television on in the background. So in his house he has 11 of them blaring all at once. Kim Kardashian admits she has at least 20 shower gels, body scrubs and shampoos in her bathroom "all colour co-ordinated, height co-ordinated and scent co-ordinated". As for the designer Philippe Starck, he says that, apart from insisting on specific types of taps, towels and toothbrushes, he keeps one lot of black clothes and one lot of beige. "I can't work in beige, so I know when I'm wearing it that I mustn't take the day too seriously." Things are so simple when you know how.

The combination of celebrity supernovae and quotidian detail makes for compelling reading, not only for the individual stories but also as snapshots of culture and key events across recent decades. In compiling this anthology, I have aimed to provide a selection that spans more than 40 years, choosing those individuals who seem most entertaining, informative or quirky, ranging from

lasting icons to the occasional more transient figure. So there's Muhammed Ali, the champion boxer as famous for his charisma as his punching power; but there's also Nancy Dell'Olio, best known as a socialite, who proves gloriously candid about how beautiful, intelligent and generally fabulous she is – though her star has somewhat dimmed of late.

The entries are arranged alphabetically, rather than chronologically, but every interview is marked with the date it was originally published. Over the years, the presentation of the column in the magazine has remained broadly the same, apart from modest changes to the way subjects are introduced and whether or not the interviews included ancillary items, such as the subject's 'words of wisdom'. So you will notice some variation in the way each entry begins and ends.

In all cases, however, each interview is self-contained as well as part of the whole. Many readers may find this to be a volume for dipping into, for opening at random to stumble across some unexpected gem. It is, though, perfectly possible, entirely acceptable and totally legal to read this book from cover to cover, beginning to end, all in one go.

Either way, I hope you enjoy it and the people it presents.

Richard Woods

A Note on the Methodology

This book reproduces the original interview texts as they appeared in The Sunday Times Magazine. But I have edited some of the introductory paragraphs to the entries to avoid excessive duplication of names and other material, and in some instances I have trimmed the interviews to control their length. In a few places I have added explanations or context, in brackets, within the interviews. The update notes at the end of each entry are additions made specifically for this book.

The entries are drawn from The Sunday Times archives; some have appeared in two previous books, one hardback published in 2003 and one digital book published in 2014.

My thanks for producing the original interviews go to the current A Life in the Day editor, Emma Broomfield, and all her predecessors.

Lives

50 Cent

JANUARY 15, 2006

The US rapper 50 Cent (real name, Curtis James Jackson III), 30, sold nearly 11 million copies of his debut album, Get Rich or Die Tryin'. His next album broke industry records. The movie Get Rich or Die Tryin', loosely based on his life, is out this week. He lives in Connecticut and has one son, Marquise, 9.

 I'm usually up by 7.30 to 8am, and once I've brushed my teeth, I stick on trainers and shorts and do a workout. I recently bought Mike Tyson's mansion, which, as you can imagine, is pretty state of the art and has a fantastic gym. I used to box as a kid and have a huge appreciation for the psychology of boxing. It teaches you not only to watch your opponent but also to get behind his mindset. Over the years, I've realised I can apply those lessons to life.

I don't eat breakfast, as a rule, but if I get hungry I'll have something like a bagel with American cheese. When I'm going out I obviously dress to suit the occasion, so it varies from T-shirts and trainers to Armani suits and ties. I have sponsorships with people like Reebok, but I'm not one of those confused-looking people you see walking out in a pair of trainers and a designer suit.

I like my jewellery, so I always wear something round my neck, something pretty big. I get a lot of it from the diamond district in Manhattan. Whatever the occasion, though, I always wear a bulletproof vest and I always travel in a bulletproof car. It's a reminder of where I've come from.

The thing is, some people criticise my lyrics for being aggressive, but in my eyes it's a direct reflection of the environment I grew up in as a kid, in Southside Queens, New York. Mom was 15 when she had me, and sold drugs to get by. My father disappeared, so I never knew him, and when she went off to do what she had to do, she'd drop me off at my grandparents'. When I was eight, she was found dead. I went to live with my grandparents, but from then on, every little thing that went wrong in my childhood was because she wasn't there. Even if it rained, it was because she wasn't there. Then,

of course, it wasn't long before I was hustling on street corners myself. As a 12-year-old, I'd see the drug dealers with flash cars, smart clothes and fast money, and think that selling drugs wasn't an option, it was the *only* thing to do. I didn't connect with school and although music inspired me, and encouraged me to rap and write my own lyrics, there was no outlet for it, no teacher showing me the way to be successful at something I was good at.

Sure enough, once you get involved in that environment, that gang life, it's violent and it's hard to escape. I ended up serving time. That type of life becomes a cycle of being inside, then out, then in again. The turning point came when I became a father. It was then that I made the decision to break that cycle and try and find a way of making music for a living. I knew I had a talent for it; my son coming along gave me the determination to do it.

I got to the point where Columbia Records offered me a publishing deal in 2000. I'd just signed it when I got gunned down with nine bullets, including one in the face. The doctors said it was a miracle I'd survived. But then Columbia heard what happened, got scared and cancelled the deal. Hearing that was harder to deal with than getting shot. Next, Columbia turned around and said I could keep the $100,000 advance and keep my publishing. It was one of those moments when you think: "There really is a God." I knew then that I'd be able to look after my son, get myself better and not give up the dream. When Eminem called me up a few years later and offered me a record deal, it was no longer a dream.

What with the albums, the touring and now the film, the pace of everything has been mad the last few years. I try to have a healthy lifestyle, so I eat things like grilled chicken and I don't drink. I know that tomorrow's opportunities are about continuing to be successful today, so I continue to record and perform on stage as a rap artist because I enjoy it and it's lucrative. I also have my own record label now and, as well as a personal assistant who basically goes everywhere with me, I have a team of people working on different projects, from clothes to drinking water. I might be the rapper from Queens, but most of my time is now spent thinking about brand names, company profiles and empire-building. In that sense I see myself primarily as a businessman.

I still see my grandparents; I still appreciate the simple things in life. I've got a cook at home who prepares all my food, so if I'm in for the evening, I'll have something like steak with plenty of vegetables and then maybe watch a movie or a load of music videos – I have a home theatre system. My son is living with his

mom at the moment, but I see him as often as I can. He's having home-schooling for the next year or so because too many people are starting to recognise him. I want to get him away from that kind of attention for a while.

People say money changes you, but money doesn't change you: it changes everything around you and everybody's perception of you. Yes, I have the diamond crosses, the gold watches, the customised cars, the real estate, the sponsorship deals… The lifestyle that comes with being successful in this business. But the thing is, I know I could be right back where I started. I'm really conscious of that. Right now, I'm looking ahead. And from where I'm standing, everything is possible. President 50 Cent? I'd never say never.

Interview by Ria Higgins

50 Cent filed for bankruptcy in 2015, citing debts of more than $30 million. He paid off $22 million, emerged from bankruptcy and has been promising a new album, Street King Immortal, for some time. In 2020 he conceded that some of his lyrics were misogynistic, but defended their context and his right to artistic expression.

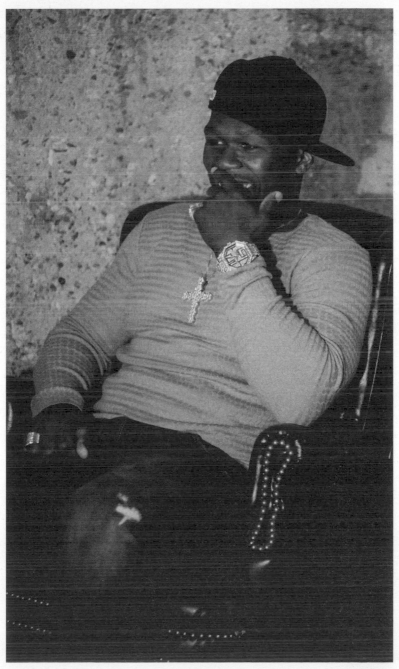

Muhammad Ali

MAY 10, 1981

Muhammad Ali, three-times world heavyweight boxing champion, was born Cassius Clay in 1942. He first took the title in 1965, from Sonny Liston, and lost his final fight against Larry Holmes last year. Now a champion of Islam, he lectures extensively and lives with his second wife, Veronica, and two daughters.

After years of striving to keep my body in good shape it's a real pleasure, now that I've retired, to live each day not worrying about staying fit. About the only habit I still have from my boxing days is getting up early. I'm always up at 7am – but even that is late compared to 4.30am which was the time I used to get up to do roadwork when I was boxing. I only get about four hours' sleep during the night because between midnight and 3am I read the Holy Koran and the Bible and prepare my lectures. But I catch up on my sleep in the afternoon.

The first thing I like to do when I wake up is eat an orange. I don't always remember to have one by my bed so often I've got to wait until breakfast, my favourite meal. I have fruit, steak, sausages, eggs, tomatoes, mushrooms, toast and orange juice.

I've got two homes in the States. The place in Pennsylvania was my training camp when I was fighting. Now I allow promising young amateur boxers to train there.

I'm very proud of my home in L.A. Most of the furniture was specially made for me in Egypt by local craftsmen. Home life with my wife, Veronica and our daughters, Anna and Laila, is one of the most precious gifts Allah has given me. I love sitting in front of the TV with my daughters and watching cartoons, especially Batman.

When I'm not travelling around the world meeting presidents and prime ministers, I'm usually travelling around the States giving lectures. I have 54 topics – the purpose of life, the real cause of man's distress, heaven and hell, the heart, drugs, angel cake…That last is about the white supremacist society; angel cake is white, devil's food cake chocolate!

I want to be the black Billy Graham, spreading the message of Islam. If I had my life all over again I would be a preacher.

Lecture tours give me the opportunity to go out and meet people. It's something I really enjoy, and it doesn't matter whether they are black, white, yellow or whatever. If I've got a free morning when I'm at home in LA I get into my car and visit strange towns to meet people. I'm not concerned about any crazy guy who may want to shoot me. I have no bodyguards; Allah is my protector.

I am the most recognised person in the world. There's not a place on Earth where they don't know me.

The country I most enjoy visiting is England. Both Veronica and I feel quite at home in London. We enjoy the shops, the restaurants and the night life, especially dancing at Tramp and Annabel's. Veronica even went horse riding in Hyde Park during our last visit, while I went out and bought a new Rolls-Royce.

I understand my fans in England have been quite concerned about the reports that I had suffered brain damage in my last fight against Larry Holmes and that my speech was slurred. The media were trying to railroad me for just one bad fight. Okay, I didn't box too good but I wasn't properly prepared. Even I am entitled to one bad night. Tell my fans there's nothing wrong with me.

Since playing the lead role as a senator in *Freedom Road*, I've had offers of other film parts, but I don't intend to make a career in films. Acting is nothing new to me, I've been doing it for 20 years.

I'm often asked if I'd like to be a real-life senator, but I'm not interested in politics. I wouldn't mind being world emperor but it's got to be handed to me. I wouldn't fight for it.

There'll be no more fighting for me. I only wanted to fight Holmes again to give the world heavyweight championship back to the people.

But then I realised that everywhere I went people wanted to meet me, shake my hand and get my autograph, no one was interested in Holmes. In the eyes of the people I was still champ, so I didn't need to fight again. I don't need boxing but boxing needs me. Now I'm going to be a promoter – the greatest.

Interview by Glenn Gale

In 1984, Muhammad Ali developed Parkinson's disease, but he continued to make public appearances, receiving acclaim wherever he went. In the US he was awarded the Presidential Medal of Freedom and in Britain he was voted BBC Sports Personality of the 20th century. He died in 2016.

Pamela Anderson

APRIL 7, 1996

The star of the TV series Baywatch, 28, recently married
Tommy Lee, the drummer in the heavy-metal band Mötley
Crüe, after a whirlwind romance. She is now due to give birth to
their baby.

❝ We are woken at around 6.30am by the tiny barking of
our puppy, Maximum, because he needs to go to the
bathroom. He is a Mex [Chihuahua], weighing only 4lb
at the moment, in contrast to our two Rottweilers, Justice and
Sacha, who guard the house, and Star, a golden retriever. I get up
and put the kettle on so I can bring Tommy his tea. He is a real tea
man and can't function without it. We play with Maximum – we call
him Max – and then we start to play with each other. Tommy and I
have a great sex life. It's even better now I'm pregnant – I feel at my
most womanly. Making love in the morning got me through
morning sickness – I found I could be happy and throw up at the
same time.

The bedroom is made for love. We have a king-size bed
with a headboard bought from an Indian palace, all carved wood.
There are two stone pillars from a cathedral, with tons of fabric and
a huge circle of dry roses hanging above us. It looks like a pumpkin
carriage. For Christmas we put up a set of purple lights. We can lie
on the bed and see our Jacuzzi tub and the waterfall coming down.
That is where I'm going to give birth to my baby.

After a breakfast of cereal we go to the gym in Malibu on
our bikes and I walk on the treadmill. I usually do more energetic
stuff but I'm being careful while pregnant. Tommy works out really
heavily with his trainer. Afterwards I go to a garden centre and come

back with flowers. I love rose bushes and Tommy is planting some for me. He likes being in the garden so much. He knows the name of every plant, flower and tree. He is so sweet and romantic and an absolute gentleman. I've probably ruined his career, saying that!

We try and get back for lunch: fruit, yoghurt and cottage cheese for me, while Tommy loves fried eggs. He can eat what he wants, while I have to be careful. I've decided to let myself go with this pregnancy, though. I don't care if I put on 30 or 40lb, so long as he or she is a healthy baby. But I have to get my figure back for a new series of Baywatch, which starts three months after the birth.

I have my internet session in the afternoon. I "talk" to strangers and we get a lot of messages, including some that say, "I am going to get you off line because you are impersonating Pamela Anderson." I type in: "I *am* Pamela Anderson." Another message comes back: "No, you can't be. Pamela Anderson doesn't write or spell." Tommy joins me. He's a fanatic for the internet. He's bent over the keyboard while I'm saying we ought to get out and have some fresh air. He has three motorbikes, all Harley-Davidsons. I like to get on the back for a ride. We took little Max the other day, cradled in my arms. His face was a picture as he looked at the beach speeding by.

When the script came in for Barb Wire, my agent said, "I know you won't want to do this: they want you to play a comic-book character who rides around on motorbikes and shoots people." I said, "What? Get me on that f***ing bike and give me the gun!" He said it would be a crazy career move, but I wanted the chance to kick some ass on screen for a change.

It was great. I nicknamed my character Pambo. She's tough. I like to think I've got that kind of strength. A lot of people look at my blonde hair and big boobs and think I'm there to be taken advantage of. To an extent, I have been, particularly in my early days in Hollywood. I came originally to do a Playboy shoot after I'd appeared in commercials for beer in Canada. But I've been a fast learner in negotiating a deal.

Money is great, particularly as I didn't have much when I was growing up, and I love spending it. We're having the house renovated, and I see the builders at the end of the day to check on progress. But I can get careless. One afternoon I left a few Polaroid photographs lying around of Tommy and me having oral sex. They went missing and turned up in Penthouse in France. I could have died! But then I looked at the pictures, all blurred, and thought it was the sort of thing newly married couples do. The only difference

was that ours were treated as newsworthy. In the end, I thought, "So what!"

We like to admire our house as the sun is setting over the ocean. It shows off all the colours, particularly the purple in a couple of rooms. When you walk in you go through glass doors with hearts on them, then you see a drum kit under a huge vaulted ceiling, and a grand piano. I've had the piano redesigned: all Tommy's tattoos are now carved on it. There's also a swing above the piano, like a fairy tale.

Tommy likes me to have a swing before dinner. He sits there, playing away, while I take off my clothes and swing naked above him. I've always loved swings – I'm like a monkey – and he looks up every so often. Since I've got a belly from being pregnant, I'm feeling a little *too* naked. So I sometimes wear a hat. And shoes. I said to Tommy the other day we should get a swing over the bed. It's the kind of crazy thing we love to do together.

People are a bit horrified at the sight of Tommy. When I announced we were going to get married, my best friend cried and my mother threw down the phone and refused to pick it up. But she got used to it, and she and my father are moving down from Vancouver soon to be with us for the baby's birth. I suppose marriage did come as something of a shock. We met on New Year's Eve, 1994, in Los Angeles. He came up, grabbed me and licked my face. I thought he was a nice guy and gave him my phone number. But I wasn't ready for what came next. He bombarded me with phone calls, 40 or 50 a day. I foolishly told him I would be in Cancún for a couple of nights and he turned up. We fell in love when we really looked into each other's eyes. And we married after four days.

We hardly ever go out at night; we're happy with each other. After dinner, usually fish with some pastries from an Italian bakery, we have a bath together by candlelight. We're sometimes in bed by seven or eight o'clock. Then Tommy reads a fairy tale to my stomach. Right now he likes the Stinky Cheese Man. As the baby listens, I drift off.

Interview by Garth Pearce

Pamela Anderson and Tommy Lee were divorced in 1998 after he admitted hitting her and he was jailed. She bounced back to appear in numerous television shows, have four other marriages and write several books, including one entitled "Lust for Love: Rekindling Intimacy and Passion in Your Relationship".

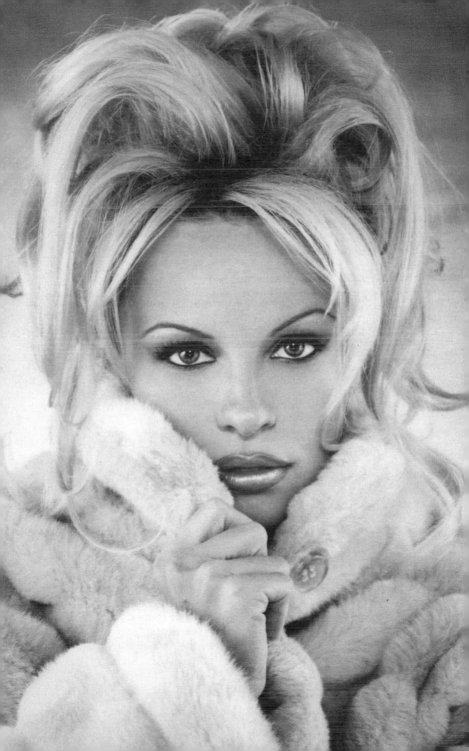

Tom Baker

SEPTEMBER 17, 1978

Tom Baker, 44, spent six years as a monk but left after deciding it was time for 'pubs and women' and went on to become TV's favourite Dr Who. He likes to travel light.

 You could say that yesterday was fairly typical of a day in my life when we're not recording *Dr Who*. I woke up at 5.15am in a brown cork-lined room in Soho and then got into bed. But where am I? I dreamt about a tall, thin woman, but who is she? I suffer recurring images of tall skinny ladies. They look so good and release all those fantasies. I woke up again at 6.10am. I got up and began the process of dragging my feet to their final destination at night. I was hit by terrible waves of anxiety. The feeling of loneliness that smacks of self-pity. I drank a glass of water and felt for a toothbrush, wondering where on earth I was. If I'd had a radio I would have put it on, but it's too early, of course, for Radio 3. The anxiety persisted and I thought: "Suicide is the answer." I got out of bed and looked at some electrical flex. The ceiling was too low. How could I have hanged myself in a room only 5ft 10in high? I gave up the idea, found a radio and switched it on. I heard some news and my anxieties instantly increased. Then I took a sly bath and checked my pockets. I found £114 and a pair of clean underpants and began to walk confidently. All you really need for confidence is always to have a toothbrush and a hundred or two in your pocket. Oh, and a cheque book. I'm very check conscious. I usually dress in check trousers containing a cheque book. That and a velvet jacket and a raincoat. I went out and bought *The Times* and read the obituaries. There was no pleasure in them for me. Then I went to Valerie's in Old Compton Street for some coffee and tried to do the crossword puzzle. At 9.30am it was 'voiceover' time at a Soho recording studios. I performed for Norsca Foam Baths and they seemed pleased by my enthusiasm. I find it quite interesting to try and give credibility to a blatant sell. After the voiceover I signed an autograph for a child called Donalbain and a few minutes later I signed one for a child called Wee Peng. Then I went for a drink. I usually go to the Swiss

Tavern, The Carlisle Arms, the Coach and Horses or the Yorkminster. After a few drinks the miracle is that one has something to say. Then, no matter how I feel, I feel an obligation to feel no anxiety because of being recognised. There is a constant stream of hallos, nods and autographs. All very good medicine for anxiety. At midday, I went to the Yorkminster, hoping for the miracle that I might see someone I'd never seen before. After lunch in the Paparazzi – I usually eat the calf's liver and bacon – I went to a rehearsal for the BBC in North Acton. It's Kafkaville. At teatime I arrived at The Colony Room Club and Francis Bacon bought me a large gin and tonic. The anxieties went away and the conviction grew that I had something to say on any subject. Kenny Clayton played the piano and a bunch of inebriates harmonised to *Home on the Range*. I went back to the Yorkminster in the hope of finding some conversation before bedlam set in. Then I went to Gerry's Club and met Peter Crouch, the agent, and played some pool and lost. Dee Lynch, the manageress, embraced me and that was nice. Then I talked about cancer for a while with a man who had a bad cough. After that, I was introduced by an actor acquaintance to a Welsh school teacher who said he was delighted to meet me. We shook hands and he promptly had a heart attack. Astonishingly enough there were two doctors in the house – well, three if you include me – and the poor man was carried out and put into an ambulance. And then we embarked on a conversation about having heart attacks. I tottered off back to Gerry's Club and spent most of the rest of the evening telling everyone I met there about Peter Crouch. I had several nightcaps and felt relieved that another day had passed. As usual there was someone there with whom to discuss crumpet and the meaning of life.

I then popped into Ronnie Scott's club and sat there at the bar self-consciously affecting a knowledge of jazz that I haven't got. The recurring image of tall, skinny ladies came back and still looked good. Then I went back to Gerry's Club for another drink, and after I'd cadged a Valium from someone, I went home to my padded cell.

Interview by Jeffrey Bernard

Tom Baker played the Doctor from 1974 until 1981. In 1980 he married Lalla Ward, his co-star. After parting from her "quite passionately", he wed the director Sue Jerrard in 1987. He has featured in many other television shows, including reappearing as the fourth Doctor in later series of Dr Who.

Ed Balls

OCTOBER 2, 2016

The Labour ex-minister, 49, on life after politics, Strictly Come Dancing and being the household drudge. Born in Norfolk, Balls went to Oxford and Harvard, and served as an MP from 2005 to 2015. He is married to the Labour MP Yvette Cooper. They have three children and live in north London.

 I wake up at 7am to the Today programme. After losing my seat at the last general election, Yvette and I stopped listening to it because it reminded me too much of my political past, but it's back on now. Then whoever's up first makes the tea. Mine's Yorkshire, hers is redbush — the last thing you want in the morning. I don't eat breakfast, but she's started making these green juices with things like spinach — and they're appalling. I can only drink them if I do it in one gulp.

The kids, Ellie, Joel and Maddy, are 17, 15 and 12 and get themselves ready. We live in a typical north London terraced house in Stoke Newington and they all go to a local comp. Yvette's still a Labour MP, and generally they've all left the house by 9am, which is when I like to do piano practice — another aspect of my midlife crisis, along with golf clubs and my electric drum kit.

I want to take my grade 5 exam before Christmas, but training for Strictly's getting in the way. When I got invited to take part in this year's show, Yvette said I had to do it. She loves it and I think she's really jealous. Luckily, the dance studio I'm in is just down the road in Shoreditch, but it's 10am to 6pm most days and it's intense. I like the idea of the rumba, but it's the cha-cha-cha I'm worried about. I'm OK with rhythm. I just can't isolate my hips.

My dance partner, Katya Jones, says things like: "Shake your shoulders!" But my hands are the only things I can shake without everything else shaking. And when she says, "Go down on one knee," I can go down, I just can't get up. I've got facial issues too. The kids came to watch me and fell about laughing. I was destroyed. I had to go and lie down.

Lunch depends on whether I'm going through a carb-free phase. In fallow periods, I try not to eat too many carbs, but it's a barren existence — I have to eat things like egg salad. But I really need to lose some weight for the show.

At the start of this year, I sat down and wrote a book about my time as an MP. Each chapter has a heading like Mistakes and Spin, but it starts off with my defeat. I wasn't expecting it, but, looking back, the biggest change for me was Labour's defeat in 2010. After 13 years in power, opposition wasn't much fun and I wouldn't have enjoyed five more years of it... Labour's in a terrible mess.

One of my first ambitions was actually to become a footballer. I was the eldest of three, grew up in Norwich and went to a private school, where I was probably a bit of an extrovert — the only way to cope with my surname. Dad was a scientist and we moved to Nottingham, where he was professor of medical cell biology. By my teens, Thatcher was in power and I was really into politics. I went to Oxford to do PPE, then Harvard, and was going to stay and do a PhD but the FT offered me a job. By the age of 38 I was an MP.

Around the house, I'm the tidy one — Yvette isn't. You can see where she's been by the trails she leaves. I know if she's had tea and toast because she leaves the lids off things. My bugbear is wet towels on the floor. But the years of complaining are long gone. The sun rises, the seasons turn, I pick up the towels. I don't say anything.

I make most of the evening meals; chilli or lasagna one night, flank steaks or a cheese soufflé the next — I do a great smoked haddock soufflé for the Spectator's Christmas party every year.

After eight hours of jive moves or waltz steps or whatever it is I've done that day, I tend to crash out in front of the television and watch a box set or think about what else is on my bucket list. It's the first time since my teens that I have no idea what I'll be doing in five years, but that's OK. I'm optimistic. I even think David Cameron will vote for me in Strictly.

Interview by Ria Higgins

In the 2016 series of Strictly Come Dancing, Ed Balls and his dance partner Katya Jones lasted until week 10, and in 2021 he won the BBC's Celebrity Best Home Cook show. He is now a professor of political economy at King's College, London.

WORDS OF WISDOM

BEST ADVICE I WAS GIVEN

Always try to plan five years ahead in politics, but never forget today might be your last day

ADVICE I'D GIVE

Keep your children out of the spotlight – you've chosen this life, they haven't

WHAT I WISH I'D KNOWN

Going public about my stammer would have made speaking and TV interviews so much easier – it would have saved lots of anguish

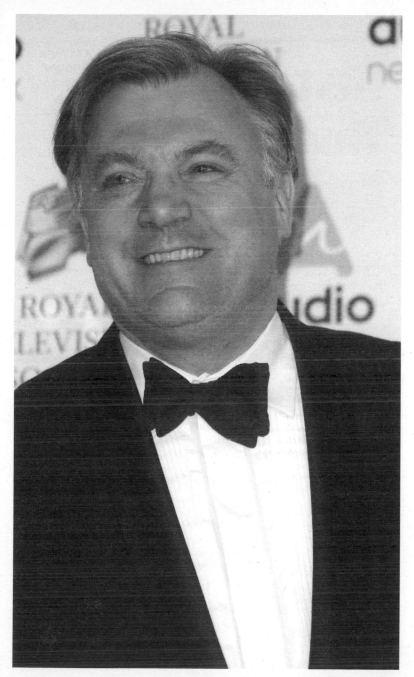

Sister Wendy Beckett

NOVEMBER 8, 1998

Sister Wendy Beckett, 68, joined the Notre Dame nuns at 16 and graduated from Oxford with a first in English. Her books and TV series have brought her fame as an art historian. She lives in the grounds of the monastery at Quidenham, Norfolk.

" Getting up at 3am is one of the minor high spots in my day. I have an alarm clock, just in case, but it only goes off about twice a year, because I'm nearly always awake before then. When I first became a nun, in 1947, I was taught a waking prayer which begins, "O God, it is to praise thee that I awake". Now that prayer comes automatically, like a fountain, into my mind, and I start each day with a wonderful spring of happiness.

I walk through the copse and walled garden up to the monastery, which is an 18th-century mansion – 27 novices live there. After contemplation and prayer, I go to the house for 8 o'clock Mass, which is the great high point of my day. When I'm filming I'll climb ladders, do anything, but I insist on morning Mass.

Sister Mary gives me my basket of food for the day, and we decide whether I'll have two or three bottles of milk. I eat frugally, but I do very well on it. I have bran for breakfast. Lunch is two Ryvita biscuits with Philadelphia cream cheese, plus some cooked vegetables. I allow myself four crisps each day. Sister Theresa thinks I should eat fish. Once a week she makes me two little fish fingers. If I've been given a bottle of wine, I might have a glass.

My great friend Delia Smith usually buys me a box of chocolates for my birthday in February; but she says she's not going to buy me any more, because at Christmas there are always some left and, of course, by then they're stale. Apart from coffee, which I

make on my funny little kettle, I don't have anything else all day. On Sundays I drink Nescafé. The rest of the week it's coffee the sisters buy in vast cartons to help the Third World.

After Mass I waddle back to the caravan, where I won't see or talk to anyone until the next morning. Hurrah! The rule of silence is that we don't talk unnecessarily. But if the sisters are working, one of them might have to say "Please will you push the paste pot over to me?" The sisters also have two hours' recreation, where they talk, play ping pong, do country dancing and just enjoy themselves. They have a telephone but no television. The library van comes once a month. I read military history, biographies, art books and novels.

When I came to live in solitude, I decided I would spend seven hours in prayer and two in work. Now, at 68, it's a great disappointment that I'm too old to die young. Death is a supreme act of faith. I hope that, when it comes, I will have long enough to say a total "Yes!"

Interview by Sue Fox

In the 1990s and 2000s, Sister Wendy's art documentaries drew huge television audiences and her Story of Painting was a video hit in the US. She died on Boxing Day in 2018, aged 88.

David Beckham

FEBRUARY 2, 2014

The former footballer, 38, on cooking lunch for his daughter Harper and why his eldest son Brooklyn prefers not to be seen with him.

I'm usually up early and will spend about five minutes getting ready. Once I've been in the shower, I'll put on deodorant, aftershave and moisturiser, and style my hair. I then get the kids up around 7.30am, but getting the four of them ready can be a bit more of a challenge.

If I'm at home for the day, which I often am, I'll also do the kids' breakfast. It's healthy food, but if one of them wants a pancake with a bit of syrup, I'll give it to them.

I then take the kids to school and, thankfully, we don't get pestered by the paparazzi any more. The only one we don't walk to the door is Brooklyn. Sometimes, he makes me drop him on the other side of the road. It's not cool to be dropped off by your dad.

When you have kids, structure can go out the window, but though I've retired from football, I still have a lot going on. Some of it is brand-related. One of my projects is being an Active Kids ambassador for Sainsbury's, so the other day I was shooting a TV ad for them. It's to inspire kids to be healthy, to be active, and I enjoy it.

Generally, I don't have a problem moving around London. I get in the car, or on my bike, and I usually wear a cap and a coat, and just keep my head down. Sometimes I get spotted in a shop and get mobbed, but if I'm quick I can be in and out without being noticed by anyone. I also do the weekly food shop — in fact, I've always done it. People are surprised about that, but it's easy; I know exactly what the kids like and I know exactly what Victoria likes.

Once Harper's home for lunch, I'll make her something to eat. One of her favourite vegetables is broccoli — she calls them trees.

Victoria and I definitely have different ideas about lunch. She eats lots of fish, vegetables and fruit; I love pasta and meat. If I'm on my own, I love nothing more than a nice piece of meat, cooked well, with a few vegetables.

Maybe once a week we'll go out and meet friends for lunch. When we were living in LA, Tom Cruise lived two minutes away. He's a good friend. There were occasions when I'd call him up and ask him if he had a new movie that wasn't out yet and if I'd go round and watch it with him.

I've met the prime minister quite a few times, too. He's a really nice guy, but I'm not sure I could go and invite myself to No 10 in the same way.

I love living back in London; it's where I was born. But, of course, I haven't lived here for a long time because I was only 15 when I moved up to Manchester. I enjoy its big parks, especially ones like Battersea. I love walking through them after I've been playing five-a-side with some friends.

I have weekly meetings with my business team, whether it's at my house or in the office. We'll sit down to discuss what's going on that month, whether it's a photoshoot, an advert, a charity event... I'm always being asked for autographs and photos, but I've never had a problem with that, it's just part and parcel of being me.

When the kids finish school, they might have different activities going on, like football or rugby. But when they get home we'll often play one of their favourite games, like Connect 4. They also love Lego. So do I. The last big thing I made was Tower Bridge. It was amazing. It had about 1,000 pieces. I think Lego sometimes helps to calm me down.

It's the same with cooking. I find it very therapeutic, which is just as well as I'll often do the evening meal. When I was in Italy, I loved the food and learnt how to cook it. Luckily, the kids love it too, so it's easy for me to put something together.

I might have a drink in the evening, maybe a glass of red wine. One thing I really love about being back here is the pubs — I even have a couple of locals that I actually go to. The people there know me, so it's easy enough to go in and have a pint.

When I go to bed, I often find my mind is kind of wandering from one thing to another. Since retiring, it's the first

time I've really sat down and looked at my career and the success I've had as a footballer. But I never think of myself as any different from anyone else. I don't look at my life like that.

All I think is that I'm a dad, I have four kids, I'm married, I do the school run every morning and make the dinner every night.

Interview by Mark Edmonds

Since retiring as a player, David Beckham has developed business interests promoting products from drinks to footwear and clothing. He and his wife Victoria have homes in London, the Cotswolds and Miami. He is co-owner of Salford City Football Club, and Inter Miami CF, a club that plays in US Major League Soccer.

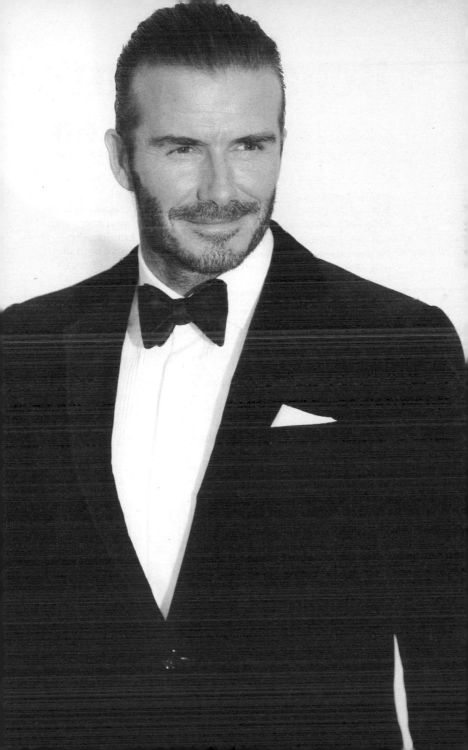

Benazir Bhutto

JANUARY 4, 1987

Benazir Bhutto, 33, is the leader of the Pakistan People's Party and the eldest daughter of Zulfikar Ali Bhutto, the former Pakistan premier who was executed in 1979 by General Zia, who had seized power in a coup two years earlier. She was detained for five years and exiled to England before returning to Karachi to lead the Opposition last April.

The story of my life is that either I'm in jail and have all the time in the world, but can't see anyone – or, like now, I'm free and have endless demands on my time. When I returned from exile I was expecting a big welcome, but what happened was beyond my wildest imaginings. There was a sea of people. Nobody had anticipated such crowds, and arrangements were totally inadequate. I used to have nightmares when I was young about climbing ladders. Suddenly in front of me I saw the ladder of my dreams. There were thousands of people around me and I had to climb it to get on top of the truck. By some miracle I got to the platform, and my heart was singing with joy.

I was thinking: what better vindication for my father than that he died for his country, and that after all the terror, the oppression, the darkness, here are people who acknowledge and respect him? Everyone says people's memories are short, but it isn't true. The crowd was shouting, "Bhutto, Bhutto!"

I had prepared a speech. I wrote it in England with the help of [the activist and journalist] Tariq Ali, whose political beliefs are different from mine, but we were both believers in democracy. I always get butterflies before speaking. Even when I was president of the Oxford Union I used to worry that I'd forget myself in mid-sentence. This time so much depended on it. But the larger the crowd, the more I feel the magnetism, and the crowd was with me all the way.

I like to think I'm carrying on my father's vision of a federal democratic Pakistan. He set the way for a society in which

there should be no discrimination on the basis of sex, race or religion, and I too am fighting for this.

My day varies depending on whether I'm on tour or at home in Karachi. When I'm at home, I'm woken at 8am, and one of my staff wheels my breakfast trolley in. It arrives with tea, fruit and bran flakes from Safeway – I brought quite a few cartons back from England with me – but I get so involved reading and marking the newspapers that I only have time for the tea. I take all international papers that carry news on Pakistan and that are not banned. Then I force myself to get up and, still in my pyjamas, I do 20 minutes of keep-fit exercises.

By 9am I'm washed and dressed. I wear shalwar kameez [traditional dress and trousers] and a dupatta [matching shawl] because for this climate I need loose comfortable clothes. In England I found shalwar materials too chilly so I often changed over to jeans and Western clothes. For an hour I deal with bills and paperwork, and then at 10am I start seeing people at half-hourly intervals. I have advisers on every subject but no one person whose advice I take on everything. I don't like to be caught up with details so people come to me with well-prepared options. A typical morning's discussions revolve around constitutional and parliamentary matters, intelligence reports and the state of the party.

At about 1pm I have a working lunch: something light like lentils and yoghurt. I don't cook or do any housework – an old family retainer manages the household. In the afternoon the pace hots up. I see people at 15 minute intervals until 5pm, and then at 5-minute intervals until 8pm. I always ask for my schedule to end at 8pm, knowing that if I do this I may finish at midnight. In Pakistan you say one thing, and it always ends up something else.

When I'm on tour, my day is equally relentless. The programme is arranged by local organisers and approved by me. I like to have the mornings to assimilate information and to write speeches so I request a midday start, but it rarely goes according to plan. Like tomorrow – the tour starts at 8am. I usually squeeze in 10 to 14 places a day, stopping to address roadside gatherings and public meetings. Everywhere I go, people press food and drink on me. It's a matter of honour that I eat with them, so I end up having several snacks too many.

It's not an issue that I'm a woman politician in a Muslim country. Although in general women have fewer rights than in the

West, Asia has a history of politically prominent women. I'm not a militant feminist, but I strongly oppose cruel inhuman laws that degrade women and make us second-class citizens. There are personal difficulties that I experience as a female politician. I can't embrace people or ruffle their hair like my father and brother used to do. Such actions often say more than words, but this camaraderie can only exist man to man.

I haven't always wanted to be a politician. When I was a kid I wanted to be a lawyer or a journalist. I read PPE at Oxford and then decided I wanted to join the foreign service. My father didn't want people to think I had got in just because he was prime minister, so on his advice I took courses in contemporary government and international relations.

When he was arrested it was an agonising time. I had to watch how he was kept in a death cell. They didn't really let him live before they killed him. They even refused permission for me to go to Mecca on his behalf, but I managed to make the pilgrimage in his name before I returned from exile. There were reports that the regime would assassinate me, so I went while I had the chance.

I came to terms with life during the years I was in prison. The first month was the worst. I was fed information that other party supporters had compromised, and was urged not to waste my youth and health. I felt so alone that if anybody had been sweet or kind to me, perhaps I would have broken down. But I was treated harshly, which brought out my individual defiance. Most of the time I was in solitary confinement without books or newspapers. If I wanted to write a letter, I was given one piece of paper at a time. I learned patience. I had to deal with the options in front of me, and not dream of the options that I might have.

When I was freed it was a moment of pure joy. As the plane landed at Zurich I felt burdens falling from me, like rocks off my shoulders. People who've had a lot of grief and pain know when a magic moment occurs. Just being able to see the world again, realising that [General] Zia wasn't behind me and that I wasn't going to be arrested was such a moment.

I went to England and lived in a flat in the Barbican. It took me a while to relate to people again. I was fearful of being on the street and seeing so many new faces. I kept trying to take the tube, but my heart beat so fast, I ended up in taxis. My days were spent dealing with party matters and forging international links. I hardly socialised at all.

Now I'm home I work 16 hours a day. Most evenings I spend four hours on the phone talking to people all over the country to keep

abreast of the situation. The sooner we can force an election and free Pakistan from dictatorship the better. When I was in London a distinguished politician warned me that wherever I went, in my house, my car, my garden, others would be listening. On his advice I bought a little anti-bugging device and I keep it in my bag at all times. He was right. When I don't have it on, I can overhear the security forces trying to listen to me on my short-wave radio!

At about 1am I go to my room, and while I'm washing and creaming my face, a couple of girl friends from school come to see me. One of them always spends the night in my sister's old room. We have a chit-chat about who's doing what, who's wearing what. I really need an hour or so to unwind like this. I have no time for hobbies, or for romance. I don't know how I'd fit it into my schedule, but one never knows. No, I'm not lonely. I meet so many people who pray for me and who support me because of what I'm doing that it gives me strength. In jail I had trouble getting to sleep. But now I just close my eyes and that's it.

Interview by Michele Jaffe

In 1988, Benazir Bhutto was elected prime minister of Pakistan and served until 1990. She was elected again in 1993, serving until 1996. Accused of corruption, she moved abroad, returning to Pakistan in October 2007 after being granted an amnesty. Two months later she was assassinated while waving at a crowd in Rawalpindi.

Ronald Biggs

MAY 21, 1978

Ronnie Biggs, 48 (known to his neighbours as Mike Haynes), great train robber and fugitive, lives with his son, Mike, 2½, in Sepetiba, near Rio de Janeiro.

I rise at 7am. I sleep naked. I have a pot of tea – Lipton's best Indian – and two fried eggs with a rasher of bacon. I like my eggs sunnyside up and my bacon crisp. When I can, I have toast and marmalade.

I lunch soon after noon on feijoada, a bean stew I prepare myself which looks like something the dog threw up on a raw morning but tastes fine. I take my feijoada with hot peppers on my verandah: my son usually settles for ketchup indoors.

I had to give up the maid three years ago – simply couldn't afford her, old chap, you know how it is – so I spend a lot of the day pottering round the villa and garden. I do all the cleaning and washing for the two of us. Any free time I spend in the sea – it's only 300 yards away – or the local bar on the beach.

I dine at 7pm on eggs and toast. If in funds, I'll have a few nightcaps of imported Scotch, but it's £28 a bottle so that's not often. I'm more likely to write poetry or read. Right now I'm reading John Fowles's *Daniel Martin*. My favourite author is Marcel Proust. At 11 o'clock I get out of my swimming trunks and go to bed.

The craziest thing is that I'm not allowed to work. As a young crook in England they were always telling me to work. Now I want to, they won't let me. So I spend a lot of time lounging about and looking after Mike. His mother came over in January to see him. I've taken him to meet his grandparents in Maranhão. But now I'm divorced from Charmian, I hope to be able to give him my name.

It's awkward, though. I don't officially exist in Brazil. They still know me as Mike Haynes, the name I came off the boat with. I do the whole one-parent family bit. Washing up, tidying, shopping, doing the clothes. But then, time is no problem.

Twice a week, we take a two-hour bus ride down to the Federal Police building in Rio. I sign a paper to state that I'm still here. It used to be only once a week but there's a character there now that doesn't like me too much. The travelling cuts down on time. It takes two days. It seems absurd not being allowed to work and having no free time. But there's always something on, people to see.

We seem to be on the tourist circuit. Just before you arrived, two landladies from Blackpool came here to pay their respects. They said coming to Brazil and not seeing Biggsie was like going to Egypt and not seeing the pyramids. An Englishman who had done nine months for corrupting a police officer was here between Christmas and Carnival. He runs a restaurant in Cornwall and he was discussing a winter holiday with his wife when he said, "I know, let's go to Brazil and see Ronnie Biggs."

There are lots of Germans, very keen on autographs. And New Zealanders, and stacks of Australians. I've just done a TV film for Australia, and an introduction for a cook-book. And of course Slipper of the Yard came four years ago in January 1974 to arrest me.

I'd been at my lowest. I was missing Charmian and the kids, missing Australia, even missing England. I was tired of running. The money was long gone. I was living in a crummy flat doing house conversions and painting jobs. I thought if I gave myself up, went back and said, "Okay, it's me, folks!" they'd take it into account with the sentence.

So I got a friend who was going back to London to fix a deal with the *Express*. He said, "Ronnie, you're mad, but I'll see what the *Express* will come up with for the story." Thirty-five grand. To send to Charmian in Australia. Not bad – but then it was a bloody good story. I was all fixed up and ready to go – and who turns up on Copacabana Beach? Slipper of the Yard.

Now that wasn't what Biggsie had in mind at all. I wanted to go back, sure, but as the guy who'd gone straight and done the decent. Not hauled back in cuffs like a screaming felon.

The morning they came for me, my bird, Raimunda, told me she was pregnant. Now, on a normal day, that would have made an impression. But not with Slipper, the whole of Fleet Street and half the Brazilian Federales after my little body. I found myself in a cell, feeling very sour, with a couple of Rio taxi drivers who shared the bedclothes with me – gave me the sports pages to sleep under.

There I am, all upset, and one of these blokes says to me, "If you could pretend to have got a Brazilian girl pregnant, bribe or beg

one, do anything, but get one, then they can't extradite you. Only deport you." I said, "Look, fellas, you're not going to believe this, but..."

I don't see myself getting back to Britain. And I don't believe I'll ever go to prison again. I'm satisfied in my own mind that I'm rehabilitated. Why put me back in prison, in a criminal environment, when I've been straight for so long? What do they want to do: make a criminal out of me?

Interview by Brian Moynahan

Ronald Biggs was convicted of involvement in the Great Train Robbery of 1963, but escaped from prison and fled to Brazil. After decades on the run, he returned to the UK in 2001 to complete his 30-year sentence. He suffered a series of strokes and was released on compassionate grounds in 2009. He died in 2013.

Dickie Bird

JUNE 2, 1996

Harold Dennis 'Dickie' Bird, MBE, 63, has been umpiring cricket matches for 23 years. He plans to retire later this month. He lives near Barnsley.

 I have nightmares. I'm in the middle of a match and bowlers are appearing at me shouting, "Howzat!" so it doesn't take much to wake me up. It used to be my peacock. When I bought the cottage there was this peacock in the garden. The owner said to me, "Do you want that peacock?" I says, "Well, I can't look after him, I'm never at home." But it wouldn't go.

Next thing I know it's brought a mate – where it got it from I'll never know. 'Appen it were Pontefract. Before long there's four young peacocks, but they were too noisy so now a farmer's got them, and I rely on an alarm clock like everybody else.

I'm always at the ground by 8am for an 11am start – I'm there before the ground staff sometimes, and all the gates are locked. It has been known for me to climb over a wall because I've been so early. I'm always punctual. When I had lunch with the Queen at Buckingham Palace I had to be there at 12.45pm. I was there by 8.40am.

I'm a shy bloke, and a terrible worrier. I visit the gents three or four times before a match. But once I come down those pavilion steps and onto that green, I'm completely different. The world's mine then. If you were a fast bowler bowling from my end, and you were sending down short-pitched deliveries, I'd be straight into you.

In my pockets I keep miniature Watney's Red Barrels to count the balls in the over, a penknife to get mud out of the players' spikes, and chewing gum – players always ask if I've got any – a spare ball and bails. So we need big pockets. Cricket's all about being a good sport, but winning means everything now. Sport is to be enjoyed – you've got to have a laugh. And I've had a few of those. Like when Dennis Lillee [the Australian fast bowler] put a rubber snake in my pocket. Bloody hell – I was jumping all over the place. And when Alan Lamb came out to bat for England, he gave me his mobile

phone. I put it in my pocket, and after a few overs it rings. I said to Lamby, "The phone's ringing." He said, "Answer it, man." I said: "You what? We're in the middle of a test match here." Anyway, I answered it. "Hello?" It's [Ian] Botham calling from the dressing room. "Tell that fella Lamb he's to play a few shots or get out."

On my way home of an evening, I pop into the butchers in the village. They make me up a potted meat sandwich and a pie. Then I go home and make a cup of tea.

I've given my life to cricket. I hope I won't be lost to the game now I'm retiring; I don't want to be sat at home. Fishing might be nice, but I'd only be on the river bank thinking about cricket. It's my life.

Interview by Richard Johnson

Dickie Bird umpired in 66 Test matches and 69 one-day internationals. After he retired, a statue of him was erected in Barnsley, his birthplace, showing him with arm outstretched, one finger raised to give the batsman out. The statue later had to be placed on a tall plinth to discourage revellers from hanging underwear and other mischievous items on the finger.

Mary J Blige

NOVEMBER 27, 2016

The Grammy award-winning R&B singer, 45, on divorce, self-destruction and redemption. Once dubbed the queen of hip-hop soul, Mary J Blige was born in New York's Bronx to a nurse mother and a jazz musician father who left the family when she was a child. After dropping out of high school, she got her break at 18, as a backing singer at Uptown Records. She has since recorded 13 albums and won nine Grammy awards. She filed for divorce from her husband, Martin "Kendu" Isaacs, earlier this year and fired him as her manager. She lives alone in LA.

 My eyes open at 6am. I'd love to laze around, but if I want to have a good day, I need time to centre myself spiritually. The first hour is prayer: thanking God for this day, thanking him for the good stuff, asking for help with the bad stuff. My life is a mess at the moment. I'm going through a difficult divorce [from Martin Isaacs] and I no longer have a relationship with my stepchildren.

In the past, I'd have wallowed in that pain, felt sorry for myself. Now, with God's help, I can make it through the day.

I make myself a vegetable shake while watching one of the spiritual TV channels — maybe Joel Osteen and Joyce Meyer — and then drive to the gym, not far from my house in LA. As I get older, I notice my butt cheeks hang a little lower. Everything hangs a little lower! Working out makes me feel positive.

So much of my life has been… negative. I was born in the Bronx and raised in the projects. It was tough for my mom because she was a single parent and my father didn't treat her too good. Things happened to me, too. [Blige was molested by a family friend when she was five.] For years I blamed myself and it made me want to self-destruct.

Then, when I became famous, I had access to all the weapons that could help me self-destruct — drugs, alcohol, any substance you name. I attacked myself because I felt I deserved to be hurt. Even my relationships caused me pain. [Blige was in an abusive relationship with the R&B singer K-Ci Hailey for six years.]

I used to hate looking in the mirror because I hated the person I'd become. Now, when I get home from the gym, I look in the mirror and see my friend, a person I love. I've waited so long to see you, girl!

I listen to music all day. The Clark Sisters, the Jones Girls, Stevie Wonder. They hit me right here [she thumps her chest]. That life I was telling you about, there was only one way it was gonna end. In the ground. Music saved me.

I ain't no chef, but I can feed myself. Gluten-free toast and avocado for lunch, with lots of tea. Then I'll clean the house. When I was a kid, Mom made us do chores and now it's my therapy. If I make my kitchen look nice, it's my way of saying: "You can't touch me here. This is my home."

My wardrobe has all the labels — Tom Ford, Moschino, Stella — but it's nice to just hang out in sweatpants and a T-shirt. I guess my relationship with money and material things has changed. When I made my first million, I went crazy. Money and all the things I could buy became part of who I was.

Now I watch all these young kids on shows like The X Factor and so many of them think fame is the answer to all their problems. But if you worship fame, it will only add to your problems.

New York was home for a long time, but LA ain't quite so crazy. I don't feel I have to go out every night. I'm more excited by what's on TV — How to Get Away with Murder, Scandal, Empire. I might bake chicken with scallions, green beans, rice, gravy, and have a glass of wine. The only difference is, drink no longer controls me.

I go to bed about 11pm, but the TV stays on for a while. When I do close my eyes, I'll pray again. All the years I spent hiding from the world, hiding from myself — now I can take off the disguise and be me.

Do I miss marriage? No way. I'm done with that. But it doesn't mean I'm done with love. I'll never be done with love. If you ain't got love, you really are in trouble.

Interview by Danny Scott

As well as her career in music, Mary J Blige has appeared in numerous film and television productions. She was nominated for a Golden Globe and an Academy Award for her role in the 2017 hit movie, Mudbound.

WORDS OF WISDOM	**BEST ADVICE I WAS GIVEN**	**ADVICE I'D GIVE**	**WHAT I WISH I'D KNOWN**
	One of my favourite singers, Chaka Khan, once said to me: You gotta get out of your own way	Don't worry about what people think. Just be yourself	Confidence is key

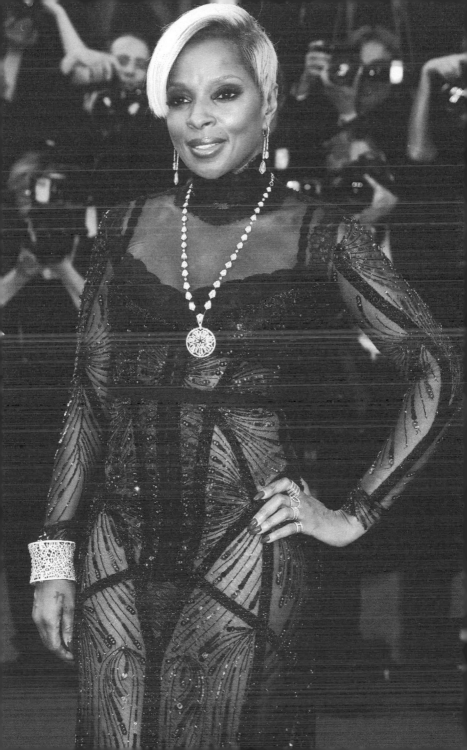

Orlando Bloom

MARCH 21, 2021

The actor on life with Katy Perry and their new baby, Daisy, Buddhism and Lego. Orlando Bloom, 44, grew up in Canterbury, Kent, before studying at the Guildhall School of Music and Drama in London. He got his big break at 22 when he was cast as Legolas in the Lord of the Rings. His other acting credits include the Pirates of the Caribbean films and the TV series Carnival Row. He was previously married to the Australian model Miranda Kerr, with whom he has a ten-year-old son, Flynn. Bloom lives in California.

I wake up at around 6.30am. I have a smart ring sleep tracker and the first thing I do is look at the app to see if I've had a good sleep and check my readiness for the day. Then I check on my daughter, who's usually up and cooing in her cot. My fiancée [Perry] needs her sleep, so I try to let her have a lie-in. Daisy's a very happy baby. I'll kiss her and we'll spend some time connecting. I'll do eye-gazing with her and sing songs, "Daddy loves his Daisy Dove", so she knows who Daddy is. My son's first word was "Mama", but Daisy said "Dadda".

It's amazing to be a father again. There's less anxiety this time and more presence. I'm a Capricorn, so I crave routine. Fortunately my partner is really into that too.

I chant for 20 minutes every day, religiously. I've had a Buddhist practice since I was 16, so that's infiltrated my whole being. I'll read a bit of Buddhism and then I'll type it up and add it to my [Instagram] Stories. Other than that, I won't look at my phone yet. I don't want to be sucked into the black hole of social media.

I like to earn my breakfast so I'll just have some green powders that I mix with brain octane oil, a collagen powder for my hair and nails, and some protein. It's all quite LA, really. Then I'll go for a hike while I listen to some Nirvana or Stone Temple Pilots.

By 9am it's breakfast, which is usually porridge, a little hazelnut milk, cinnamon, vanilla paste, hazelnuts, goji berries, a vegan protein powder and a cup of PG Tips. I'm 90 per cent plant-based, so I'll only eat a really good piece of red meat maybe once a month. I sometimes look at a cow and think, that's the most beautiful thing ever. At some point in time we'll look back and not be able to believe we used to eat meat.

My son spends half his time with me and half with my ex-wife. If he's with us, I get him breakfast before school. Then I'll have a shower and get dressed. I like to make an effort. No tracksuit bottoms. I have a deal with Amazon where I work on projects exclusively for them. I spend a lot of my time dreaming about roles for myself and others — for minorities and women. I'm trying to be a voice for everybody.

I had this remarkable opening chapter to my career, for which I was only semi-present. Without my Buddhist practice, I could have easily come off the rails. I've been changing the narrative in my head and feel that I can be the driver of my train. I can set it alight, but I can get the fire crew and put it out.

As a Brit and a parent living in America through this election cycle [Donald Trump v Joe Biden], I was very challenged. The news is no longer salacious, but there's lots of work to be done. I was super-proud of my girl [Perry performed at President Biden's inauguration].

Lunch is mostly plant-based again, vegetables or a stew. I will cook at times but otherwise there's a team of people. Then I'll have a Zoom and read scripts.

During Covid I started building Lego again. I dip in and out while I work. I build mostly cars and find the methodical nature of creating this little thing makes me feel like I'm achieving something else. Then I'll do heavy weights for an hour, something to exhaust me.

We'll put the baby to bed, then it's dinnertime. After that, I like to watch a movie or documentary for work. I aim to get to bed by 11pm. If I get eight hours' sleep I'm happy and so is my sleep tracker. Time is so precious. I was always giving my time to other people before. Now I have the space to dream.

Interview by Hannah Swerling

Among Orlando Bloom's neighbours in LA are Prince Harry and his wife Meghan. Harry has said that Bloom sometimes tips him off if paparazzi are in the area.

WORDS OF WISDOM	BEST ADVICE I WAS GIVEN	ADVICE I'D GIVE	WHAT I WISH I'D KNOWN
	Respect everyone from the doorman to the director	Be the master of your mind	It's a marathon not a sprint

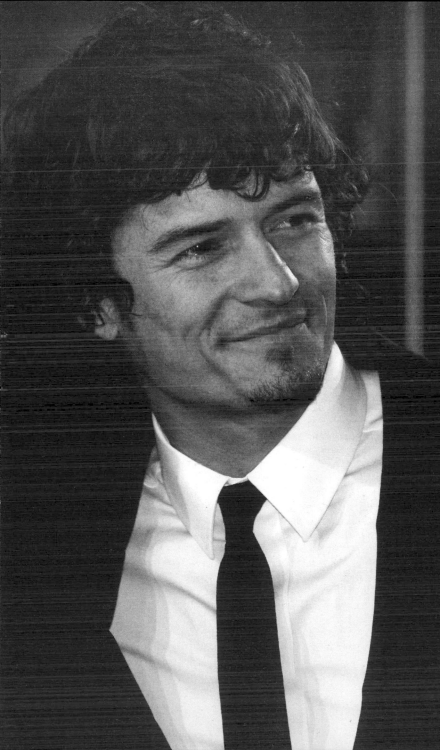

Richard Branson

FEBRUARY 7, 1993

Richard Branson, 42, lives in Notting Hill, London, with his second wife, Joan, and their children, Holly, 11, Sam, 6. From there he runs his company Virgin, the media, retail and travel group.

❝ I wake up to a kick in my groin. For 11 years now, I've had either my son, my daughter or both in my bed. They come in during the night. My son squirms enormously, so we wake up on average four times a night, and if I've forgotten to put a pillow between myself and his legs, waking up is normally quite a painful experience. Sam's six, and I'm trying to bribe him not to come in the bed. It's 10p a night – and we've had one successful night so far. It's money well spent.

We used to live on a small houseboat. But the kids couldn't swim and it started getting a bit dangerous, so we moved to this house in Notting Hill Gate. It's where I run everything from. As with most families, everything centres on the kitchen. Apart from baked beans on toast and fried eggs, I don't really cook. Ever since I was born somebody has always been kind enough to look after my eating.

We have breakfast on our laps on the sofa watching TV. The children usually dominate the screen. When I was doing my Pacific balloon crossing, I told them when they'd be able to see me on the news. Their answer was, "We don't watch the news, thank you, Daddy."

Breakfast might be a kipper, or it might be porridge. We're not overly careful about what we eat. We'll go for brown sugar rather than white, and brown bread rather than white, no sugar in

our tea – little things, but nothing that's very painful. We avoid red meat except once a week.

Sam will usually be rushing around, finishing off a bit of homework. So will Holly, but she's about to do her exams so she does it on her own. I don't check it – I'm not allowed to. I believe you should try and encourage your children all the time. Never criticise them unless they're going to cross the road and their lives are in danger. All of us flourish under praise – children, staff, the chairman of the company…

I have an early-morning secretary who comes at 8am, a late secretary who leaves at 8pm, and three girls who work throughout the day. I join them at 8.30am once the kids have gone to school. From then on there's no real pattern. That's what I enjoy about my job and why I don't really see my job as work. One day I'll be talking to the engineers on the airline; the next talking to Boy George's manager.

I've never read a book on management. I just realise people are the most important assets. I give them my home address so if they've got worries they can write to me with ideas and suggestions.

Joan and I are very unsociable during the week. Weekends are my real battery-recharging time. We take off to our home in the country, invite a few friends round and shut the gates. I love to balloon over the countryside, particularly over the River Colne in Gloucestershire. You hear every sound – even dogs barking. But you can't normally control which way you go, and the first time I went solo the wind died on me and I ended up on a bakery roof. I take off from my cricket pitch with nephews and nieces, sons and daughters. Last weekend I had eight kids up there, *literally* flying with the swans.

Our home in the country is two cottages knocked into one. It's a home for the kids really. They can run riot. We're not fussed about material things. I was once on the houseboat when it sank. It put my life into perspective; losing the photo album of the family was the only thing that really niggled me.

What money brings me is freedom – to dress as I feel comfortable, or to make my kids well again if they are ill.

Joan will tell you my principal weakness is women. Since she'd rather I didn't touch, I'm apt to find myself indulging in one or two too many drinks at a party instead, or even the occasional cigarette, which I loathe.

The kids are normally up quite late – about 9pm or even 9.30pm – but the last thing I hear will normally be Joan saying, "It's 11 o'clock – time you were asleep…"

Interview by Richard Johnson

Billionaire Richard Branson, who was knighted in 2000, now lives mainly on Necker Island in the Caribbean, which he bought for $180,000 in 1979. You can book the island, which takes up to 40 guests, at a cost of $105,000. That's the fee per night in 2021.

Kelly Brook

AUGUST 25, 2019

The presenter and model on the joys of gardening barefoot and braless at her 600-year-old oast house. Kelly Brook, 39, was born in Rochester, Kent, the daughter of a scaffolder and a cook. She started modelling aged 16 after winning a beauty competition and became a lads' mag favourite. She co-hosts Heart London Radio's Drivetime on weekdays and the Breakfast show on Saturdays, and she is a panellist on ITV's Loose Women. She lives with her boyfriend, the actor and model Jeremy Parisi, dividing their time between homes in north London and Kent.

66 I have a bit of a lie-in during the week, but on Saturdays my alarm goes off at 4.30am. I shower and glam up in 10 minutes, jump in the car and fly through Regent's Park, which is heaven. Leicester Square at that time is quite apocalyptic, full of waifs and strays. Back in the day that would have been me, still out at 5am, and here I am all fresh-faced, going into work.

Before we go on air at 6am, we discuss the papers and TV. I'll grab a sausage roll for breakfast or someone will do an Egg McMuffin run, then at 10am I jump in the car again and drive to my house in Kent, popping into M&S on the way for stuff for the barbecue.

My childhood was very Darling Buds of May. Dad would drive my brother and me around village pubs in his truck and we'd go cherry and strawberry picking. I dreamt of a cottage with roses round the door.

I came across our 600-year-old oast house in Kent when I was 27 and I've spent 10 years taking the garden back to its bones and planting crab apples, roses and a wildflower meadow. We have apples and pears, and make juice.

The first thing I do when I get there is take pictures of anything flowering to post on Instagram. Then I'll pop into the village and buy something ridiculous I don't need from one of the beautiful antiques shops. Jeremy's family has a huge estate in Italy

producing olive oil, so he's a proper country boy, but he doesn't understand flowers. He turns the compost.

Every spare moment I'm outside, hair in a scrunchie. No bra. Bare feet. We'll throw some vegetables on the fire bowl for lunch and in the afternoon I'll be in my potting shed, sweeping up. It's next to a stream and I've planted summer veg. I've even got a frog living in there. It's the perfect ecosystem. We also have a pool, so on a hot day my family will come to swim.

I had a late miscarriage in 2011 and it really made me rethink my journey as a mother. The biggest challenge has been finding inner peace. Being in my garden and growing things has been therapy. I think I'm fine with not having children, but if it happens, what a blessing it would be. I'm so blessed anyway — sometimes I think maybe you can't have everything.

I know I'm fit, so I never think about my shape. I lost a lot of weight when my father passed away [of lung cancer in 2007], but when I'm happy the pounds pile on. The bigger I am, the happier I am. But then sometimes I'm so happy, I'm eating dessert every night and that can't be good. Jeremy keeps me on track.

At one point we were visiting National Trust properties every weekend — I love Sissinghurst and Great Dixter for inspiration — but everyone there is in their sixties. Jeremy's a bit younger than me and said, "Come on, we're not retired yet." He was keen to spend more time in London, so we're living in Hampstead during the week. I'm often papped outside the flat on a Sunday night. The headline will be "Shock horror: Kelly goes make-up free!" and you know what? Kelly doesn't give a shit. That's pretty much what I look like all the time.

I jump in the shower, pull the twigs out of my hair and meet friends at a pub for dinner. Moving back to London part-time has been fantastic. I've finally found a decent bloke and I'm super-happy. I'm hitting 40 in November and I feel like I've nailed it.

Interview by Caroline Scott

In addition to her radio and television audiences, Kelly Brook has 1.3 million followers on Instagram.

WORDS OF WISDOM

BEST ADVICE I WAS GIVEN

Don't believe the bad stuff written about you — but don't believe the good stuff either

ADVICE I'D GIVE

Invest your money while you're young

WHAT I WISH I'D KNOWN

That I'd still be working in broadcasting in my forties. When I did The Big Breakfast, aged 18, I was written off as useless

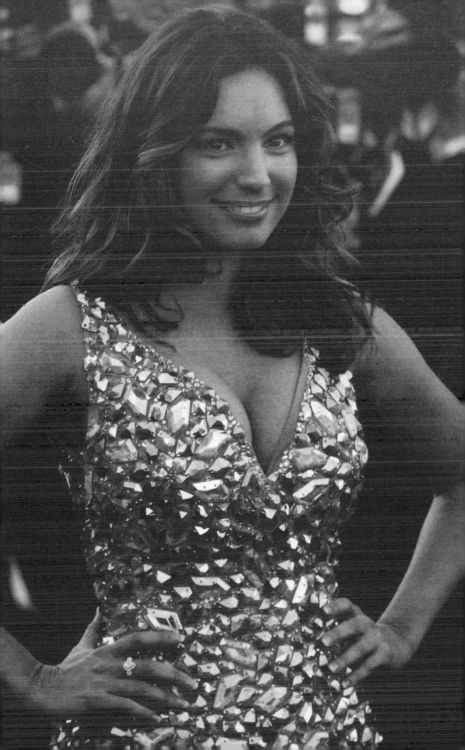

Dan Brown

SEPTEMBER 27, 2020

The author of The Da Vinci Code on divorce and being puzzled
by his critics. Dan Brown, 56, was born in New Hampshire.
After a brief career as a singer-songwriter, he published his first
novel, Digital Fortress, in 1998. His first three books were
commercial failures, but the fourth, The Da Vinci Code, became a
global bestseller. He lives alone in New Hampshire with his dog,
Winston, and his cat, Zeus, after his divorce last year from Blythe
Newlon Brown, his wife of 21 years.

"" I wake naturally at 4am with Zeus on my chest and
Winston beside me. We sleep in a turret on the third
floor of a stone hunting lodge. I make a cup of matcha
tea, then meditate for 22 minutes in a round room in the basement
before taking Winston for a walk. Breakfast is a blueberry and spinach
shake and, by 5am, I'm at my desk. There's no phone and no internet.
Every hour my computer shuts down for three minutes and I do
push-ups and stretches.

Successful writers don't have to carry on writing, but I love
to work. My characters don't care how many books I've sold. For
some reason critics in the UK just hate what I do, which I find
puzzling, but it doesn't bother me any more. If you've been fortunate
enough to develop an audience, you owe them.

My first love was music and I still play piano every day.
Mom taught me to turn pages for her on the organ bench during
church services. As an adult I moved to LA and made a record. I
thought I was on my way, then about nine people bought it. The same
thing happened with my first three books. I had two teaching jobs
just to pay the bills. I struggled and failed and tried again. I knew I had
something with *The Da Vinci Code*, but if I'd found that kind of
success at 25, I think I would have lost my mind.

I finish writing at 11am and I'm starving for lunch. I work
out three afternoons a week via Zoom with a trainer in Denver.

I love living alone. Anyone who has been in a difficult
relationship knows there's nothing worse. When we separated she

received half of everything and more money on top. [This summer, Blythe sued Dan for allegedly "misrepresenting" their wealth in their 2019 divorce settlement and accused him of multiple affairs.] Towards the end of our marriage, when we were each looking for comfort in other places, I met someone. She's hurt. I get it, and I've apologised. But it's not enough. So here we are.

I called my publisher and said, I'm so sorry, I hope this doesn't impact sales. He said: "Are you kidding? Everyone thinks you're the most boring guy in the world … multiple affairs with beautiful women, finally there's a story!"

I love very deeply — whether it's people or the creative process. But feeling too much is a double-edged sword. My biggest challenge is a racing mind. When something goes wrong, I'm straight to the worst-case scenario.

You've got to remember, for years there was nothing. When *Angels and Demons* came out [in 2000] I found one copy in my local bookstore. I took it to the desk and said: "I'm the author! Would you like me to sign it?" And the manager said: "We'd rather you didn't because we'll probably have to return it to the publisher." I'd give readings to empty chairs. I still carry that inside me.

I play golf and tennis and I have plans almost every night. I have a fire pit area where friends can talk at a distance [because of coronavirus] and we'll order pizza. The friends are the ones I had before success and they all say I haven't changed. I've never wished I'd had children, but I've always wanted to write a children's book — everything in life is a puzzle and kids love puzzles.

Winston and I walk the golf course again before bed at 10.30pm. I've tried to sleep more but my body doesn't want it. I wake up at 4am ready to go again.

Interview by Caroline Scott

When The Da Vinci Code, which has sold more than 80 million copies, was turned into a film, the critics gave it a drubbing. But the film is said to have earned more than $750 million worldwide.

WORDS OF WISDOM	BEST ADVICE I WAS GIVEN	ADVICE I'D GIVE	WHAT I WISH I'D KNOWN
	Don't take yourself too seriously	Live with an open mind … and an even more open heart	Don't believe your own press

Derren Brown

JUNE 1, 2003

The 'psychological illusionist', 32, concludes a UK tour at
London's Palace Theatre next Sunday. He lives with his
parrot, Figaro, in Bristol.

"I have to sleep in a cold room. Warmth makes me very
uncomfortable, so even in winter I have the windows
open and an electric fan directed on me. Normal waking
time is 9.30-10am, but it's sometimes much later. One of the reasons
I became a performer was in order to have time under my control.

I love cooking for myself – my big breakfast thing at the
moment is poached eggs. I spend such a lot of time in hotels, I've
become fascinated by presentation. I'm trying to get them just right
but it's so difficult to keep the shape. Food quality and my
surroundings in general are very important to me. I lay out silverware
and proper china and napkins and read from a book propped up on a
book stand. This all makes me sound incredibly pompous, but I just
enjoy taking time over these things. I simply wouldn't dream of
eating a bowl of cereal standing up.

I live in a flat which is quite musty. There are books
everywhere and a lot of parrot poo. To be honest, it's all a bit tatty
round the edges. I don't notice it but I expect other people do. I
spend a huge amount of time on my own and the clutter is my way of
pampering myself. I'm drawn to taxidermy because the pieces are so
weird. I'm desperate to get hold of some of those tableaux the
Victorians used to create: squirrels playing poker dressed in little
jackets, kittens in a classroom, that kind of thing.

I used to be self-conscious about clothes. When I was at
university I'd go round in a cape and big, blousy shirts. I thought I
looked cool and cavalier; in fact I looked like a camp gypsy from the
Wild West. Now, if I see something I like, I buy five. Then I don't
have to think about what to wear at all. After breakfast I deal with
emails from fans, mainly good, but with the occasional crazy thrown
in. Some think I have a psychic gift, others see what I do in terms of
hard science; actually it's somewhere in between. I'm not psychic, I

just spend a lot of time studying human responses. My shelves are crammed with psychology books and I devour anything remotely connected with human behaviour.

I have a friend locally, a musician and actor who comes over in the morning, and we drink tea and chat. It's helpful to discuss how my ideas for a show might work. Beyond that, there isn't much preparation I can do. Everything happens on the night. During a show, I'm scanning the audience all the time, looking for someone who is open, unquestioning, naturally responsive and gregarious.

Confidence plays a big part in what I do. You're facing an audience of 500 people you've never met before and you have one chance to pull someone out and convince them their feet are stuck to the floor and they can't move. I'm not controlling people's brains. I'm working with ordinary suggestion.

I go out into the village for lunch – a salad or a sandwich – and do a few jobs.

Thinking-time is very important. For years I worked as a magician at corporate functions. I'd do the same tricks at 50 different tables. What made it interesting was the way people reacted to certain suggestions.

Subconsciously we're all keen to follow certain behaviour patterns. I developed tricks to encourage people to give me the information I need. It's a kind of psychological sleight of hand. It's a dynamic, a conversation, and it always feels lively.

I drink earl grey in the morning and lapsang souchong in the afternoon. If I'm touring, I spend a huge amount of time on the road. I'm not remotely superstitious about performing. And I don't get anxious. My natural response to anything emotionally demanding is to detach.

I can be very intolerant and that comes from liking things to be just so. I love the theatre but I always go on my own. Anything which feeds one's soul has to be done alone. But then I will become infuriated by someone else's banal conversation behind me. And what makes it worse is that I'm aware that my rage is caused by my obsessiveness. It's an unpleasant trait.

I'll happily sit in a restaurant and eat dinner and read. But I also enjoy company in the evening, so if I'm eating out I'll often invite friends. I'll have a couple of malt whiskies at home, then I'll potter, email and talk to the parrot until 2 or 3am. I loathe the phone, and I'm terrible at chatting – that's the intolerance thing again. I

adore going to bed, I love the cosiness amidst the coldness of the room but I have to wear earplugs because everything in the flats above and below disturbs me. It takes quite a while to feel sleepy. If I'm thinking about a show, I can still be awake at 6am.

Interview by Caroline Scott

In his television specials, Derren Brown has persuaded people that, among other things, they are taking part in an armed robbery, the world has ended in a meteor strike and they're having supernatural experiences. His books about psychology include Happy: Why More or Less Everything is Absolutely Fine.

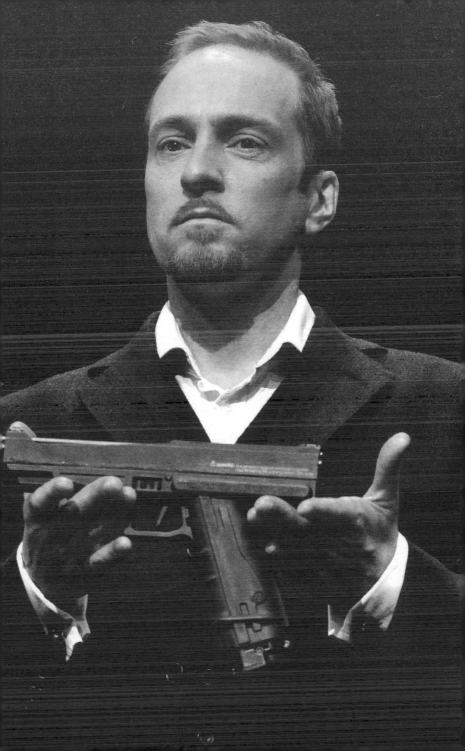

Frank Bruno

MARCH 31, 2019

The former heavyweight boxing champion on losing his
parents to cancer and looking out for his mental health. Frank
Bruno MBE won 40 out of 45 professional fights over the course
of a glittering career. In 1995 he was crowned the WBC
heavyweight champion of the world, and retired the following
year. He was sectioned in 2003, two years after his marriage
ended; he was diagnosed with bipolar disorder and went on to
launch a foundation to support people with mental health
problems. Aged 57, he has four children and two grandchildren,
and lives alone in Bedfordshire.

I set my alarm for 7.30am. If it's a bright day, I can see
light streaming through the curtains. I live in a nice
gated house with space around it. I like to see hills and
breathe fresh air, thanks to my mum, who sent me to a Sussex
boarding school at 12. That love of the countryside stayed with me.

I make cornmeal porridge with nutmeg first thing, but I'm
not big on breakfast. As a former boxer I can put on 6lb easily, and
when I'm worried I sometimes binge-eat, so I monitor my intake and
go to the gym most days. I've been doing yoga and meditation for
years. It keeps me well. Sometimes you've got to just shut your eyes.

My mum, dad and grandmother all died of cancer, so you
never know when that might strike. I lost Dad at 13, but he was my
biggest inspiration growing up — he taught me discipline and focus.
I used to talk to my mum on the phone every day before I lost her in
2016. She was a nurse and preacher, and knew the right words to say.

It's all too easy to think only about yourself, but you've got
to sow the seeds of goodness around you. I find it empowering to
help others, and to that end I've got a trainer's licence and completed
a counselling course.

At the moment I'm driving here, there and everywhere for
personal appearances. I dreamt of becoming world champion and
fulfilling that at 34 was incredible. Little did I know there was a very
rocky road to come. There's been talk about a film of my life, which

would be amazing. I fought my last fight [against Mike Tyson in 1996] with a detached retina. My trainer, George, would say things like: "You've hurt the left hand, what's wrong with the right one?" That was the reality of boxing, you couldn't feel sorry for yourself.

Lunch is usually something light, like a chicken caesar salad. I'm not a bad cook and find it therapeutic making recipes passed on from my mum, sisters and grandma. I love making fish, oxtail and lamb soups. I'm like Gordon Ramsay if I'm in the right mood.

Given my mental health issues, I have to be careful not to overload myself. I'm cautious of trusting people because so many have let me down. After I got divorced [from Laura Mooney in 2001], I was trying to do too much and I just burnt out. I had to speak out about my experience of being sectioned, because I was treated so badly. Everyone struggles in sport when they retire, and you have to find something to replace what you've lost.

For dinner I eat a lot of fish, pasta and fruit. I meet people all the time for work, so I don't socialise much in the evenings. I'm a music man and like to DJ on the decks in my kitchen — it's got me into a bit of bother with neighbours. I love Ray Charles, Sting, Dire Straits... sometimes I'll even drop some Elvis.

I go to bed at the same time every night and I've learnt to shut off. If I've been at the gym, I'm zonked and sleep easily. Before bed, I read motivational books and the messages are similar: stress is one of the most powerful things, you can't run from it. Occasionally it's good, but you've just got to put it aside and try to be happy.

Interview by Sofia Zagzoule

In Bruno v Tyson, a documentary shown on Sky in 2021, former heavyweight champion Mike Tyson admitted that Frank Bruno had nearly knocked him out in their first fight. "It was like electricity," he said of being hit by one Bruno punch. "I saw white lights."

WORDS OF WISDOM	BEST ADVICE I WAS GIVEN	ADVICE I'D GIVE	WHAT I WISH I'D KNOWN
	We are only here on borrowed time and time waits for no man or woman	Try and look after yourself as best you can	Accepting help is crucial

Michael Caine

MAY 27, 1984

Michael Caine, born in Rotherhithe, southeast London, in 1933, became a major movie star with Alfie in 1966. He now lives in Beverly Hills with his wife, Shakira, and their daughter, Natasha, 10.

❝ I've totally accepted the American way of life. We have a very high standard of living, but not in a stupid way. We don't have mink-lined, kidney-shaped swimming pools. I could retire now, but like most people from poor backgrounds I have an insecurity about money. I'd have to have three times what I needed before I'd think of it. I do miss England a bit. I still love London, no matter what they do with it. But I can be out of the pool and down to Beverly Hills for a business meeting in minutes. It's having the best of both worlds. I love it. Sitting out there by the pool is like being in the south of France. Except that you can understand the television. When I'm not working – because when I'm filming I wouldn't be here anyway – I usually rise late, say around 9.30am, sunbathe, swim, snooze, play tennis, have a sauna, go out to a party, go to bed. Typically exhausting day. I have a glass of fresh grapefruit juice – I don't know anyone here who bothers with breakfast. I do it in England, all that heart attack on a plate. Sausage, bacon, eggs, tomatoes, white bread and butter, and tea with milk and sugar. The heart-attack rate in England is still rising because of that bloody breakfast. But I do miss Melton Mowbray pies. We've got four cars – a Rolls-Royce Silver Wraith II, then there's an old American banger, a Volkswagen station wagon and the new VW saloon. When you go to a party here there are two questions you don't ask: "How's the wife?" and "Are you working?" You wait for them to tell you – if they want to. Things can happen very quickly in this town, and you never know who might be with whom. I see people like Rod Stewart, Barbra Streisand, Dudley Moore...At the moment I'm dickering over a film that would take five months in Tunisia. But Shakira and I have never been separated for more than four weeks before, and our little one is at school here. So unless they make me an offer I can't refuse... ❞

Interview by George Perry

Michael Caine has appeared in more than 130 films, including
The Italian Job, The Quiet American and Inception. He has been
nominated three times for an Oscar as best actor in a leading role
and has won twice as best supporting actor. In 2000 he was
knighted – under his real name, Maurice Micklewhite.

Simon Callow

APRIL 9, 2017

The actor, writer and director, 67, on newly married life, weight gain and his obsessions. Born in London, Simon Callow got his first job at the National Theatre box office after writing a fan letter to Sir Laurence Olivier. Best known for his role as Gareth in the film Four Weddings and a Funeral, he was also one of the first actors to declare his homosexuality, in 1984, in his autobiography, Being an Actor. He lives in Islington, London, with Sebastian Fox, whom he married last year.

I love early morning. By 6.30am, I'm out of the trap like a greyhound. There's no way I could lie around in bed. It would feel like wasted time and I can't abide wasted time.

My husband, Seb, gets up at the same time and always has the first shower. I get an orange and a bowl of muesli, then sit on the stairs by the bathroom chatting to him. I get the muesli from a shop near our house in Islington. If I can't get that particular one, it drives me mad!

Classical music is a passion and I turn on Radio 3 while I'm having a shower. I use one of those loofah mitts to scrub my body. And it must be a real bar of soap.

My weight does yo-yo, but I got a real shock a couple of years ago. Seb and I were on holiday in Turkey and there were photos of me in the Turkish version of Hello! I go to the gym two or three times a week, so I thought I was in good shape, but when I saw them… oh, my ever-expanding girth!

My family has German, Danish and French roots, but I was born in Streatham and London's in my bones. My father's work took us to Zambia when I was a child, but I hated it. I was short, fat and daunted by the insects. I'd dream of the Woolworths in Streatham.

If I'm working from home, I have to get into tunnel mode. Seb is working on a creative entrepreneur scheme for the Guildhall School, and when he leaves for work, I go to my study and wade through whatever's on my plate. When it comes to work, I'm a greedy boy.

Some days, I don't even bother getting dressed. I'll sit there in my dressing gown and underpants, surrounded by books. A Kindle's no use at all. A book is a book...the smell, the feel. But it's getting out of control — I've just given more than 1,000 books to Westminster Reference Library.

I am fanatical about lunchtime. I always stop at 1pm and always have the same thing... much to Seb's horror! Sardines and sun-dried tomatoes on Ryvita. With several pots of darjeeling — light, no milk.

Most people probably call me an actor, but I've no idea what I am. I consume work like tea, whether it's writing, doing a film or directing, which I've just been doing at Trafalgar Studios — Christopher Hampton's The Philanthropist, which opened this week.

At some point, my dressing gown will disappear. I'm fond of designers such as Ermenegildo Zegna, but I can barely afford them. I try to wear a mix of colours and like outfits to have a certain chunkiness. What's that I hear you whisper? "If he's gone for chunkiness, he's certainly succeeded."

Once Seb's home, I stop work. I'm an unimaginative chef, so he does most of the cooking. It amazes me that he never follows a recipe. He just throws stuff together and makes something wonderful.

I never drink during the day, but a glass of wine is an essential part of any dinner. Many glasses of wine! A jeroboam of wine! I disregard all government guidelines — a load of nonsense — but I do have a sense of the damage it's doing to my body. If I'm feeling liverish, I pull back.

Occasionally, we might watch TV, but I prefer sitting round the table with friends. Politics isn't the best after-dinner topic, but it's hard not to think about it. Seb's half-German so obviously we've been watching what's happening. These are alarming times. I still remember the anxiety of the 1960s; the feeling the bomb was going to drop any moment. That's how I feel now!

Seb always goes to bed before me. I look for things to do, then wander up. I resent sleep, I often lie awake riddled with anxiety, thinking, "F***! What am I going to do tomorrow?"

Interview by Danny Scott

Though best known as an actor, Simon Callow has written more than 10 books, including three volumes of a biography of Orson Welles. He has said a fourth and final volume is under way.

WORDS OF WISDOM	BEST ADVICE I WAS GIVEN	ADVICE I'D GIVE	WHAT I WISH I'D KNOWN
	Even if people give me advice, I usually ignore it	Try to keep a nice balance between pain and pleasure	I knew an awful lot at 15. Probably more than I do now!

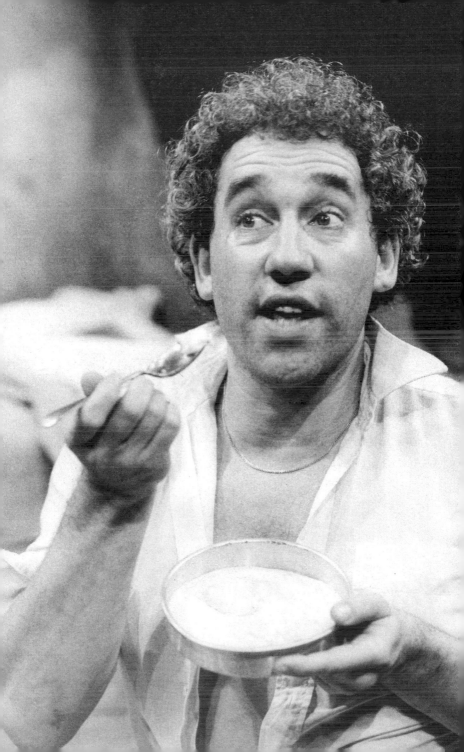

Roko Camaj

JANUARY 4, 1998

Roko Camaj, 56, cleans the windows of New York's World Trade Center, at 1,270ft the third highest inhabited building in the world. He lives in Long Island with his wife, Katrina.

66 Every morning it's the same thing. Up at 4.30am with my wife complaining, "It's the middle of the night!" There's no time for breakfast, so I just glug down a glass of milk. I check in the hall mirror that I'm not going out into society with a white, milky moustache.

The Center is relatively quiet first thing. It starts buzzing at 7.30am when the "suits" arrive. My first task is to make sure the window-washer machine is happy. It's basically a small cage with washing brushes attached. Most of the windows are washed automatically. The only ones I have to do by hand are on the top three floors: the 110th, the observation deck, and the Windows on the World floor. They were pretty stupid when they designed this building – they went for aesthetics and didn't worry about who was going to clean the windows, which curve inwards on the 110th floor.

Once I've checked the electricity and cables I'm free to have a nice greasy American breakfast of bagel, bacon and eggs and tasteless coffee.

Window cleaners are weird guys. I think it's because when you go down the side of a building it's a completely different world. It's you and the person working with you and nothing else. You look straight ahead and everything's normal, then you look down and *whoaaa!* – there ain't nothing for over 1,000ft. I've been working up here for 22 years. I remember on the first day my stomach gave a little lunge when I looked down. Now it's just like I'm standing on the ground. I'm not a scaredy-cat.

This tall city seems so shrunken and insignificant from up above. It's like a toy town, with tiny cars and people who look like toothpicks. I'm even higher than the clouds and aeroplanes. When they flit by I have an urge to jump out and ride on the back of them. I see a few birds circling round and I often have the unpleasant task of

cleaning squashed birds from the windows when they've crunched into the glass by mistake.

Everything has to be very secure in the window-washer cage. You can't, for example, have loose change or an identity card in your pockets. God forbid – if you drop one penny from here you can kill someone down below. My world consists of windows and reflections. You see everyone else from the other side of the glass. I prefer to be on the outside looking in. I'm the one who's free. Inside, it's like a jail. I wouldn't ever want to trade places with the big shots sitting inside in their leather chairs. As I pass their air-conditioned cages, I can see they'd love to rip off their ties. Me, I don't have any stress. I'm always having fun and my face is bronzed from being outdoors.

It's pretty hellish up there when the wind whips around, though the cage is rock solid. But I've often come off the building with windburn. In summer there's a nice spidery breeze.

I'll never forget February 26, 1993, the day Muslim extremists set off the bomb here. Six people were killed and thousands were injured. I was on the 110th floor, luckily on the inside, and I heard a dull *whooomph.* I looked up; no lights. And I heard screaming on my walkie-talkie: "Oh my God, it's a bomb!" It was very confusing. They were shouting: "Bomb over here, bomb over there!" There was so much smoke I didn't know where to go down – it took me three hours to reach the ground floor. Women with high heels left their shoes everywhere. It was like a carpet of stilettos. If I'd have been hanging outside, I'd have been stuck and they'd have had to lower me by hand.

But I love this job. I get $75 more than the window cleaners downstairs. Those guys call us crazy. They even take pictures of us as if we were urban freaks.

I'll break for lunch at about midday and rush to empty the contents of my lunchbox. My wife packs something hearty like goulash, which I warm up in the microwave I've installed in the shed on the 110th floor. Then I listen to my cassette of Albanian songs and my heart soars. Those are my roots.

I head home at 3pm. I work a little bit on the house and I'm obsessed about cleaning my own windows. My wife tries to interfere with comments like, "You're making too many suds." But my windows are *sparkling.*

My wife will make dinner at 8pm or we'll order in some cheap fast food. I go to sleep at 10pm. It runs in the family; everyone sleeps good. How many times did I ask my wife, "Did you bring me my glass of water?" And by the time she's gone to get it, I'm snoring like a pig.

Roko Camaj was on the roof of the south tower of the World Trade Center when a plane struck the building in the 9/11 attacks of 2001. As fire and chaos broke out below him, he phoned his wife from the 105th floor where he was sheltering with scores of other people. He told her: "We're all in God's hands". He did not survive.

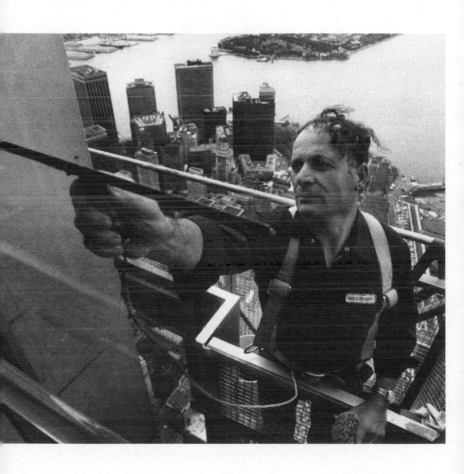

Naomi Campbell

MAY 14, 2017

The supermodel on colonic hygiene and her guilty pleasure: watching Real Housewives. The first black model to grace the covers of French Vogue and Time magazine, Naomi Campbell, 46, was born in Streatham, south London. She was discovered by Synchro model agency at the age of 15, while at the Italia Conti Academy of Theatre Arts. She has been on more than 500 magazine covers, appears in the Fox dramas Star and Empire and is the founder of Fashion for Relief. She has several homes.

66 I like to get up about 8.30am. Wherever I am, the first thing I do is say my prayers. I then have hot water with lemon, followed by a green juice with fruit such as pineapple and blueberries. Or a green powder juice. I also take zinc, antioxidants and a probiotic — I think it's important to keep your colon as clean as possible.

I regularly use facial masks for cleaning and exfoliating my skin. For my face, I then use a serum with stem cells by Rescue. I also use Dr Sebagh's Gold Elixir, neck cream and rosehip serum. Going out, I wear a tinted moisturiser foundation, and I go between four brands: Bobbi Brown, Burberry, Laura Mercier and Nars — I've worked with François Nars for years. He's a great make-up artist. If I'm on a shoot or going on a TV set, I use Pat McGrath's make-up.

I've been on the road a lot this year, so I don't want to say where my homes are because I've had so many security problems. Also I'll leave to go to one country, then find myself going to four instead, so I can be away a long time.

I've got a team of people that includes my agents for modelling and TV work. One thing I've been doing lately is filming for a drama series I'm in called Star. It's based in Atlanta, so I was there a lot. I'm also hosting Fashion for Relief in Cannes next Sunday. It's in aid of Save the Children, so I hope it raises much-needed funds.

If I'm working, I don't stop for lunch, it slows everyone down. But I carry snacks like apricots, red raisins, almonds, walnuts and crispy seaweed. I might even have a packet of salt-and-vinegar crisps or a Galaxy Ripple — I love those big-value bars of Galaxy you get at the airport. If I have to do a lunch, maybe I'll have a piece of sole. I do eat meat, but no chicken. And no coffee — it's ginger or green tea.

If I have a couple of free days, I do things like going to the dentist, doctor or a pilates class. Last year I did a Transcendental Meditation course at the David Lynch centre in New York. A great guy, Bob Roth, taught me things like how to cut the mind off. I also go to NA meetings. Things that matter.

I'm so grateful for where I am right now. I've had many turning points, from meeting Nelson Mandela to being discovered in Covent Garden when I was 15. I was at the Italia Conti school back then and people would have said I was shy. But if I was going to an audition of 800 kids and they only wanted eight, I was going to do my damnedest to be one of them.

I think I get my drive from my mum — my biggest inspiration. She raised me, she made a lot of sacrifices for me, she believed in me. We lived in Streatham, in south London, and on Saturdays I'd go to Brixton market with my grandmother. With my friends, I'd go to places like the ice rink on Streatham High Road.

Wherever I am, I like to catch up with friends. I often do that in the evening, when I have my main meal. I like Italian, Japanese, Lebanese. I still love Jamaican, things Mum cooks. Red snapper, callaloo, green banana. It's comfort food, but it's healthy too. I only started eating crap when I became a model. Now I know better.

Before bed, I love watching reality shows. It used to be Towie, now I'm a fan of Real Housewives. I love Shereé in the Atlanta series and Erika in the Beverly Hills one. I like to see what someone else's life is like. I also watch my own shows, Star and Empire.

As you get older, you know the people who love you, who are true to you and who are there for you. I'm at a point in my life

where I'm comfortable in my own skin, not looking for any new friends and I don't have time for bullshit.

For bed, I love pyjamas or shorts and camisoles. I get beautiful ones from For Restless Sleepers. They are designed by my friend Francesca Ruffini. And I love nightdresses. I'm feminine that way. The last thing I do before I go to sleep is say my prayers.

Interview by Ria Higgins

In addition to modelling, Naomi Campbell has overcome drug and alcohol addictions, dated various actors, musicians and moguls, and amassed more than 10 million followers on Instagram. In 2021 she became a mother for the first time, at the age of 50.

WORDS OF WISDOM	BEST ADVICE I WAS GIVEN	ADVICE I'D GIVE	
	Nelson Mandela always used to say: "Use yourself to help others"	Only commit to things you feel passionate about. It has to come from within	you. Ultimately, you have to be happy with yourself at the end of the day

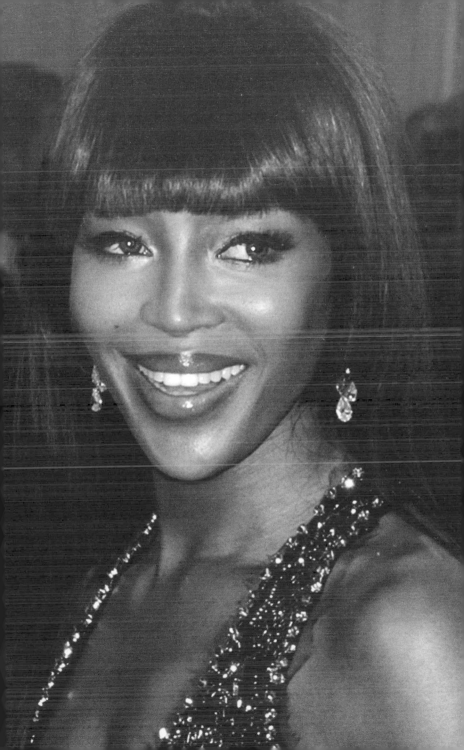

Eric Cantona

JANUARY 6, 2019

The former Manchester United star on singing at breakfast and keeping his temper. Eric Cantona, 52, is an actor and former footballer from Marseilles, France. The son of a nurse and a dressmaker, he won four Premier League titles and two FA Cups in five seasons at Manchester United. He reportedly wants to be the club's next manager after Jose Mourinho was sacked last month, though ex-teammate Ole Gunnar Solskjaer has been named caretaker manager until the end of the season. Cantona has four children: two from his first wife, Isabelle, and two with his present wife, Rachida. They live in Lisbon.

 I am an early riser — 6 or 7am. Breakfast is crostini with butter and jam, and green tea. At the table, with my wife and children, I like to stand up and sing. My songs are surreal: the words come out automatically. To me, control is boring. Some people get freedom from drinking alcohol. I lose control when I sing.

For a long time, my life was strict. As a boy at football academy, in Marseilles, I had to get up and make my bed or I had to pay a fine. For the rest of my life in football, every morning I had to arrive at a time and place. I was never late for training. Now I spend the mornings writing or painting or just thinking. I don't get paid for this, but that's OK. My goal is to do what I love: art. If I can't express myself, for sure I will die.

In the middle of the morning, I do some exercise. I need to. If I cannot go to the gym, I do weights around the kitchen for 45 minutes. Then I go in my little car to the sea. I never stay anywhere too long — I prefer to say I'm "in transit", otherwise I start to feel like a prisoner. In 20 minutes I am by the ocean with kilometres of nothing and nobody, just the boats and the planes in the sky. I feel invincible on mornings like this.

For lunch, there is a local fish restaurant at the port. It can be white fish like haddock or sole. Not fried, but grilled with tomato, oregano and olive oil, and with homemade french fries.

Another reason I like Portugal is that I am not from there. I used to read Le Monde and Libération every day, but I needed to take a distance from politics. Politicians just do what they want. Nothing changes. I love England and for me Brexit doesn't change anything. I don't have any countries or regions, but they decided on these borders for today. It is easy for me to travel, so I don't feel the difference.

Football is like politics. It is all about money. My father never spoke to me about money. I had a passion for the game and he said, if you have a dream, then try. That's it. I know I am a lucky man. I can have everything I want. But in my heart money still doesn't matter to me. I go in business class now, but if someone said, "Come back into economy class," that would be OK.

People think I lost my temper and got so many red cards, but it's a myth. The kung-fu kick [Cantona attacked a fan in 1995] wasn't me, it was the testosterone — but I don't regret it. I wouldn't have done it harder, but I wouldn't have done it any less hard either.

In the evening, I love to cook. I love risotto with lemon. We eat with family and friends with all the children around. I met Rachida while doing a production in Comédie-Française, kind of like the Royal Shakespeare Company. I fell in love with her immediately. I saw her eyes through a mirror in a make-up room. I was supposed to look like I weighed 200kg, so I was wearing this silicone costume. She was the beauty, I was the beast. But she liked herself in my eyes and I liked myself in her eyes. It's why we are still in love.

At 10 o'clock, we put the children to bed. I don't get angry with them or lose my temper with them, or lose my temper at all. Before bed I like to get into a lucid dream. Then around 12pm I sleep straight until the morning.

Interview by Gabriel Pogrund

Since retiring from football, Eric Cantona has appeared in numerous films and TV programmes. In 2020 he starred in a French mini-series called Inhuman Resources.

WORDS OF WISDOM

BEST ADVICE I WAS GIVEN

Johan Cruyff said that you have to anticipate and see everything before you receive the ball. I apply it to life

ADVICE I'D GIVE

Receive advice like love

WHAT I WISH I'D KNOWN

When you meet somebody, it is because it is the right time to meet

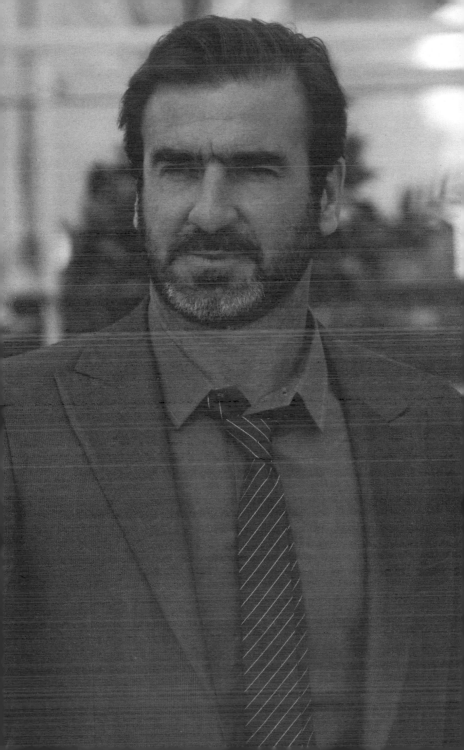

Lee Child

JANUARY 3, 2016

The bestselling author, 61, talks about his addictions,
reinventing himself and working with Tom Cruise.

" We recently moved to an apartment on Central Park,
and all the rooms face east, which means that most days
I'm awake with the sun, whether I like it or not.

Breakfast is a long, drawn-out affair: a pot of coffee and
about six Camel cigarettes that I will smoke over the next hour. I
know it's unhealthy, but frankly I enjoy it. Then maybe a bowl of
cereal: mostly Kellogg's Honey Smacks. If I feel virtuous, I'll have
Alpen, but the original recipe with the added sugar.

I'm a fairly disciplined writer. I start each new book on
September 1. It's a sentimental anniversary for me, because it's when
I started writing my first novel about Jack Reacher, who's a former
military policeman turned vigilante. I've since written one Reacher
novel a year [the novels have sold 70m copies in 41 countries] and my
latest one, Make Me, is the 20th.

It's been fun watching the books become films — Tom
Cruise played Jack Reacher and is currently filming the sequel.
Cruise is a nice guy, a pleasure to work with. There has been a lot of
tabloid nonsense about him, none of which I feel to be true.

I don't write in the morning. I read or I do errands,
anywhere within a 10-block radius — the post office, FedEx,
groceries, the bank. While I'm out, I might also go for a walk in
Central Park.

When I get back, I'll have lunch, which is mostly toast —
nothing fancy — and slices of emmenthal, stilton or cheddar. Then
it's more cigarettes, more coffee. Jack Reacher's famous for his coffee
consumption, so I tend to get manufacturers and fans sending me a
lot of it.

After that, I get down to writing. I work in the back room of
our apartment; it's the fourth bedroom, the one that doesn't look
over Central Park, which is perfect because I don't want the

distraction. It's also spartan, just my desk, hammered together out of aluminium, and a couch.

Having done so many of the Jack Reacher novels now, the writing process comes naturally to me, so I can write straight onto the Mac — one draft, more or less. At some point I should think about ending the series, but people like Jack, they want more, who am I to deny them? I write on the verge of a stroke, I suppose — all the coffee and cigarettes — but I was once misquoted as saying I wrote while I was high. I don't. I might smoke a little weed at night to unwind, but writing while you're high just produces a lot of gobbledygook. I'm pretty disciplined, but one of the great things about being a writer is you can lie down and stare into space in the afternoon.

I don't know if I wanted to be a writer at the start, but I have always wanted to entertain. I was born in Coventry; my father was in the civil service, my mother was a housewife. They weren't particularly creative, but books were encouraged, so I read a lot.

When I was four, we moved to Handsworth Wood, a suburb on the north side of Birmingham. It was because my parents knew the area had good state primary and secondary schools. If I had left school at 10, I still would have been perfectly functional.

Theatre was my first love and my first job was as a volunteer at a local theatre. I then gravitated towards television and ended up at Granada TV as a presentation director, but in 1995 I was made redundant. I was 40 and it was unsettling. It made me crave reinvention, which is why I ditched my real name, Jim Grant.

At that point, my wife, Jane, and I decided to move to New York. It was my idea, but our daughter, Ruth, who was then a teenager, wanted to go to college in America. She's 35 now and has at last found her true metier as a dog trainer — people here pay a fortune for it.

Jane's American and we've been married for 40 years now; we met at Sheffield University, where I studied law. She does charity work for environmental groups, and if she's here, she'll cook — we eat a lot of organic and non-GMO food. If she's out or away, I'll have another bowl of cereal.

If I'm hard at work on a book, I often return to it after midnight for a couple of hours. There's something magical about working when everyone else is asleep. I still get up the next morning with the sun, and that's fine. The coffee, cigarettes and writing all keep me going.

Interview by Nick Duerden

In 2020 Lee Child said he was going to stop writing Jack Reacher novels and that his younger brother, Andrew, would take over as author of further books in the series. Lee told The Sunday Times: "I'm running out of energy, I'm running out of ideas and, crucially, I'm getting old".

Yvette Cooper

FEBRUARY 9, 2014

The shadow home secretary, 45, on why her husband, Ed Balls, makes her stress levels go up.

66 I'm not the liveliest person when the alarm goes off at 7am. I listen to the Today programme on Radio 4, together with my husband [Ed Balls, the shadow chancellor]. We were the first married couple in the Cabinet, before Labour lost the last election.

I'm first out of bed and thrown straight into the chaos of getting the kids ready for school. Our routine often includes the mundane searching for homework books and PE kits.

When it comes to breakfast, everybody has to fend for themselves. I normally eat a bit of muesli, followed by toast and Marmite. TV news is usually on in the kitchen, and stress levels are often made worse by Ed, who has taken to piano practice at 8.30am. He started learning 18 months ago and has reached grade three, so at least now he can string a tune together.

During the week we live in a terraced house in Stoke Newington, in north London, then on Friday morning we travel back to our neighbouring constituencies in Yorkshire to work and stay for the weekend.

Our children, who are 14, 12 and 9, all go to local schools, and Ed and I share the school run. We need to be out by 8.45am to walk them to school, but sometimes that's complicated by events in the news. If I'm tight for time, I race back home on one of their toy scooters. Ed and I try to go to work together on the bus and Tube, but some days we drive. I use that time to work or tweet, but my experiences with Twitter haven't always been good. Once, my phone accidentally tweeted gibberish from the bottom of my handbag, and I got a barrage of replies. One said that they had never heard a politician speak so much sense.

I aim to be at my office by 10am. It looks out over Parliament Square and I have a picture of Emmeline Pankhurst on the wall. There's no such thing as a typical day, but mornings often include

dealing with issues that have come up in my Yorkshire constituency, which is Normanton, Pontefract and Castleford. It could be housing problems, a family with financial pressures, or help for a local company.

As shadow home secretary, I focus on home affairs, which right now includes Labour's policy on tackling domestic violence against women. It's crazy we still don't have compulsory sex-relation education that teaches zero tolerance of violence. The guidance is so out of date it doesn't even refer to the impact of the internet.

I'll drink several cups of tea before lunch, which is usually from one of the canteens here. Sometimes there's no time to actually stop, so I'll just grab a cheese-and-coleslaw sandwich and have it walking through the corridors, going from one meeting to the next.

Ed and I don't tend to have many meetings together. We stay in touch by text and it's usually concerning the kids. The Commons sits at different times during the week and I might go into the Chamber for debates on home affairs or justice.

Immigration is a big subject and when we were in government, we got some of our policies on it wrong, so we need to address that. After the next general election, I want to be Labour's home secretary because there's a huge amount you can do in that job and I feel I can do it. We've had women leading the Labour party in the past — both Margaret Beckett and Harriet Harman — and I'm sure we will again. During the afternoon I tend to snack on savoury foods, like crisps or soup; it keeps me going until evening. We have childcare after school because neither Ed nor I know what time we'll arrive home. My Mum stays a lot to help out, too.

If I do get home early, though, I like to help them with their homework or collect them from after-school hobbies. Somebody once asked me if I have any hobbies and I thought: "Do mothers have time for such things?"

Ed makes dinner because he's a better cook than me, and a favourite of ours is chicken stir fry, which is fast and easy — his mum taught him how to cook. When you're juggling children it can be exhausting. If he didn't cook, we probably wouldn't eat.

If there has been a late debate in the Commons, it can be gone 10pm by the time I get in, and midnight by the time I finally get into bed. When I put my head on the pillow, I'll no doubt still have all these thoughts going through my head about the day's events, but in this job it's impossible not to.

Interview by Jeremy Taylor

In 2015 Yvette Cooper, who served in the governments of Tony Blair and Gordon Brown, stood for election as leader of the Labour Party but lost to Jeremy Corbyn. She is the current chair of the House of Commons Home Affairs Committee.

Dalai Lama

APRIL 26, 2009

His Holiness on prayer power, surgery, and his tireless fight for
his people.

 My day starts at 3.30am. I recite an inspirational stanza in
praise of Buddha Shakyamuni. It reads: "Enthused by
great compassion/ You taught the immaculate teaching./
To dispel all perverted views/ To you, the Buddha, I bow." I recite that
with prayers in prostration. After that, analytical meditation. What is
Buddha? What is self? I reflect on emptiness — the ultimate
reality — and altruism. All human beings are the same: we all want
happiness and we do not want suffering. Then the treadmill, jogging
for 40 minutes. If you hold the rail firmly you can recite a prayer and
meditate too. But you must take care or you might fall off!

Breakfast is at 5.30am, a porridge called *tsampa*, made from
roasted barley. Delicious and good protein — quite heavy, but
necessary, because empty stomach since lunch the previous day.
Then heavy work in the bathroom or toilet. Before my gall-bladder
surgery in October, this not so certain: sometimes you have to force
your way through! But now seems more regular.

I listen to the radio, mainly BBC or occasionally a Tibetan
broadcast from America. Then meditation, for five hours if possible.
This includes visualisation of the mandala [an image representing
the universe], or deity-yoga meditation. We say that these
meditations can prepare one for death and give some power of
control when it happens.

Mid-morning in Dharamsala, where I live, I go to my office
or to a meeting. If I'm not in a hurry, I study Tibetan scriptures, then
the Indian newspapers and perhaps Time and Newsweek. The hours
simply fly by. Lunch is at 11.30am. For Buddhist monks, lunch must
begin before noon. Except for two days a week, it is vegetarian food,
which in India is excellent. Sometimes in the West the food is very
good quality, very poor quantity. Then you need three or four bowls
of rice to fill up.

People say: "Dalai Lama, where is home for you now?" I
spent my first 25 years in Tibet, but I'm nearly 50 years in India, so

now Dharamsala is our home. The scenery here is beautiful and the temperature is very good. My garden is very special to me. I love tulip, hyacinth and delphinium, lupins and cyclamen. Friends bring me beautiful orchids, but most cannot survive in our climate. I designed something to water them and regulate the temperature, but still they die. It struck me that my design is like a cemetery for orchids! I also like polishing stones and beads, and I am good with mechanical things.

Two American ladies, years ago, came to see me. Their camera had broken, and they asked me to repair it. I said, "I am not 100% sure," but I opened the camera and found the damage, so I fixed it. But I have no knowledge of computers and I don't even own a mobile phone.

Buddhist monks take vows of simplicity, which means refraining from gathering wealth for oneself, as it hinders one's spiritual growth. That is a joyous part of my life. A reporter said to me: "Dalai Lama, you are the most respected leader for the people." I said: "I'm just a simple Buddhist monk." One thousand years ago, a Tibetan master said: "When many people respect you, you must feel you are the lowest, so you will not develop prejudice or arrogance." This I always practise.

In the afternoon I go to my office again. I do interviews or meet the Kalon Tripa, the head of the Tibetan government in exile. Now I'm older, my physicians advise me to do less.

But I like to go daily to meet my people who have come from Tibet to India. After the riots in Tibet on March 10 of last year, the Chinese always say: "These crises are originating from the Dalai Lama." In fact, I'm always telling the Tibetans we must work and not demonstrate. But then it happened like that.

At 5pm I have tea. Then meditation again, for one or two hours. This helps me in many ways. If the plane should be delayed, when I meditate I can wait one or two hours and I have no impatience. Around 7pm, sleeping. Sleep is the most important meditation. Sometimes nine hours without disturbance. No sleeping pill. Nothing. A doctor examined my body recently, and he said: "Your age is 73, but your body element looks like 60." So that brings some hope I will live another 10, 20, even 30 years! Would I like that? I don't know. Until we see a solution between the Tibetans and Chinese, it's difficult. Should that change, then if death were to come tonight, I would have no regret.

Interview by Beverley D'Silva

The 14th Dalai Lama was born in 1935 to a farming family in northeastern Tibet. At the age of two, he was recognised as the reincarnation of the previous Dalai Lama. In 1959, amid Chinese suppression of Tibetan nationalism, he was forced to escape into exile. Ever since, he has lived in Dharamsala in northern India.

Nancy Dell'Olio

JUNE 12, 2011

Nancy Dell'Olio, 50 this summer, ex-girlfriend of football manager Sven-Göran Eriksson and current squeeze of theatre director Trevor Nunn, on being kind, charismatic and looking fabulous.

" I wake up early, despite the fact that I function much better at night. I'm gifted to not need a lot of sleep. Five hours is normal, seven is luxury, but it's rare. I have a very busy schedule. I don't need to sleep. I go to the bathroom, then I drink a litre of water, which my dermatologist recommends to keep my skin lifted. I try not to have any meetings before 11.30am to allow me time to wake up properly. I like to relax, maybe make a few telephone calls in my dressing gown, do a little breakfast. I have plain yoghurt with fresh fruit, some berries, half a banana and green tea, and after breakfast I get out my diary. Three times a week a man comes to give me a massage. But I'm not telling you who – it's a secret. Or I do some yoga. And I love to walk in Hyde Park, but it's so difficult to find the time.

Since I was a little child in Italy, people have looked at me, and not just because I'm beautiful; it's something else that comes from inside me. I know I'm fascinating. But I prefer the word charisma to beauty. I've endured jealousy since I was small, but I don't care. I'm blessed. The most important thing I have is myself. And it's part of my culture to take care of me.

I'm privileged to have good skin. It's not olive, you know, it's rose, and very delicate. I dedicate a lot of time to cleansing and moisturising. Lately I'm using a cream with vitamin C and collagen, made especially for me, which gives a little lift for the evening. I love to look 30, like I look now. And it's my goal to look 30 at 70. Diet is important too. You need to know your metabolism. I like a lot of protein – I always have salmon and mozzarella in my fridge and I eat a lot of fruit. But no bread. I take vitamins and minerals and I have a blood test at a clinic every six months. When you're in the public eye like me you need a 48-hour day just to take care of how you look.

I phone my assistant, Massimo, or he comes to my place and we go over things. I love clothes but I hate to go shopping, so Massimo calls and they send clothes to me. I have a lot of meetings, which I like to do over lunch at the Berkeley in Knightsbridge, 10 minutes from where I live. Or Claridge's, or the Ivy Club. I don't know anyone who does as much as I do. I'm a lawyer first of all. I do public affairs. Call it lobbying. I do special networking for firms in Italy, America and the UK. But it's boring to do one thing, so I write. I'm working on a novel and a book about travel and food, and I want to co-produce two big projects on TV, but I can't mention them. I wish one day there'll be a movie about how I spend my day because it is quite intense.

I'm a very loved person. Women and men, they both love me, and this is because I'm the kindest person I know. I'm never rude, which is important, but the characteristic I'm most proud of is that I do love to spoil my man. And you can't spoil your man if you don't know how to spoil yourself, which I do. I'm not a feminist, I'm feminine.

It's my nature to put my man first and I've always adjusted my life to his. I did it with my first husband and my second, and I'll do it with the new man in my life [Trevor Nunn]. I never wanted children; I knew when I was pregnant it wasn't what I wanted, I felt completely overwhelmed because I would have had no time for me, but I'm like a mother to my man. I shower him with attention – physical, material, psychological – it's the way I love. And I require attention back, because I know how good I am. Sometimes it does get quite stressful. I'm special, you know, so you're going to have a very unique and intense experience with me. But at the same time, I'm very demanding. It's not easy. But then, who cares for easy things?

In the afternoon I make phone calls, I read the papers, have my acupuncture. I still have to learn how to really relax. I love to be at home, to have a whirlpool bath with oils and candles, but I'm out nearly every night. I'm invited everywhere and I can't say no. I always change for dinner with my partner and I refresh my make-up and my hair. I've been going to the theatre a lot – it's always been my passion – and I love the opera. He [Nunn] said already I'm the most intelligent person he's ever met. I'm sure the majority of people haven't sat through seven hours of Wagner as I have. I can describe every opera to you and I do know Shakespeare very well.

Sometimes, if I'm too tired to take my make-up off, I just take off my lashes and spray my face with water. I sleep on my side, with three or four pillows, and the make-up stays. Next morning I

retouch it. I wear a little Parisienne [nightie] and if I'm not alone... nothing, of course. I always wake up after two hours, then I need a trick to make me relax – some natural herbal drops or sometimes a sleeping pill to switch my mind off. Maybe people think I have everything. Nobody has everything, but I'm very privileged.

Interview by Caroline Scott

Not long after this interview, Nancy Dell'Olio appeared in the ninth series of Strictly Come Dancing, where she was the fourth celebrity eliminated; and in 2016 she participated in Celebrity Big Brother, where she was evicted after 11 days. Her relationship with Trevor Nunn did not last.

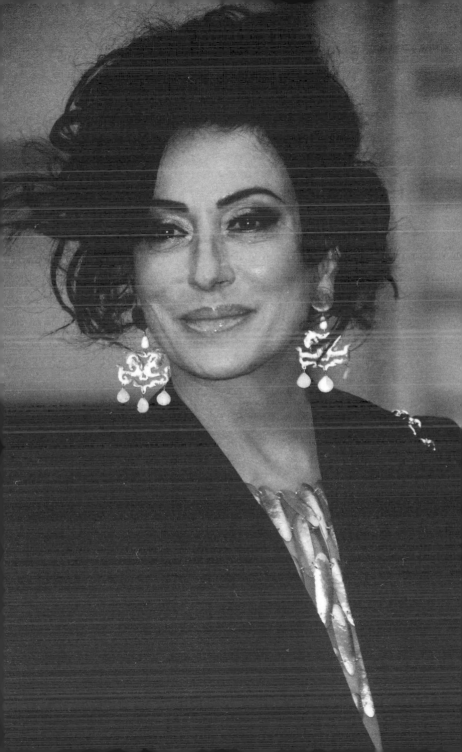

Judi Dench

NOVEMBER 27, 1983

The actress Judi Dench, 49, and her husband, Michael Williams, appeared together in the hugely successful TV series A Fine Romance. They live in Hampstead, London, with their daughter, Finty, 11.

Our three cats jump on the bed at 6.30am. That's when my day begins. As soon as I open the bathroom curtains, I can hear Sausage and Mash, the guinea pigs, squealing for their breakfast. Food for pets comes before everything.

Michael likes to have breakfast in bed, but I go downstairs and eat with Finty. We love to chat, especially walking to school. When I have to be out early, Finty goes with Rachel, our mother's help. We couldn't give her a secure family life unless we had someone living in. I wish acting didn't make so many demands – I loathe being away from home.

For the number of people who live here the house is too small, but we would never move. I bought it before Michael and I were together and the previous owner left us incredibly happy vibes. I can never wait to come home. It's such a joy to potter around, cook and sew, grow tomatoes. There are times when I actually believe that acting cuts into the day. Michael says I'm being daft and would miss working. He's probably right, but I adored my time at home when Finty was tiny.

Something Michael and I both dread in the morning is the postman. There are so many letters we need a secretary! Of course we're not nearly so efficient. What happens is that we wait until the carrier bags are so enormous that we have to scream for help. An extremely capable friend comes over to straighten us out. Although we try desperately hard to reply to everyone, Michael recently discovered a large bag of letters dating back to 1969. Can you imagine? All those people writing: "Dear Judi, please, please let us know as soon as possible."

I'm never bothered by working in a television series during the day and appearing on stage in the evening because I'm not one of

those terribly theatrical people. I don't pace up and down worrying about a part. Good gracious no. I like to have a good laugh about it when I can. That's more my style. At home, Michael and I never discuss theatre.

I'm famous for my lists. They're written on large laundry cards. Every single thing I need to do or buy is written down. Today I managed to check off green wellingtons, meat, batteries, dry cleaning and Christmas presents. Ian McKellen more or less refused to work with me again because he insists that all I do from July onwards is worry about what to buy people for Christmas. Well, I've got 13 godchildren and this year I have 150 presents listed and 18 stockings to make.

We're terribly family-minded. Michael and I both had wonderful childhoods and still like to spend weekends and holidays with his father in Warwickshire. I love the typically French way of life where all the generations sit around a table for hours. When the weather is good, we sometimes stay up after a barbecue until 2am, just talking.

Being such a homebird, I think it's important to make my dressing room at the theatre as cosy as possible. Getting the nest right is a top priority. I bring in pillows and rugs and knick-knacks to brighten up the place.

There aren't any set rules about when we eat. If Michael and I are in a play we sometimes see friends afterwards for supper. When I was in *The Importance of Being Earnest*, I occasionally polished off four eggs on toast before the evening performance. But I have been known to go to the other extreme and have days of nothing but grapes and Perrier. Wouldn't it be something to be tall and thin?

On holidays we go camping in Scotland and it always rains, which is part of the fun. After breakfast, it takes me half an hour to clean up the tent, then we go off to explore for the day. After a nice supper out, I climb into the sleeping bag with Finty, and Michael gets out his book of Scottish ghost stories, which frighten us to death. As Michael says, we really don't ask for much out of life. Just the three of us, shut up at home together, with our feet stuck up the chimney.

Interview by Sue Fox

Among many awards, Dame Judi Dench won an Oscar as best supporting actress in 1999 and has been nominated as best actress in a leading role five times. From 1995 to 2015 she played the role of spy chief M in the James Bond movies. Her husband Michael died of lung cancer in 2001.

Frankie Dettori

DECEMBER 10, 2006

The 35-year-old jockey made history at Ascot in 1996 by winning all seven races. He has now ridden nearly 3,000 winners. He lives in Stetchworth, Cambridgeshire, with his wife, Catherine, and their children, Leo, 7, Ella, 5, Mia, 4, Tallulah, 3, and Rocco, 1.

" I wake up to exercise the horses, not every morning but two or three times a week. In the summer it may be 5am, in the winter 7am. I was terrible at getting up in my teens and early twenties, but for more than a decade I've been late for the horses only once.

I have a wash and, like every Italian, I have an espresso to kick-start, which I make myself. I get dressed, something casual. I like good clothes: Gucci, Prada, shoes by Bellucci. Then I drive myself to the stables, two miles away. I own a Ferrari but I usually take the Audi S8.

I've worked for Sheikh Mohammed of the Maktoum family for 12 years. We have 150 horses — the best in the world. We take them to Dubai for the winter and bring them back to England for the summer. I put on my crash hat, boots and breeches and I test one of the horses each day, on the gallops, to see if they are well or not and ready to run. After an hour I go home. The kids are up and it's like an atomic bomb let loose. I help Catherine get their breakfast, then read the papers. Then I try to kick them all out and go back to bed for an hour.

If I haven't nicked one of my kids' sausages, I have chocolate or a biscuit. I don't eat much breakfast. As a jockey I have to weigh between 8st 7lb and 8st 9lb. I check my weight three or

four times a day. If I eat late, I put on 2 to 3lb, and in the morning I have to lose it. I do 5k on the running machine in our gym at home, six days a week. I wear a ski suit, hat and gloves, to sweat. If I still haven't lost enough, I jump in the sauna.

When I've lost the weight, I go to the day's first racecourse — from April to September we do two meetings a day. It's usually about two hours away by car. I have a driver, so it's my chance to catch up on some sleep and study The Racing Post. You have to know your horse and your opponents' horses, your strengths, their weaknesses, what the dangers are. You need a plan, how you're going to beat the others.

We usually get to the races around 1pm. I put on my racing colours: every owner has their own set, and our stables', Godolphin's, are blue. The first race is usually at 2, and I ride between four and six a day. Racing is dangerous. I broke my ribs, collarbone, elbows, fingers, a couple of toes, concussed a few times — just the normal. But it's also very exciting and unpredictable. You could start the day thinking, "I've got four good horses to ride," and end up with nothing. Or you could think, "I've no chance of winning," and win five races.

I have two mares I breed from, and we have five ponies for the kids, but jockeys aren't allowed to own racehorses or bet on them. Riding is a bet in itself anyway. For every race I ride, I get a flat fee of £90, but if I win I get a percentage of the winnings. If you win a £1m race, you get £100,000, but most races I ride are small.

My favourite horse is the fastest one. At the moment, it's Ouija Board. She's a smashing filly. I enjoy winning and being successful. It's quite selfish, really. I win about one race in every four. Horses have the sixth sense. When you're on a winning streak, it transmits to the horse and it runs faster for you. The Epsom Derby is the only race I never won. I've had 14 goes. But I'll get there.

My dad, who was a champion jockey himself, was strict and pushy, and just said get on with it. I came to England at 14, alone. It makes you streetwise, but I couldn't do that to my children. I didn't believe in myself. But I got better and better, thanks to Dad and my teachers.

After two or three races, we'll go from, say, Kent to Windsor or Leicester for two or three more races. On the way I grab a Coca-Cola or a piece of fruit. In the summer it's harder to keep the weight off — you eat late and pick at the wrong things. When I stop riding, in winter, I can eat more, and I put on 7 to 10lb. Not eating what I'd like is tough, but it's my job. And in 10 years, when I retire, I'll be able to eat as much as I want.

I don't mind any of this, though. I feel lucky to be here at all. June 1, 2000, I got a second life. I was at Newmarket, we were taking off for another course when our plane crashed. Sadly, the pilot, Patrick Mackey, died. Myself and Ray [Cochrane, now his racing manager] survived. I managed to get out of the plane but my leg was broken — Ray dragged me away. Then the plane blew up, so I was lucky twice. For a second I thought of packing it up. But if it weren't for racing, what would I do?

At the end of October, when the season here ends, the big international races begin. I've just been to America and Australia, then it's Japan. I love going around the world — all the different faces, the challenges, the competition. Getting the MBE, in 2001, was a big surprise. Unfortunately, it was stolen from our home in September, with some of my medals and cups and my wife's jewellery. It was very upsetting. What use they will be to the thieves? Maybe they put them on their own mantelpiece.

I get home at 10 or 11pm in the summer, around 7pm in the winter, so I get to see the kids. I'll be on the Aga, inventing dishes, usually fish or chicken. And I love salad.

If I have a day off, I'm a couch potato, watch TV, stay up late. My wife likes to read, so she goes up first. Half an hour later, I go. When I'm working I'm in bed by 9.30pm. I'm so tired, I can't wait to go to sleep.

Interview by Beverley D'Silva

Six months after this interview, Frankie Dettori won the Epsom Derby on a horse called Authorized, and in 2015 won it a second time on Golden Horn. He has amassed well over 3,000 race wins in the UK, including 20 "classics" — top flat season races. He is about 5 foot 4 inches tall.

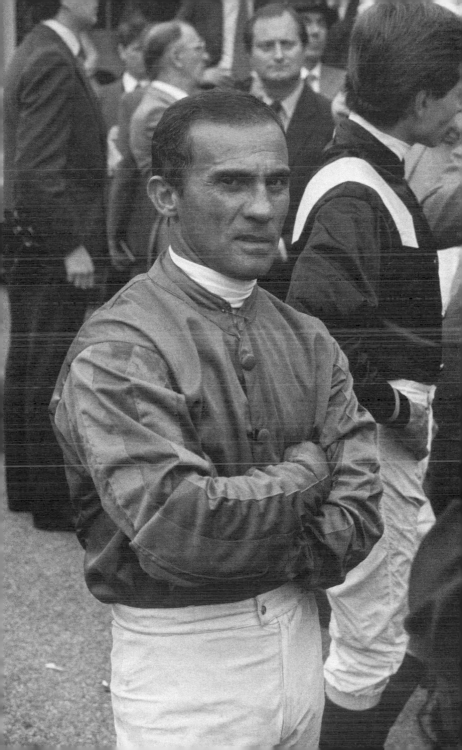

Julian Dunkerton

FEBRUARY 25, 2018

The co-founder of the fashion brand Superdry on his coffee addiction and love of fishing. At the age of 19, Julian Dunkerton set up his first clothing business, selling it for a profit a year later. In 1995, he opened Cult Clothing, a stall in Cheltenham, which grew into a nationwide chain. In 2003, he co-founded Superdry with his friend James Holder. The fashion group has helped the divorced father of two build a £366m fortune. Dunkerton, 52, also owns a number of gastropubs, hotels and a cider factory. He lives just outside Cheltenham.

My alarm goes off at 6.50am and I head to the shower to wake up properly. I have one that sends the water down from a huge rectangle, like a cloudburst. I'm passionate about a good shower — and coffee. I never eat breakfast, but I couldn't live without my nine shots of coffee throughout the day. I've got one of those big industrial La Cimbali machines at home.

If the girls [daughter Kitty and stepdaughter Matilda] have stayed with me the night before, I'll drive them to school in Cheltenham with Radio 1 blaring — their choice, not mine. I fell in love with Cheltenham when I first arrived in the 1980s.

I head to the office for 8.30am. We have 600 employees there and thousands more worldwide. I set up my first business in the 1980s, bringing eclectic clothes from London to sell in Herefordshire. It was an exciting time, with punks and rudeboys influencing what young people wore. While my friends were reading about sports in the newspapers, I absorbed the business and political pages.

I always aimed to be top of my game at understanding what is going to happen next in the consumer world. Show me pretty much anything and I'll work out a way of making money from it.

I have other businesses, but Superdry is my obsession. Its success is down to great product design and branding. The only other people who think in the same way are at Gucci or Louis Vuitton. I live, breathe and wear Superdry and I am very focused. Part of that discipline is not having a smartphone. I watch other people clog up their time with emails and fill their heads with thoughts they don't need, but I don't want any distractions to affect my ability to do my job. So I keep it simple — other people do my emails.

My desk gets in a real mess over the course of the day — I'm very untidy. I excuse myself by saying my brain is working on bigger things. There is much to do and I'm always looking to the future. I don't want to sit on a fancy yacht and twiddle my thumbs; working is what I like best. If you were a brilliant tennis player you wouldn't stop playing, would you? You're only here once and if you can effect some change in your lifetime then you've achieved something. Creating jobs and beautiful things is thrilling.

For lunch I have something light, such as soup. I know I should exercise more, but it's hard to make the time. Occasionally, if I find myself with an unexpected hour spare, I'll go fishing. The office is close to the River Avon and I've got a little boat moored there with my rods all set up. I'll put on bait and see if a pike, roach or zander takes a bite. I love the tranquillity. It's the only downtime I take.

If the girls are with me in the evening I'll stay in with them. I'm dedicated to being a good dad. I come from a left-wing background and I have a deep-seated desire to do the right thing. I was a Labour supporter in the 1980s, but today I'm non-party political and a strict Remainer.

Most evenings I eat in the restaurants of the hotels or pubs I own. If things are working well, I can relax, but I'm fully attuned to any flaws. When I get home at around 11pm, I'll go straight to bed. I don't need to unwind. I'm good at going to sleep.

Interview by Caroline Hutton

Julian Dunkerton gave £220,000 to the Greens, Plaid Cymru and the Liberal Democrats ahead of the 2019 general election. His fortune was put at £182 million in the 2020 Sunday Times Rich List.

WORDS OF WISDOM	**BEST ADVICE I WAS GIVEN**	**ADVICE I'D GIVE**	**WHAT I WISH I'D KNOWN**
	My dad used to say, "Always question professionals and work out if they know what they're talking about"	Altruism and emotional intelligence are the best tools for conquering the world	Not everyone can deal successfully with having money

Emily Eavis

JUNE 21, 2015

Emily Eavis, 35, on the long days and sleepless nights preparing to host the Glastonbury festival.

> I am up by 6am, as is my husband, Nick, and our two boys, George, who's 4, and Noah, who's 2. They're small balls of energy, so while one of us will get them ready, the other will lay the table for breakfast, which will be a medley of cereals, fruit, tea, toast, butter and Marmite. We'll also put on the Today programme, then switch to 6 Music or Nick Grimshaw.

We live in the farmhouse that's been in Dad's family for six generations. It's situated right in the middle of the festival site, which for the rest of the year is Dad's farm. He lives on a hill nearby, with his wife, Liz, and still keeps 500 friesian cows. This year he actually won Dairy Farmer of the Year, which is the ultimate dairy prize.

At about 8.30am, he'll come by to give the boys a ride around the site in his Land Rover. In the two months leading up to the festival, they've loved watching the crews arrive with their lorries and forklift trucks to assemble the stages and the eight-mile, 12ft-high perimeter fence. Dad will often drop them off at the nursery, too.

By 9am, Nick and I will head over to the new offices we've had built. They are right next to the house and filled with old festival posters and photos, including one of the Smiths, who were here in 1985, and one of Bob Dylan, who played here in 1998. We have a brilliant team who look after everything from contracts to tickets — and this year we sold 135,000.

For the last few years, Dad's handed over a lot of the running of the festival to me and Nick, whose background is in music, so he works on the line-ups. But Dad's influence is everywhere. He and my mum, Jean, put the first one on in 1970 and had people like Marc Bolan and David Bowie here in the first two years. So, as lucky as we are in getting bands like U2 and the Rolling Stones in recent years, they had something special from day one.

Festival-goers start arriving on Wednesday, but even now there can be last-minute logistical problems of one kind or another, so I'll often spend my day driving around the site, which covers Dad's 1,000-acre farm, plus 10 neighbouring farms. It accommodates not only 100-odd stage areas, but the campsites, car parks and loos — there's 5,000 of them, including the world's biggest installation of compost loos!

At lunchtime, we all head down to Goose Hall, the dining area run by team of local caterers for everyone working on the festival. They make up lots of lovely salads and things like fishcakes and jacket potatoes. It's a great chance to catch up with people who've worked with us for years; some have known me since I was a child.

I grew up in the house we're in now and went to Wells Cathedral school; it specialises in music and I played violin. I then studied education at Goldsmiths, and in my early twenties went to work for Greenpeace, then Oxfam. My time with them had a huge impact on me, which is why I'm so passionate about their links with the festival now. Sadly, Mum died of cancer when I was 19. I knew then that I'd want to come back and help Dad run the festival one day.

It never ceases to amaze me that so many great acts play here for a fee that is 10% of what other festivals pay. I also love the diversity it attracts. This year, we've got Kanye West headlining one night, and the Who the next. I'm also looking forward to seeing two amazing women: Patti Smith and Florence Welch.

Once the festival's over, the huge operation to clean up and dismantle everything begins. It takes all summer and ends with a party we put on in Pilton, our local village, to say thank you to everyone. By then, we'll have already begun signing up acts for the next festival, so the wonderful cycle begins again.

Nick or I will finish at 5pm to pick up the kids. We do share childcare with a local family, but the children will often be with Dad feeding his chickens. We've started growing our own vegetables, so I love going into the garden with them to pick things for dinner. They get their buckets and spades and are so excited.

Nick often cooks and the kids love his pasta; I love his miso broth with salmon and lamb curry. Once the kids are in bed, Nick and I still have so many things to do that it's impossible to switch off. There's such a buzz in the air right now that even getting to sleep is a challenge. But I don't mind. I love what I do and it's a privilege. I have the rest of the year to catch up on sleep.

Interview by Ria Higgins

The Glastonbury Festival is a landmark event in British cultural life. But in 2020 and 2021 it had to be cancelled because of the coronavirus pandemic. Emily Eavis and her father said they were "very confident we can deliver something really special for us all in 2022... let's look forward to better times ahead".

Tracey Emin

JUNE 8, 2008

The 44-year-old artist lives on her own with her cat, Docket, in east London. Now a Royal Academician, she has curated a room in this year's summer show at the Royal Academy of Arts, which opens tomorrow.

I wake up at about 6.30am, and the first thing I do is turn on the BBC World Service. Docket, who's my little soul mate, often sleeps with me. He's grey and white with pink paws and big yellow eyes, and with him at my heel I'll then head downstairs to make some tea. I live in an 18th-century weaver's house with five floors; my bedroom's at the top and my kitchen's at the bottom. Docket will open his little cupboard and nudge at his food, while I reach for my china teapot. Mum gave it to me. It's got a pink rose on it and has a matching cup and saucer and milk jug. I put it all on a wicker tray and head back upstairs to my satin sheets.

This, to me, is a perfect start to the day. On my own, catching up on my thoughts, my ideas – me time. If I don't have that, I end up in a bad mood. About 9am, I'll make some porridge and two slices of toast with strawberry jam, and then get ready. My bathroom and dressing room are on the floor below, and it's either a shirt and jeans or a shirt and skirt. If the outfit doesn't work, I go to pieces – it's potentially the first massive problem of the day. Jewellery is something I always wear – I have done since I was a kid. It's not a bling thing, it's tradition – I'm half Turkish Cypriot. This gold chain, for instance, was a present from my twin brother, Paul, and I keep my nan's wedding rings on it.

What then puts Tracey in a really good mood is if she can go for a swim. It stops me getting angry and I'd be the size of a f***ing house if I didn't. But what often happens is I'll be just about to go to the pool when I'll think: "Oh, f***ing hell, I've got a meeting in an hour, I won't make it." That sends me into a sulk. I'll then sit there procrastinating about why I end up doing things I don't want to do. At 10am I'll talk to Alex or Natasha, who both work for me and who

will no doubt remind me of other meetings I've forgotten and calls I need to make, which'll make me even moodier.

Lately I've been preoccupied with things like the retrospective I've got at the Scottish National Gallery in August, a catalogue, charity work and a room I've curated at this year's Royal Academy Summer Show, which includes one of my own paintings on loan from Elton and David's collection. So it's been endless phone calls and emails. And if I see my Polish housekeeper, Joanna, coming in the door at 12, I know I've f***ed up because it means half the day's gone and I haven't left yet. Then before I know it, it's lunchtime. Every Monday I make chicken soup from Sunday's roast; that usually does me for several days.

If I'm not rushing around like a lunatic, it's heaven. It means I can go to my studio. I've got two, both nearby: one I call my "dry" studio, where I create all my non-messy things like sewing and drawing, and the other where I do painting and sculpture. It's where I am at the moment, and the first thing I do when I arrive is turn off my mobile and take off my clothes – I'm more comfortable in my bra, shorts and an apron. Then, within these walls, I create this other world, Tracey's world. As it happens, I'm working on a series of self-portraits, and recently did this mad, gothic one of myself. In it, I'm half-naked, wearing a black baroque dress. I guess I've been thinking about the fact that I'm getting closer to 50 than 40, so I'm trying to make myself feel sexy.

In the lead-up to any show my art becomes all-consuming and exhausting. And yet, I need to do this. In fact, if I'm away from my work for any length of time, I start feeling unwell, frustrated, upset, angry. It's on the same level as a baby not getting its food. If art was taken away from me, my world would fall apart ... I'd fall apart. I'd lose my personality, my direction, my focus. If I hadn't managed to wangle a good art education, I don't know what I'd be doing.

In the evenings I might see a friend, and last week I had my mum staying. It was her 80th birthday and we went to see Pygmalion and had dinner at the Ivy. She still lives in Margate, where I grew up, while my dad, who's 87, lives in Cyprus. To be honest, I'm a very homely person. I like nothing better than going home in the evening, putting something in the oven and getting into my tartan pyjamas. And although I've got a lovely living room and what I call my Freud room, where I keep all my paraphernalia, I spend a lot of time in my bedroom. It runs the length of the loft and

has a leather sofa, bentwood rocking chairs, a 1920s Persian carpet and two old fireplaces I've turned into bookshelves.

I've lived alone for years now, and although I have a boyfriend – who's a photographer – he's up in Scotland. Most of the time I'm on my own. I guess the saddest thing for me at this point in my life is I've always wanted to be in love and have children at the same time, but it never happened. When I was 32, the idea of having a baby was a joke and I'd be the first to admit that at any time my selfish levels run high, a good 86 out of 100. Now it's not going to happen because I'm getting too old – it pisses me off. It's a hard one, something Tracey thinks about a lot these days.

But at the same time, I've worked incredibly hard at being a good Tracey, doing what's best for Tracey, and when I drift off to sleep, I know I'm one of the lucky ones. I do what I love and I get recognition for it. That still makes me think: "Wow!"

Interview by Ria Higgins

In 2011, Tracey Emin was appointed professor of drawing at the Royal Academy, one of the first female professors at the institution. She was diagnosed with aggressive bladder cancer in 2020 and underwent major surgery. After having her bladder and other organs removed, she told the BBC that her cancer had "gone".

Nigel Farage

FEBRUARY 14, 2016

The leader of Ukip on booze, bodyguards, cheesy pop and his silk pyjamas. Born in Kent, Nigel Farage, 51, went from Dulwich College to the City as a metal broker. In 1993 he co-founded Ukip [the United Kingdom Independence Party] and in 1999 he was elected an MEP for South East England. He lives in Bromley, southeast London, with his second wife, Kirsten, and their two daughters, Victoria, 15, and Isabelle, 10. He also has two sons from his first marriage.

" I'm out of bed by 5am and I'm first up. The day starts with tea. Loose tea. Proper stuff. Depending on what I drank the night before, I can be very thirsty and easily get through three pots. It's Radio 4 at that hour, but my favourite station is Absolute 80s. It's great to hear a song by, I dunno… Depeche Mode.

Kirsten works in my office, too, so it's difficult to avoid politics at the breakfast table. We actually met in Frankfurt when I was still a broker. She was a bilingual government bond broker and our companies worked together. She understands how much work impacts on our lives. We'll start talking about what needs doing around the house or how the girls are doing at school, but then we'll hear a news story on the radio and there's no escape.

There ought to be an exercise regime, but a treadmill seems so bleak. I do a few stretches, avoid biscuits and cakes, but like a cooked English breakfast. Yes, I'll have a fag, but I'm trying to cut back.

I shave every morning — wet and with real razor blades. Moisturiser is too modern, but I'll splash on a bit of aftershave to hide the smell of tobacco. My suits are a mix of Jermyn Street made-to-measure and off-the-peg. Call me old-fashioned, but if your job involves meeting people, you make an effort.

Security and my family's safety is a serious issue, so I tend to travel with bodyguards. There was an incident at home last year that made me realise some people are intent on violence. It's also

been an issue for my two daughters, but kids can be cruel to each other for all sorts of reasons. Even my aunt stopped using her surname because she's not sure how people will react. In a way, it makes me think Ukip must be succeeding.

At lunchtime, I like a pint with my sandwich — Adnams or Shepherd Neame. During the election last year, I went to a working men's club in Yorkshire one afternoon and it was great fun; a lot of mickey-taking, but a lot of kind words, too. We were actually only 300 yards from Ed Miliband's office and I asked them if he'd ever popped in to say hello. Not once!

People have some strange ideas about my background. Yes, it was semi-rural and we were fairly well-off, but my parents split up when I was a child; there were difficult times, too. [His father, Guy, was an alcoholic and walked out when Nigel was five.]

Divorce is never a "good thing", but like a lot of kids I just got on with life. I was rather reckless and noisy, but it had nothing to do with my dad; it was just who I was ... I wanted to make my mark. Getting [testicular] cancer when I was 21 only added to my ambition and drive. Nothing was going to stop me.

My MEP work in Brussels means that, as a husband and father, I'm not around as much as I'd like to be, but I always make sure all my kids are supported, encouraged ... have a go at painting, have a go at rugby. Yes, they ask about things that are written about me, but I never try to hide anything. They know politics is a rough game.

Believe it or not, I'm quite handy in the kitchen and I love cooking. Game or a bit of fish, especially something I've caught myself. I've got some skate wings in the freezer that I'm cooking later with black butter and capers. Evening TV is a luxury, but I'm watching the Channel 4 drama Deutschland 83. You're more likely to find me at a meeting. People always want to buy me a pint after, but I try to be in bed just after midnight.

Someone recently asked me if I wear silk pyjamas in bed. Perhaps a satin smoking jacket? It's a lovely image, but, er ... let's just leave it at that, shall we!

Interview by Danny Scott

On June 23, 2016, Britain voted to leave the European Union. Job done, Nigel Farage resigned the following month as leader of Ukip. He continued as an MEP until January 2020, when Britain finally left the EU. Now pursuing business interests, he has said he's retired from politics.

WORDS OF WISDOM	BEST ADVICE I WAS GIVEN	ADVICE I'D GIVE	WHAT I WISH I'D KNOWN
	Keep your nails short, polish your shoes, comb your hair and call everyone Sir or Madam until they tell you to stop being silly	Don't worry about what society says you should do. If you've got a passion, follow it!	Life doesn't always have to be lived in the fast lane

Mo Farah

SEPTEMBER 25, 2016

The four-time Olympic gold medallist, 33, talks about his four kids, his man cave and Arsenal. Born in Mogadishu, Somalia, Mo Farah spent his early life in neighbouring Djibouti. When he was eight, he came to join his father in Britain. He went to school in Isleworth, west London, where his PE teacher spotted his ability to run and encouraged him to take up athletics. He is only the second athlete in modern Olympic history successfully to defend the 5,000m and 10,000m titles. He lives with his wife and four children in Portland, Oregon.

I'm up between 7 and 8am, depending on what time my son, Hussein, wakes me. He's nearly one now, and I don't need an alarm — as soon as he cries, I'll lift him out of his cot, change his nappy and make his food. By then my wife, Tania, will have got the twins, Aisha and Amani, ready. They're four and Rihanna, our eldest, is 11, which is quite scary. For breakfast, I have two slices of toast with jam and some black coffee. After that, I'll drive to the track at Nike's headquarters in Beaverton and do a 10- to 12-mile run. It's just 15 minutes away, so I'm usually back home by midday.

For lunch, I might have a panini, a chicken salad or pasta. I tend to have a slightly bigger meal if I've trained really hard. Then, in the afternoon, if I want to relax on my own for a bit, I have a room I call my man cave, where I keep a pool table and my PlayStation.

When I'm not in full training, I get involved with the kids as much as possible, so, if I can, I'll pick the older ones up from school and take them to the park. Amani loves running. She'll say: "Daddy, I've got my running shoes, can I go for a run?" No one makes her; she does it because she enjoys it.

When I went to Rio, the family stayed at home and watched me on the TV. Apparently, Aisha was saying: "I saw Daddy on TV! Olympics, Daddy, Daddy!" Of course, Rihanna's the only one who can remember me winning a medal at the London Olympics. She'll say: "Where's my medal, can I have it?" But I want her to know what

it took to achieve it. I want her to think: "I must work hard. I need to overcome my obstacles." That's the vibe I want to give her.

I've been running for years now, so I'm no spring chicken any more. My body's getting tired, it takes me longer to recover, so I've got to be smart, train smart. I think I'll make it to Tokyo, but my aim is to take it one year at a time. Once I get next year's World Championships out of the way, I'll see if I can go. The passion's still there, but there will be a day when I wake up and think: "I can't do this any more, I'm not as hungry as I was, I don't enjoy it as much." That's the day I know I'll need to hang my spikes up.

When I retire, I'd like still to be involved in sport. I'd love to be able to help kids, whether it's with athletics or something else. I'm not the most academic person, but I'm good at being active.

One thing I really love is football and I have a good relationship with Arsenal. I started supporting them when I first came to Britain as a kid. I liked the way they played. They also had a lot of players from African backgrounds. One day, I'd love to be able to work for them, maybe as a fitness coach. I'm a big believer in what the body's capable of with proper training.

Before dinner, I like to go for an evening run. If I'm cooking, I love making spaghetti bolognese — I always add a pinch of sugar; not too sweet, but sweetish. I then let it stew for a good while. The meal reminds me of my university days, at St Mary's in Twickenham, where I did a lot of my early training. Back then, I never imagined my life would change so much. When I first came to Britain, I couldn't even speak English.

At night, I love reading to the kids — it's one of the reasons I've recently published a children's book. I love teaching them new things, educating them about life. They mean the world to me. I would do anything for them.

Interview by Shingi Mararike

In 2017, Mo Farah, the most successful Olympic runner Britain has ever had, announced he was retiring from track racing. He was knighted the same year. He later returned to track racing in the hope of going to the 2021 Tokyo Olympics, but failed to qualify.

WORDS OF WISDOM	BEST ADVICE I WAS GIVEN	ADVICE I'D GIVE	WHAT I WISH I'D KNOWN
	Be adaptable. If a place isn't what you expected it to be, deal with it	Work hard, no matter what you do	Nothing. Yeah, I've made mistakes, but everything happened for a reason

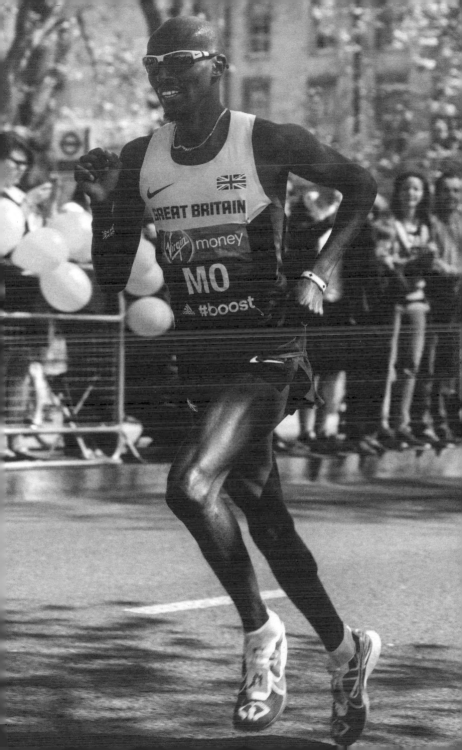

Ralph Fiennes

OCTOBER 14, 2018

The actor, director and producer on growing up poor, panic attacks and scaring kids as Voldemort in the Harry Potter films. Ralph Fiennes, 55, earned Oscar nominations for his roles in Schindler's List and The English Patient, and terrified children the world over as Lord Voldemort in the Harry Potter films. In 2011, he made his directorial debut with Coriolanus. He married the actress Alex Kingston in 1993. They divorced in 1997, after Fiennes started a relationship with the actress Francesca Annis, 18 years his senior. He lives alone in Bethnal Green, east London.

"I get up quite early, at about 6am I'll have a cup of tea, no milk, then on alternate days I work out with a man who beats me up in a heavy training session. Or I do yoga. If I don't start the day with exercise, I feel I'm in a bit of a knot.

I've lived in Bethnal Green since 2000, before it became so popular. My house was once artisan craftsmen's workshops, used by glaziers, carpenters and furniture restorers. It's a great space, but has no garden. I have an unrealised ambition of moving to the country and getting a dog.

I love breakfast and often have scrambled eggs. If I have to cycle to rehearsals, I'll eat something quicker. When I'm doing a play, I keep the text near me constantly. At the moment I have scripts of Antony and Cleopatra all around the house, by the loo, by the bed… You need to be as inside and close to the play as you can be.

I'm the oldest of six and grew up all over the place: West Cork, Dorset, Salisbury… We struggled financially and grew up with the refrain that we had a big overdraft. We had food, but it was often packets of soup and mashed potato. My father was a farmer who became a photographer. My mother was a writer. I think my love of the theatre comes from her and my approach to work from him. He loved using his hands and was very gifted at building shelves and things. He trained me in painting and decorating, how to replace a sash window and so on.

He was very masculine, though I felt only a positive sense of wanting to answer to the role model. I wasn't brought up to feel there is a definitive way of being a man. There are clichés of male tropes — competition, strength, vigour — that are always circling you. But received ideas of masculinity are now being challenged.

I acted in plays at school and felt at home with language, spoken in a dramatic context. I had a wave of confidence at art school and decided to pursue acting. There are famous roles in the so-called canon, but now I just hope to do something original. My father died in 2004, about 10 years after my mother. At some level, a lot of the work I do now is for them.

I tend to eat lunch out or at the National Theatre canteen. I avoid anything gloopy and tend to eat quite healthily. I am a worrier — I finish a project and never think it's quite right. I am prone to anxiety and have had panic attacks. I'm becoming less comfortable in social situations, parties especially.

I enjoyed playing Voldemort, although I wasn't familiar with the books before. The part became richer as the films reached their conclusion. Children would visit the set and look at me with deep uncertainty as they were being introduced.

I don't think it's easy to say whether one is happy. There are feelings of fulfilment, but the idea that there's a rainbow somewhere of blissful happiness is misleading.

When I'm doing a play, I'll force myself to eat something beforehand — I'm not that hungry because of the adrenaline and anticipation. At home, I love a drink — a martini or a glass of wine.

Am I in a relationship? Yes! With Antony and Cleopatra. It's a great play. And I have an intense love affair with the theatre.

Interview by Leaf Arbuthnot

Ralph Fiennes played the MI6 spy chief M in the James Bond movies Skyfall and Spectre. In 2021 he starred in The Dig, a film about the archaeologists who uncovered medieval treasures at Sutton Hoo in Suffolk in the 1930s.

WORDS OF WISDOM	BEST ADVICE I WAS GIVEN	ADVICE I'D GIVE	WHAT I WISH I'D KNOWN
	Learn to be open all the time to others' thoughts and ideas	From Hugh Cruttwell, then the principal of Rada: "Don't make it happen, let it happen"	That I would lose both my parents

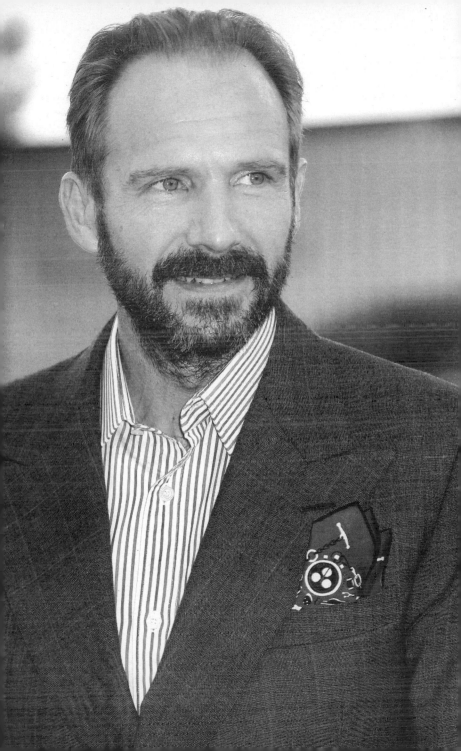

Floyde Forbes

MARCH 14, 2021

The owner of the Pelican Bar, Jamaica, on fish suppers, hurricanes and royal visitors. Floyde Forbes, 54, worked as a fisherman from the age of 13. Then in 2001, in his mid-thirties, he built the Pelican Bar, which became one of the world's most famous beach bars. Made from driftwood and palm fronds, the bar stands on stilts above the ocean off Jamaica's south coast and is accessible only by boat. Forbes, a father of seven, lives in Hill Top, St Elizabeth, with his wife and four youngest children.

 I wake at three o'clock in the morning. That was my regular time for going out to sea to fish for years and years, so the brain becomes accustomed to that hour. I get up, drink a bush tea like fever grass and do a brief meditation, take some deep breaths. That makes my day.

My wife and our four children wake up around 6.30am. My three grown-up ones work for me. At around 9.30am I eat a fried egg wrapped in bread, drive to the beach and carry my staff out to the bar in my boat. We bring out fish and rice and flour and beer and rum and charcoal, everything we need. There's no delivery service to stock Pelican Bar!

The idea to build it came to me in a dream. I didn't really mean it to be a bar, though. It started off as my personal little hangout spot. I rowed out here with the wood and I built it all by myself from scratch and lived out here, and all the people said I was a crazy man. But then a fisherman said, "Why don't you make it into a bar?" And that's how it worked out.

We had no refrigeration or power so I brought out a big chest freezer as a cooler. The bar began to get really busy. But in 2004 Hurricane Ivan destroyed everything. Not even a pole left, everything gone. I had no insurance. This time I had a lot of help to build it back, though. Everyone wanted it back and it was rebuilt in two months.

One day the coastguard came and started to tell me that I breached a lot of their laws. There was no toilet, you see, so it was illegal. Then the health department came and all at once I had more

than 20 authorities asking questions. So I went to the parish court. People started saying how all the tourists who come all this way for it bring money into the community. When the authorities heard, they said I could keep operating. I haven't heard from them in seven years.

A few visitors do complain that the decks aren't very level. I just tell them, yes, it's a bit rough, but with a great heart they can find it smooth. No one's going to say they don't have a very good heart, so that's what I always say. And we have power, now. When Red Stripe heard about the bar it organised solar panels and lights and fridges, so I could sell more beer and stay open later. We've even built a little toilet.

We are open 365 days a year. People come from all over the world. Lots of celebrities. Prince Andrew came, and two years later he sent the Duchess of York and their daughters. They brought no security, they just came out on a boat like everyone else. I liked them a lot.

We were always busy, we'd serve 70 or 80 meals of fish and rice and peas every day, well until Covid. Last March we had to shut and there were no tourists all year.

It brings joy and togetherness within me to see people start to turn up again instead of being locked away. Sunset is the busiest time. Then I eat a bit of fish, close up and go back to shore. I don't lock up, there's no door. Pelican Bar is the breadbasket for this community so people don't harass it. Everyone tries to protect it.

When I get home my two-year-old runs at me. I always have to give him fun, to watch his little cartoons. By eight or nine I start to get some good sleep.

Pelican Bar's been called the coolest bar in the world, but myself I've never been to foreign [lands]. All the world came to me here. I don't think I ever want to leave Jamaica to see anywhere else. Right here I'm satisfied.

Interview by Decca Aitkenhead

The Pelican Bar gets a rating of 4.5 out of 5 on Tripadvisor.

WORDS OF WISDOM	BEST ADVICE I WAS GIVEN	ADVICE I'D GIVE	WHAT I WISH I'D KNOWN
	Always keep and stay healthy	Stay at peace within your heart	That Pelican Bar would get so popular and famous. That would have been nice to know

Dawn French

OCTOBER 18, 2020

The actress and writer on trashy TV, adoption and Jennifer Saunders. Dawn French, 63, was born in Holyhead, Wales, and raised in the West Country. She studied acting at London's Central School of Speech and Drama, where she met Jennifer Saunders. They formed the comedy duo French and Saunders, and their BBC sketch show ran for 20 years. French has an adopted daughter, Billie, 29, with her first husband, the comedian and actor Lenny Henry, and lives in Cornwall with her second husband, Mark Bignell, a charity executive, their dog, Goodie, and cat, Mouser.

I wake up at 6.30am. The husband and I have breakfast together, then I walk the dog down on the beach. I live in a very lovely big house by the sea, but I'm definitely no lady of the manor. I'm a bit of a hermit, so this has been a wonderful place to spend lockdown. I am happiest in my home, with my animals and family.

After the dog walk I'll sit down with a big cup of coffee and crack on with writing. My latest book is probably my most personal. It's very centred on motherhood and belonging. I adopted a kid and I am interested in everything to do with who we belong to. Is it your blood? Is it who raised you? When you adopt you think about motherhood more. My daughter and stepdaughter were living with us during the first few months of lockdown. To have all of us sharing the cooking, the laughs and the telly was unusual and brilliant.

In the middle of the day I will begin snacking. It starts small and healthy with corn cakes. But then I'll slather it with butter, then add peanut butter, then maybe just a big dollop of lard, why not? I'll take a break and watch my guilty pleasure, which is clips of the *Real Housewives* shows on YouTube. I can't watch a whole episode, but I love the fighting.

There was a horrible day at the beginning of lockdown where about 18 months of my work plans just disappeared. Only one project happened and it was a surreal experience during Covid. For

the four weeks I filmed, I only ever saw the crew from the eyes upwards. When I saw my make-up artist's mouth for the first time, it felt like he had taken his trousers down.

So many people who work in the theatre have been left at the bottom of the pile. Theatre is such a part of our cultural landscape, and I really resent people thinking it's this frothy, luvvie industry. It's bigger than fishing and football!

For Jennifer and me, it was a sort of happy accident. I wasn't trying to become a game-changer for female comics, I was just enjoying myself. But what I am delighted about is I can't even name every young female comedian out there right now, because there are so many. When we were on the BBC we were the female quota: "Oh, we've got enough women now, we've got those two."

As soon as Jennifer and I were able to meet up after lockdown, we did. We started working together recording a little thing called *French & Saunders Titting About*. And that's exactly what we do. In order to hug her, I did fashion myself a coat, which I wear backwards with the hood up.

I never felt a pressure after we stopped doing the sketch show, or *The Vicar of Dibley*, to match that success. I like having a go at different things. The desire to keep doing different things is what allows us to make mistakes, it's part of your learning. Sadly, I think we live in a time where mistakes are not forgiven. Everything is the culture of perfection; from body shapes on social media to what's happening with the arts. I will be really sad if the future of comedy is "safe". That's not the comedy we love. It should be a bit naughty, a bit mischievous.

I will normally eat dinner with my husband and be in bed by 10pm. He stays up later as he's a night owl, which is a point of contention. But what's truly unbelievable to me is that my dear boyfriend Idris Elba has not come to visit me in Cornwall. He still hasn't. It is terribly, terribly rude.

Interview by Marie-Claire Chappet

According to reports in May 2021, Dawn French was selling her big house by the sea in Fowey, Cornwall, to move somewhere quieter because she felt the pretty Cornish town had become too "cool and trendy".

WORDS OF WISDOM	BEST ADVICE I WAS GIVEN	ADVICE I'D GIVE	WHAT I WISH I'D KNOWN
	It was what my mum told me, "The only way out is through"	Every day is a clean slate. Whatever happened yesterday, you can get past it	Large bosoms are a playground, rather than just a preventative for fast running

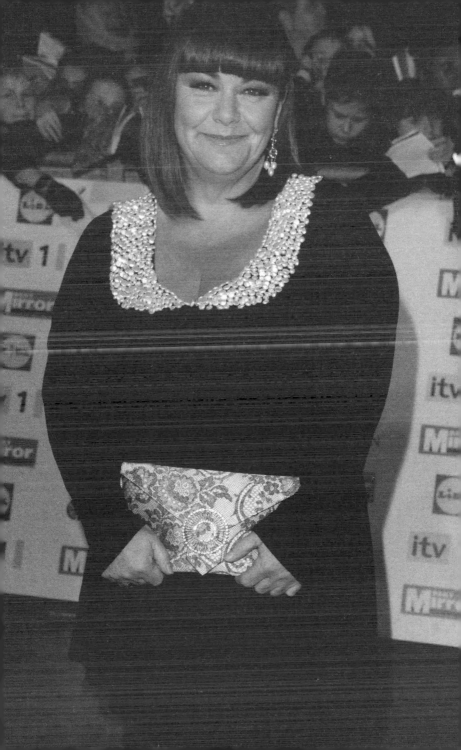

Colonel Gadaffi

FEBRUARY 10, 1985

Colonel Muammar Gadaffi, 43, helped overthrow the regime of King Idris in 1969 and is now Libya's 'Leader of the Revolution'. He lives in Tripoli with his wife, Saffia, and their seven children.

" The world is divided into those who understand me and those who are ignorant of my true personality. Few know what Islam means to me and that the first thing I do when I wake is to wash and prepare myself for my prayers.

Each day I consider that I have been dead, that I have just awakened and am about to start a new life. And the first thing I start with is my prayers. I have to pray and thank God for the day that is beginning. I live from day to day, so I also ask for forgiveness for any transgressions that I have committed. Sometimes I pray alone. At other times my wife, Saffia, and some of the children join me. But I have a young family so it depends on what is happening.

I have a very small breakfast, a piece of bread and a glass of camel's milk. That's a habit from my childhood in the desert. My Bedouin background is very important and has greatly influenced me throughout my life. My family was very poor. My father was a shepherd and my parents were illiterate. We lived in a tent, like many Bedouin. Desert life was difficult and we lived off the land as best we could. Bedouin life made me discover the value of natural laws and relationships. The desert teaches you to rely on yourself and it teaches you the importance of helping one another. The values I learnt there have remained with me all my life.

Now, even as Leader of the Revolution, I lead a simple life. My house, in the middle of the Bab al Azziza barracks in Tripoli, is

identical to any other officer's house in the compound. I still find it a bit artificial, that's why I had a tent put up near the house, and the family often gather there and often I meet visitors there. But I see to it that the children have as simple and normal a life as possible. They go to an ordinary state school in Tripoli. I have seven children – six boys and a girl.

When I was a child, near Sirte, I had to walk 20 kilometres to the nearest school. And as my parents were too poor to pay for lodgings, I had to sleep in the mosque and walk home at the weekend to see them. Thirty years ago there were no schools or hospitals for poor Libyans. Today, every Libyan has the right to free schooling, medical aid and a house. My mother used to grumble at me because after the Revolution I refused to let them move out of their tent and into a house till every Libyan had a home.

I don't have a specific daily schedule as I am no longer the president, but just the Leader of the Revolution. No two days are the same. Sometimes I go and open a new factory or another agricultural project in the desert. A few weeks ago I opened the "Great Man-Made River Project" in Sarir. This has tapped huge lakes of water under the Sahara and we'll pump it to the coast. Of course it's expensive, but then we have been blessed with great reserves of oil.

We have no real debts, no strikes. On the contrary, we employ foreign workers. Do you know that we have more than 4,000 British nationals working very happily here? We also have Moroccans, Chadiens and nearly 20,000 Italians, many of whom work on our building sites, and even Americans.

Lunch is a simple affair: Libyan soup, which is very nutritious as it has meat, tomatoes, spices and wheat in it. Then we have some lamb, made in a stew, with tomatoes and potatoes, or more often just roasted, as we used to do in the desert. Then some fruit – we have planted millions of fruit trees in Libya, apples, oranges, pears and in the season we have water melon – and, of course, dates from the oasis. Then we have our famous sweet Libyan tea, which I take wherever I am.

The afternoon varies. There are people to see. I'm still a colonel in the Libyan army, so there are military things to attend to. I feel that we should have enough arms for all the population, so that if we are attacked everyone will fight. That includes women.

I persuaded them to start a Military Academy for Women where our girls are trained to be soldiers. I feel very strongly that women are not being respected in the Arab world. What is happening now outside Libya is not in accordance with the true

constitution of an Islamic society. Islam means freedom, equality and a humane society. Some Arab women in some places are being enslaved. I want to liberate all women from the Atlantic Ocean to the Arabian Gulf.

In summer it is very hot in the desert, so I try and rest for a while in the afternoon. If I am home when the children get back from school I play with them – football or whatever. It is very relaxing and I forget my problems when I am with them. Sometimes I go shooting in the desert with them. The two elder boys have become good shots now.

I don't force my children to do anything. But I do try and put it into their little minds that they should serve people: become doctors and go into the jungles and backward parts of Africa and give their services free; help vaccinate small children and look after the sick. In fact, my eldest boy is going to become a doctor. But when the others hear of America threatening the Gulf of Sirte they say they want to become pilots and shoot the American Sixth Fleet.

In the evening I try to meet the family in the tent. We are just like any other family; we talk, play with children, and sometimes I read. Other times visitors come and we talk late into the night. It might be, like the other day, the Moroccan Ambassador, or foreigners who are struggling for their freedom. You know the Koran says it is the duty of Muslims to help those who are fighting for their freedom, so I listen and help when I can. I want there to be peace and for the people to end up as the winners. I want to change the world.

Interview by Vanya Kewley

Muammar Gadaffi ruled Libya from 1969 to 2011, during which he was viewed by many in the West as a dictator and backer of terrorism. When Libya descended into civil war amid the "Arab Spring" of 2011, he was captured, humiliated and killed by rebels after being found hiding inside a large drainage pipe.

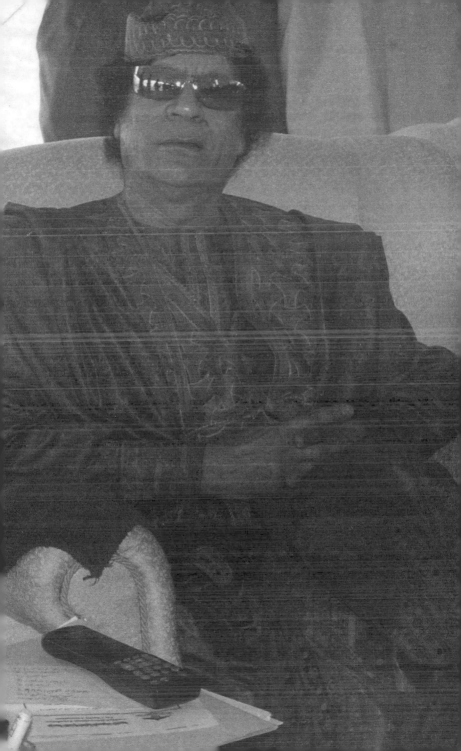

Kristalina Georgieva

JUNE 16, 2019

The chief executive of the World Bank on battle cries in the shower, sexism and her rocking commute. Kristalina Georgieva, 65, was born in Bulgaria, and her first job was selling food at a market. After getting a PhD in economics, she started at the World Bank in 1993. She served on the European Commission for six years from 2010, during which she was appointed vice-president. She rejoined the World Bank in 2017. Her husband, an engineer, and their daughter live in Bulgaria, while she is based in Washington.

"I get up at 6am, which is earlier than I would like. I have a big cup of strong coffee, go through the day's schedule on my phone and clean up important emails. For breakfast I have yoghurt or a boiled egg.

My best ideas come under the shower. When I sing it means there is a day of important decisions to be made or battles to be fought. It helps me tune in.

I am environmentally cautious and do everything I can to shrink my carbon footprint. I leave home in my electric car between 7 and 8am. If there is some serious action waiting for me, I play Queen's We Will Rock You. When I get to the office I'm ready for a good day.

I grew up in Bulgaria when there was a shortage of everything. I remember getting up at 4am to queue for milk. When the Iron Curtain fell in 1991, there was this incredible opportunity to see the world and be a part of it.

I was vice-president of the European Commission during the Brexit referendum. When I got the result, I thought, right, this

is what the British people have decided. I think the UK brought pragmatism and efficiency to the EU — something that will be sorely missed.

In the history of the EU, I am the only person who got a budget negotiated one week before the deadline. A negotiator needs to speak simply and clearly, so people can answer the critical question: what is in it for me? Have the UK and the EU done this? We need to see how it evolves.

The first thing I do when I get to work is measure the smile-o-meter. If people are not smiling it means there is tension somewhere. Recently we lost a staff member on the Ethiopian Airlines crash — Max, a climate activist. He was such a positive spirit. The beautiful thing about the World Bank is that it attracts people like him.

One of our jobs is to mobilise finances in emergencies and co-ordinate aid. I dare say I have the best job on the planet because we bring resources and solutions, especially to those who are the least privileged and in dire need.

My days are thinly sliced, like salami! I work in 20- or 30-minute intervals. In a normal day I'll have 18 meetings. My huge anxiety is how we will cope with climate change. I have seen droughts, floods and hurricanes and I worry we are not moving fast enough.

I have always worked way harder than my male colleagues to be taken as an equal. I have been in situations where male ministers have assumed I was the interpreter. Now I have one of the men in the team walk in front to introduce me, so there is no confusion.

When I travel around the world I make sure to swing by and see my husband, grown-up daughter and granddaughter in Bulgaria for the weekend. I go back every six weeks. When my husband is in Washington, I go home from work a bit earlier so he gets an extra dose. My one regret in life is the time I have not spent with family.

Normally I leave work between 7 and 8pm. In the evening I like chatting with friends over dinner, loosening up. When I have time to cook, my preferred meal is a big salad. I invented a recipe that we call "the good wife": curried veggies and chicken on top of home-cooked fries.

I hop between light and serious TV — news and The Big Bang Theory. Before bed I read books about people who have changed the world. I close my eyes and I go to sleep. No time to waste.

Interview by Megan Agnew

Kristalina Georgieva moved from the World Bank in October 2019 and became managing director of the International Monetary Fund, which fosters economic cooperation and stability among 190 countries.

WORDS OF WISDOM	BEST ADVICE I WAS GIVEN	ADVICE I'D GIVE	WHAT I WISH I'D KNOWN
	Keep your good memories, get rid of the bad	Dare to step up and believe in yourself. If you don't believe in yourself, why should anyone else?	How hard I have to work as a woman to equal men

Ricky Gervais

NOVEMBER 11, 2010

The co-creator of The Office, on swapping jumbo sausages for seared swordfish, and turning chats with his mates into comedy gold.

My alarm wakes me up at 9.30am. I'll put on my slippers and T-shirt, have a wee and get a coffee with skimmed milk. I'll check my emails – usually about 20 that have come in overnight from America – then have porridge. Porridge is a revelation: I microwave it with skimmed milk, sometimes with a bit of bran. It's wholesome, comforting and means I'm not hungry till lunchtime. While I eat that, my first call of the day will be to Karl [Pilkington] and I'll just go: "What's going on, mate?" He's always got something to moan about: it could be the bank, a workman, anything. Something will be ruining Karl's day and I can't wait to hear about it.

Around 11am I'll go to my office, a few minutes' walk away in Hampstead. Steve [Merchant] arrives soon after and we'll chat. It's just conversation, but we'll make each other laugh and there's always something that comes out of it. When we first started, if we were together six hours a day, for 5½ of those we'd be talking about mates at school, our favourite films or what we hated about TV. Steve can finish my sentences now.

Part of the morning will be taken up by admin. Steve and I run the estate of The Office. With all the remakes – America, Israel, France, Chile, Canada – it's never been busier. We own the format 100%, so everything has to come through us. It kills me sometimes but Steve and I wanted final edit, wanted to do everything ourselves, and we've stuck with that.

Sometimes we think we'll relinquish it, but in the end we can't.

Lunch is 12.55pm. Eating with Steve has got better. Jamie Oliver would be campaigning against the things I used to eat. I had a very childish palate, only went for flavour. I didn't eat vegetables, because they were boring. I didn't drink water, because it was boring.

It annoyed Steve. When we were making The Office we'd eat in the BBC canteen and he'd beg me to not have more than one jumbo sausage because I'd fall asleep in the afternoon. He said he felt less like my writing partner and more like my carer. Now we'll get a sandwich or big salad, or we'll go to a nice restaurant and have a plate of pasta or fish and chips.

The worst thing to be in my family was boring. It was the worst crime. Mum was funny, in an Alan Bennett way, and Dad was the underdog, but sarcastic, laughing in the face of adversity. I had two older brothers and one older sister – I was the youngest by 11 years. My next brother, Bob, was always funny – the really cool, blue-collar kid you wanted to be like, always saying the things everyone was too scared to say and getting away with it. That must have influenced me, because ever since I've tried to see how far I can go while letting people know it's from a good place, that it's all about empathy and warmth.

After lunch we'll come back and try to work on a scenario for a new BBC comedy for next year, Life's Too Short. We'll ad-lib a bit and then work it out, put it into a Dictaphone and that's it – two minutes' screen time in the bank. I'll leave the office at 3.50pm. I'll do another half-hour of emails at home, then try to work out for an hour. I might run on the heath, or we've got a gym at home with a spa, free weights, punchbags. It's like Batman's cave down there and I love it. I use it every day and I'm so f***ing privileged it would be a sin not to.

After that I'll have a bath and soak the old muscles. Then I'll be in my pyjamas, open a bottle of wine and Jane, my girlfriend, will be cooking. She'd have fish every day if she could, so she'll often have a lovely seared, nearly raw tuna steak and she'll burn a swordfish for me with a bit of asparagus. There's a couple of things I won't eat on moral grounds, like veal and foie gras. The rest is squeamishness: red meat gives me the creeps in case I see a bit of blood or vein. Nowadays I actually enjoy the wonders of caramelised parsnips and turnips and carrots. Amazing.

After dinner we'll watch some crap telly. Our cat, Ollie – half-siamese, half-burmese – will sit on Jane's lap then come over to me for a fight or to be brushed. Karl hates her: he says she thinks she's "it". He and his girlfriend, Suzanne, often come round. I don't really socialise with Steve. When we met he was about 13 years younger than me. Just as he was discovering he loved hip-hop I was discovering I had a favourite armchair.

I'm not someone who stays up for the sake of it. I consider myself a working person, so I'll go up around half-11 or midnight. The last thing I do before I go to bed is thank God for making me an atheist. He really does move in mysterious ways.

Interview by Anmar Frangoul

After The Office, Ricky Gervais went on to create the comedy series Extras and After Life, and appear in Hollywood films. He has presented the Golden Globes award ceremony five times, and describes himself on Twitter as a "godless ape".

Anne Glenconner

NOVEMBER 22, 2020

The former royal confidante on Princess Margaret and late-life happiness. Lady Anne Glenconner, 88, grew up on the family estate, Holkham Hall in Norfolk. She was a maid of honour at the coronation of Elizabeth II in 1953 and lady-in-waiting to Princess Margaret for nearly 30 years. In 1956 she married Colin Tennant, later the 3rd Baron Glenconner, who turned the Caribbean island of Mustique into a private playground for the rich and famous. They had five children. She lives alone in Norfolk near her twin daughters, Amy and May.

" Breakfast was always brought to me when I was a girl. These days I prepare a tray with tea and toast, then have a lovely time sitting in bed, eating my breakfast and phoning friends, some of whom are quite old, like me.

By about 9.30am I'm showered and downstairs being an agony aunt. I get letters from women all over the world who have violent husbands or who have lost children or been abused, as I was.

I did put up with rather a lot; Colin had a terrible temper. After one of his outbursts when I was expecting [their first son] Charlie, I went home to my mother and she said: "You married him. Go back."

I lived with Colin's tantrums for nearly 55 years [until his death in 2010]. We didn't see much of the children; like everyone else we knew we were away a lot and we left them with nannies. One of my nicest memories was of living with Princess Margaret in Kensington Palace for a year after Colin sold our London home. She was having a difficult time with Tony [Lord Snowdon] and she said: "Anne, it's so much easier without these difficult husbands."

I do a quick shop in the village — Cromer crabs and lobster, local vegetables. I was out for lunch three or four times a week [before lockdown], or friends came to me. The great benefit of not having staff is that I don't have to look after them. I eat what I like when I like and I answer to no one. I feel hugely free. Never been so happy, actually.

I don't worry much about Covid. As a child I lived with the fear of polio, and then there was Aids, which was even more terrifying. I had three children who were dying at one point. Two did — Henry first [from Aids] and then my sweet Charlie, having finally given up heroin. I thought there couldn't be anything worse than burying a son, until I was in the churchyard again burying another. Christopher survived [a brain injury while on a gap year in 1987] after five months in a coma. His old nanny and I nursed him: 15 minutes of sensory stimulation every hour, 24 hours a day. I don't know how we did it, but I feel blessed to have him.

After lunch I do 20 minutes, feet up, with the papers, then I birdwatch on the marsh or drive to the beach for a walk. The Queen and Princess Margaret loved it there, we'd build sandcastles all day with our nannies. My father built the Queen her own beach hut.

I always called Princess Margaret "Ma'am" — one never forgot the relationship, but she loved mucking in when she stayed at my house. I think of us side by side on our gardening mats, Marigold gloves on, weeding. We just had a lovely time. And she was so full of good advice. She was one of the few people who wasn't afraid of Aids. She visited Henry and brought her children to stay.

I eat a bit of scrambled egg and smoked salmon, then sink down in front of the television. I'm in bed by about half past ten, but I don't turn the light off until about 1am. Then I sleep soundly.

Before lockdown my life had become extraordinarily exciting. I had Helena Bonham Carter to tea [in preparation for her role as Princess Margaret in *The Crown*]. I did a series of *An Evening with Lady Glenconner* talks in proper theatres and was going to tour Scotland. It's funny, isn't it? I had to wait until I was 88 to suddenly have this amazing life.

Interview by Caroline Scott

Lady Anne Glenconner began writing late in life. Her 2019 memoir, Lady In Waiting: My Extraordinary Life in the Shadow of the Crown, proved an unexpected hit. One reviewer described it as "an unwitting examination of English repression: both of how it gets you through and of how it can slay you".

WORDS OF WISDOM	BEST ADVICE I WAS GIVEN	ADVICE I'D GIVE	WHAT I WISH I'D KNOWN
	My mother said, "Never complain, because life isn't fair"	You've only got one life, try to make the very best of it	That at a certain age in life you get a spare tyre around your middle that is impossible to shift!

Antony Gormley

JULY 16, 1995

Antony Gormley, 44, a sculptor who works with casts of his own body, won the 1994 Turner Prize. His sculptures include Bed, a life-size bed made of slices of bread, and Field, containing 40,000 small clay figures. His studio is in southeast London and he lives in north-west London with his wife, the painter Vicken Parsons, and their children: Ivo, 13, Guy, 10, Paloma, 8.

> I'm a reluctant riser but I like the moments between the alarm clock going at 7am and getting up, when you lie and think about what you're going to do that day. Usually Paloma comes into our bed for a cuddle, then she dresses by the fake gas-coal fire while Vicken or I wake up the boys.

When we married I said I'd do 50% with the children, but it hasn't quite worked out like that: Vicken does about 99.9% of the domestic stuff. Day to day I'm not a very diligent dad – my thoughts tend to be wrapped up in work. The children are my best critics: Guy strode into the studio just after I'd finished my first large body case, which was 22ft high. I imagined he'd be quite awed, but he looked up and said: "The head's too big, Daddy," and he was right. Now I'm working on a project for Gateshead, a 65ft-high angel with a 169ft wingspan, made of steel. Galleries are wonderful places but clinical, and I've always wanted to make work which is plugged into actual situations. What was important about winning the Turner wasn't the money but the recognition that I wasn't lost in a wilderness. Unlike the performing arts, sculpture is like sending out messages in a bottle. You never know if someone finds the bottle, if they're touched or moved.

Vicken comes to the studio once or twice a week, when I'm doing the body-casting. The body moulds are still the basis of my work. I give everyone hell because I work from the assumption that everything is going to be very difficult. Vicken lightens everyone up and relieves the tension.

My own body is the material, the tool and the subject. I could be standing, lying or sitting. Having decided what position I'm going to be in, I take off my clothes and wrap myself in clingfilm. Then Vicken mixes superfine casting plaster in an enamel bowl and dips pre-cut pieces of scrim, an open-weave cloth, in it. It's a race against time to press them on me before the plaster sets, which it does in five or 10 minutes. The whole process takes an hour, then I'm cut out.

Giving up one's freedom of movement and voluntarily going into a place of darkness replicates the meditative situation: you're trying to integrate the mind and the body, the conscious and the unconscious. You could easily suffocate, so it would be very difficult for me to work with anyone but Vicken. When she digs her saw into me, I shout like hell. But mostly it's pretty bloodless.

At home we don't eat red meat but we have lots of vegetables – ratatouille, or Chinese and Japanese food. Later I might watch an old film on television. Vicken may flake out at about 10.30pm, but I probably won't go to bed until midnight. I keep a sketchpad by my bed and I try to keep a dream diary – my dreams are so exciting and spectacular.

Interview by Ann McFerran

Sir Antony Gormley's Angel of the North attracted criticism on its unveiling in Gateshead in 1998, but became a much-loved landmark. It has been described by the local council as "one of the most recognisable pieces of public art ever produced".

Dave Grohl

AUGUST 20, 2017

The Foo Fighters frontman on male bonding, meeting heroes and mastering the barbecue. Dave Grohl, 48, grew up in Virginia and moved to Seattle in 1990 to play drums in the rock band Nirvana. After the suicide of the singer Kurt Cobain in 1994, Grohl formed his own band, Foo Fighters, switching to guitar and vocals. They have released eight studio albums and won 11 Grammys. He lives in Los Angeles with his wife, Jordyn, 41, and three daughters, Violet, 11, Harper, 8, and Ophelia, 3.

I don't use an alarm clock; my body wakes me up at 5am every day, no matter what time I went to sleep. My closet has got 30 pairs of jeans, 30 flannel shirts and a bunch of stuff I never wear. I dress like a lumberjack, go downstairs, make coffee, check emails and wait for the stampede.

Our eldest daughters, Violet and Harper, turn on the TV or do the homework they didn't finish the night before while I make breakfast — bacon and eggs or buttermilk biscuits and smoothies — and my wife packs lunch. Once they're dressed, I take the girls to the bus stop. The important thing is to get them out the door with a smile and singing songs, from Prince to the SpongeBob record, which Harper still loves.

After the bus leaves I head back to hang out with Ophelia. You know, I'm still changing diapers at 48 years old. One kid wants her nose pierced, one is in diapers. It's all over the place. I can't imagine the teen years…

My office is upstairs. It's a makeshift studio and somewhere to hide. Before we start making a record, I'll record by myself. But on a working day, I'll head down to the studio in Hollywood at 10am. There may be one or two Foos, so we'll have coffee and a couple of smokes. The reason we've been a band so long is we enjoy each other's company. There's not a lot of brooding and torture going on. My favourite way to warm up for a gig is to have a whisky and walk onstage with tears rolling down my face from laughing so hard with the guys. It's the best.

I did a lot of cooking while we were making the new record. I specialise in slow-cook barbecue. My day was spent checking the temperature of the beef brisket, then running in and doing a vocal or a guitar track, checking the temperature again, getting the cornbread ready and making sauce. There's something to be said for recording studios that smell like your mother's Sunday roast — it puts everyone at ease.

In this job, I've been lucky to meet some of my heroes, such as Paul McCartney, who is now a friend. It's great when he comes over. The kids get that he's a Beatle, but not really. So their interaction is beautiful because they're not trying to act cool. There have been a few seminal gigs over the years. Glastonbury this year was up there. Another was when Nirvana made the Rock & Roll Hall of Fame in 2014. I got together with my old bandmates, Krist [Novoselic] and Pat [Smear, now with Foo Fighters], and guests including Joan Jett and Lorde, and we played those songs again — it sounded just like it did, but of course with one thing missing. We hadn't played a Nirvana set since Kurt died. Could we do that again? I don't know.

If I'm not recording, I'll pick Violet and Harper up from school at 3pm, take them horse riding and make dinner. I read Ophelia stories before bed. Then I talk with the older kids. We talk so long I forget they're meant to be sleeping.

Around 9.15pm, my wife and I might have a glass of wine. I love wine. I have a nice collection. But I know myself and once I open a bottle, it's going down the hatch. So I prefer to go to bed without a drink. Twenty years ago, we'd go on the road for three months and come home for three days. Now everyone has families we only stay on the road for a few weeks. Plus, we're getting old! Touring hurts a little more. So do the hangovers. That's why I mostly drink at work. Not a lot of people can say that.

Interview by Matt Munday

Dave Grohl has released 10 studio albums with the Foo Fighters, the latest being Medicine at Midnight. Among various film and television roles, he has appeared as himself in The West Wing, the Muppets and Sesame Street.

WORDS OF WISDOM	BEST ADVICE I WAS GIVEN	ADVICE I'D GIVE	WHAT I WISH I'D KNOWN
	If you want your guests to think your cooking is delicious, starve them for hours first	Don't waste a big moment on fear. Enjoy it, because it's never going to happen again	That LA traffic would be so unpredictable – it has made me late so many times. Nobody here works regular hours, because nobody has a real job

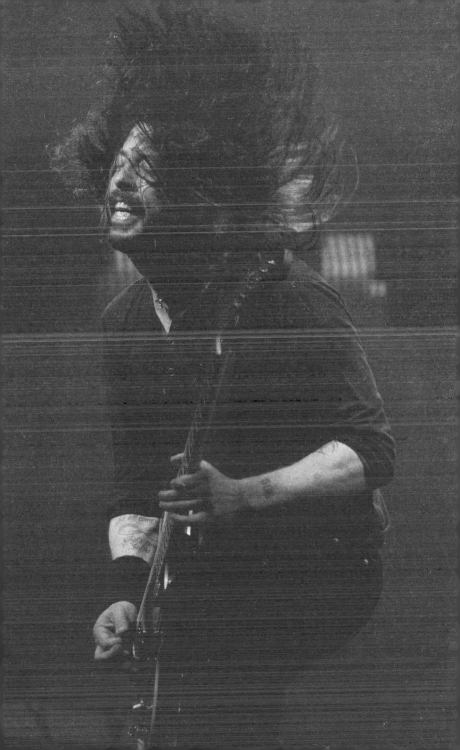

Bear Grylls

NOVEMBER 20, 2016

The TV adventurer on buying an island, fear of fame and why his wife elbows him at night. Raised on the Isle of Wight, Bear Grylls, 42, has hosted more extreme-adventure TV shows on more networks than anyone else in the world. He is a former SAS soldier and the youngest chief scout in history. He lives on St Tudwal's, his island off north Wales, and a houseboat on the Thames, with his wife, Shara, and their three sons: Huckleberry, 7, Marmaduke, 10, and Jesse, 13.

66 I'm up at 7am, and it sounds silly, but then, wherever I am in the world, I kneel by my bed and pray. There's a humility about it. It also makes me calm. I say sorry for things I've done, pray for my family and our safety and the day ahead.

My wife, Shara, and I have three young boys now, and the eldest two are at boarding school; the youngest is at day school. I always start the morning by making a monster smoothie with broccoli, goji berries, cucumbers and a huge bit of ginger so nobody else can drink it. I then do a workout that involves a pull-up bar and a kettlebell, and I am happy to say I'm fitter now than I was at 25 when I left the army.

As much as we can, we live on St Tudwal's — the island is 650ft wide, 2,000ft long and three miles from the nearest village on the Welsh mainland. Shara and I bought it when we got married in 2000. It came with a lighthouse and a cottage that sits on top of a hill. We also bought an old Dutch barge on the Thames. The total cost of both was less than the one-bedroom flat we'd been looking at in London. For the first three years we lived on the barge while we did the island up. I also bought a black cab.

The island was cheap partly due to its short lease, but a year later the law on leaseholds changed and we were able to buy both the freehold of the whole island and the cottage for £10,000 — the lighthouse is still active, but operates separately. On the island, we've got a fast Rib [rigid inflatable boat] that whizzes us back and forth to the mainland. If the sea is calm, it takes 10 minutes — half an hour if

it's rough. It's also got wheels, so at the press of a button it turns into a vehicle we can drive. We've also got a quad bike and a trailer.

Living on an island can be hard work … hauling boats up and down, getting endless supplies in and stuff for the house. There's also no mains electricity or running water in the cottage, but we have wind and solar power and collect rainwater off the roof.

The kids know that when they are at school, Papa is at work, and right now I have 30 to 40 projects on the go. One of them is a ninja-warrior-style indoor-assault programme, which I'm launching this month.

Of course, what I get to do can make me feel like I've got the best job, but I struggle with it, too … I'm not a natural performer. I've done a lot of TV work over the years, but it's not something I actually wanted. I have a discomfort with cameras and being looked at. It's why I film with no second takes. Maybe it's that raw energy that makes the shows come alive.

To be honest, I'm much better up a mountain or in the jungle than at a cocktail party — there's a calmness to the world up there. I also think the danger of wealth and fame is you develop a false self-importance, and the truth is, the real heroes in life are the unsung people. I see it with scout volunteers, people quietly, humbly giving up their time.

When the kids are home for holidays, we love spending time on the island. One of my favourite things to do is take the boat out at dusk during the summer and go to this little cafe on the mainland, tuck ourselves away and have pizza, fruit crumble and rosé wine.

In the evening, I will often read to our youngest, Huckleberry. If I go to bed early and Shara's still up, I'll always put the toothpaste on her toothbrush — it's a little symbol of connection for us.

I also say the same thing to Shara every night: "Goodnight. Sleep well. May God bless you. I love you. You are the best." Kiss. If I don't say it, there's an elbow.

Interview by Anna Gizowska

Bear Grylls continues to produce TV shows, including for Netflix and Amazon. He has been the UK's chief scout since 2009. In 2019 he received an OBE for services to young people, the media and charity.

WORDS OF WISDOM	BEST ADVICE I WAS GIVEN	ADVICE I'D GIVE	WHAT I WISH I'D KNOWN
	I still miss my dad every day, but one of the things he always said to me was: "Follow your dreams and look after your friends along the way"	The thing I always tell my own boys is: "Do your best, be kind and never give up"	All you need are five amazing friends rather than a million acquaintances

David Guetta

MAY 24, 2015

The superstar DJ, 47, talks about living in Ibiza, getting
divorced, his bodyguards and fending off loneliness.

“ I wake up around 1pm, and the first thing I do is head
outside looking for the sunshine. I have a house in Ibiza
and I like to take breakfast with the sun — usually fresh
vegetable juice, oatmeal, eggs, fruit and tea. I guess I'm not much of a
French guy... I don't like garlic and I never drink coffee.

After breakfast, I answer my emails for an hour, then go to
the gym I have downstairs and do 30 minutes of cardio and 30
minutes of weights. My life at home is the complete opposite of the
DJ cliché: everything I do is super-healthy. No drink, no drugs, no
smoking. I even put cream on my face to help my skin. Dr Sebagh [a
range of cosmetics] is expensive, but very good. The shampoo I use is
Head & Shoulders. It's meant to be for dandruff, but my trick is to
just use it all the time. No cologne or perfume. I don't really care how
I smell; I just want to be healthy.

At home during the day, I wear 501s, a white T-shirt and
Adidas sneakers, but if I'm DJ-ing, I prefer Saint Laurent. I'm actually
more of a fan of their stylist, Hedi Slimane. When he was at Dior, I
bought Dior; I moved with him because he's a genius.

I never listen to music around the house, or even in the car,
because it is my job. In an average day, I might have two or three
hours in my studio, then in the evening, another four hours of music
at a nightclub. I try to protect my ears, but when I was working with
will.i.am in LA, he had the volume of his music at supermaximum all
the time. Eventually, I said: "Please, this is killing me!"

Unfortunately, I was divorced recently. My kids [Tim, 11
and Angie, 7] come to stay with me in Ibiza during the summer. We'll
always have lunch together — chicken, rice and vegetables — and
talk about the day. They're just getting to the age where they
understand what I do, but they don't really care. To them, I'm their
dad, and it is my job to fix the TV.

I was married for 22 years, which is pretty good. I guess it's difficult for a relationship when a person is away a lot of the time, but maybe I could also say that my marriage survived 22 years for the same reason. When you're away, you really miss your wife, your family. So it was always exciting to be home.

My own parents got divorced when I was a kid. I grew up in Paris and was different to the person I am today. I was a kid with problems; I also drank too much. My parents were both extreme left-wing intellectuals — my dad was a lecturer in sociology. It was a difficult education. I did all the stupid things teenagers do, and life could have gone very bad. Was I ever arrested? Sorry, but my memory is a bit hazy! Ha ha.

Even after I started DJ-ing, drink was still too much a part of my life. I was nervous, so I'd drink to relax. Then, you drink a little more and suddenly you're getting drunk every day. You think you're the best DJ in the world, but you're not ... you're just drunk. At 18, I decided this was not the life for me.

My father would punish me when I was in trouble, but he was also clever because he never took my music away from me. He saw that I was starting to put all my energy into DJ-ing, and soon I no longer wanted to go out to parties or chase girls because I was too busy practising. Music saved me.

Will I meet someone new? I dunno. If a girl talks to me, I always think: "Is this person only interested in me because I'm famous?" But I can't help that. I can't be someone else. I am David Guetta. It's the same for a hot girl. Guys will talk to her because she is hot. Is that insulting? People are impressed by beauty and success and, personally, I am not offended by that.

My actual work day often starts in the evening. I usually eat out — more chicken and vegetables, but no carbs after dark. If I'm somewhere like Mexico or Colombia, I travel to the gig with bodyguards, but I don't like to live like that. You cannot worry-worry-worry all the time about what might happen. I try to have a normal life, but my job isn't normal.

I arrive at a venue like a secret agent, I sneak in the back door, security takes me to the stage, 20,000 people go crazy, security takes me out, and then I am gone. It gets lonely. I like people and I miss being around them.

After four hours on stage, I am full of excitement, and the one thing I've never been able to conquer is adrenaline. It's 4 in the

morning and my manager says: "Go home and sleep." That's impossible. I have to wait for the calm to come … you can't force it.

I arrive home at 6 or 7 in the morning, have a cup of tea, brush my teeth and say: "Thank you for this wonderful life." If I'd been famous at 18, I'd have gone crazy, thought I was God, and it would now be all over for me. Thankfully, success came late. I am 47, but I will still be doing this when I'm 60 … 80. I'll do this forever.

Interview by Danny Scott

In 2015 David Guetta became the third artist to rack up 2 billion streams on Spotify, and that year Forbes estimated his earnings at $37 million. In 2021 he collaborated with another top DJ, Afrojack, to release a track called Hero.

David Hasselhoff

MARCH 15, 2009

The actor, singer and producer reflects on attention-seeking pets, wilful daughters and missing his mum.

❝❞ Henry gets me up. He's a longhaired miniature dachshund and he starts licking my face as if to say: "Hey, Hoff, I need to get out and do my business." But sometimes it's the sound of Vanilla — I've never known a dog with such a snore. He's a cocker spaniel. Then there's Sadie, an Irish setter, and Harley, who's bowlegged. By 6.30am they're all on the lawn while I'm heating a cup of stale coffee in the microwave. I'm often chatting to Peaches, my umbrella cockatoo, when Isabel walks in the door. She's been my maid for years and she'll make me fresh coffee and a couple of burritos with sausage, egg, bacon and beans. Or maybe a healthier version with egg whites, potato and broccoli.

I've just moved back into the LA house I owned with my ex, Pamela. I was a bit shocked when I first walked in, because it was totally empty. I had to get my assistant, Joe B, a 300lb Hispanic who runs the Pasadena Mexican mafia — just joking — to sort things out. So now it's like little Mexico — he brings over all of his friends, relatives and kids to paint and put things in, which is no mean feat, because this place is like the White House. There are seven bedrooms, two guesthouses, tennis courts and two acres. Once I've chatted to him I'll stick on a white shirt, jeans and leather jacket. I'm 56, but I like to look young — the right clothing makes me feel hip.

Then I'll take the dogs in the car for a proper run. I've got a 1952 Buick, a 1960 Mercedes 190SL, a 1965 Mustang and a 1993 convertible Mercedes. Then there's the Harley-Davidson. But I usually get out the Escalade — it's gigantic. Then I'll go see Dad.

He's 83, lives in assisted housing and still calls me Tiger. He and Mom were married for 59 years, but Mom just passed away, so we're still raw. If we talk about her, the tears start. She was the first person to say to me: "You've got it, son." By the time I was seven she was taking me to every acting and singing class in town. She almost died three years ago, but we willed her back to life. Then, after a series of strokes, she deteriorated again and was on life support.

All she could do was blink one eye. We knew we had to let her go. But we were by her side. We held her hand until the end. It was tough. That's why I'm a little pensive these days.

On the way back to the house I'll grab a bit of sushi or have a power lunch among the paparazzi at the Ivy or the Grove and then get to work on one of my projects. I'm doing various things — a pop-opera album, a film script and a fly-on-the-wall TV documentary series called The Hoff: When Scott Came To Stay. I'm also a judge on America's Got Talent and I've got a show in Vegas in which I re-enact all my roles, from Knight Rider and Baywatch to Chicago. There's also a fun section called Baby Take Your Dress Off, which always appeals to girls out getting hammered on hen nights, and one of my prizes is a Don't Hassel the Hoff shirt.

If I'm home for the evening, I might barbecue a steak or heat a dish in the microwave — I still can't figure out how to work the oven. My two teenage girls, Taylor-Ann and Hayley, divide their time between their mom and me, so one of them might join me. They both sing and want me to promote them, but I tell them I'm too busy promoting myself.

Having said that, I've got an idea for a TV series with them. We could call it The Hoff-father and the Hoffspring. In the meantime, I'm always on the phone to them because they're either out too late or spending too much of my money — they forget I've got bills and alimony to pay.

But they worry about me too. They've seen me when I'm not well — they cry, they put their arms around me, they tell me they love me. I suppose in the last three years I've spent more time on my own than ever before, because I always used to have a family, somebody to come home to. I'm finally adjusting, but there's still times when I become a little too isolated. And that's not good — it plays on the negative — so I make myself go out.

I suppose my biggest strength is that when I'm pushed up against the wall, I'm a fighter, I'm an optimist. So while parts of my life still get exploited by the press, and while blatant, unadulterated

lies and garbage get told about me, I know that it comes with the territory. And I know that the upshot of the bad stuff is the good stuff, and being allowed to do just about whatever I want.

Last thing at night I'll say prayers for the protection of my children, my parents and my sobriety. I'll also say the serenity prayer: God grant me the serenity to accept the things I cannot change — which is the death of my mother; the courage to change the things I can — which is me; and the wisdom to know the difference. And then I let go, I drift off, I let God take control.

Interview by Ria Higgins

David Hasselhoff is perhaps best known for his starring roles in the TV series Knight Rider and Baywatch, which reached global audiences. Guinness World Records once rated him the most watched man on television of all time. As a singer he's released 14 studio albums.

Hugh Hefner

JULY 29, 2007

The founder and editor-in-chief of Playboy magazine, 81, lives in Los Angeles at the Playboy mansion with his three girlfriends: Holly, 27, Bridget, 33, and Kendra, 22.

" It should come as no surprise that I'm a pm person, so my day begins in the late morning, around 11am. The first thing I do is have breakfast in bed – an English muffin, a little jam, a bit of milk, half a grapefruit – read the newspapers, and turn the television on to the news. I want to know what happened while I was asleep and make sure the world is still here. These days, you have to be sure.

Then I have a shave, take the vitamin pills, clean up, and put on my pyjamas for the day. I wear flannel pyjamas at night, but it's silk during the day and evening. It's not a conservative look, but my parents were very conservative, particularly in the sexual area. There wasn't a lot of hugging and kissing, not an open display of affection. I rebelled to become a Roosevelt democrat when I was a little boy, before I could even vote.

After breakfast I go down and sit with my secretary. Running the magazine today is something of a labour of love. I go through various notes that I have, and look at whatever's come in – such as the layouts. I have a brown book dummy for the upcoming issues. I talk to my various editors, and take care of other kinds of business.

I think I've used Playboy in a very obvious way in terms of becoming a personal personification of the playboy. When I was 16 I had this crush on a girl, but she rejected me and that was key. I think all of my life, to some extent, has been making up for that. Having been rejected I reinvented myself and started referring to myself as Hef instead of Hugh. And I started writing stories and creating comic strips, including a cartoon autobiography of my life.

In retrospect it was obvious that it was an early, teenage rehearsal for what I did when I grew up with Playboy. It was really a matter of creating a world of my own in which I was centre stage, and

I passed it around to my friends. I became one of the most popular boys in school; I learnt to jitterbug and was voted the best dancer in the class, was head of the student council, wrote and acted in plays.

Nowadays I spend much of the day seeing the entire magazine come together, though I don't read every page. I change layouts and still pick the pictorials and the covers, and I edit the party jokes and the letters column. Plus I pick the Playmates – why would I push that off to somebody else?

I picked the first ever Playmate we photographed – a girl who worked in our office that we named Janet Pilgrim. We told a little story about how she worked at the magazine, and that was the beginning of the concept: it suggested nice, regular girls like sex too. The idea was to create a lifestyle magazine for young urban guys – a magazine that was related to the life I wasn't living. It was 1953, I was in an unhappy marriage, and I remember standing on a bridge in my native Chicago thinking: "Is this all my life is going to be?"

In the weeks and months that followed I started making plans and borrowed about $8,000. The magazine was a hit immediately, and profitable in the very first year. The 1950s were such a conservative time – politically, socially, sexually – that a magazine like Playboy was a true revolution, and it was embraced very quickly.

These days we're still expanding the brand. We just opened a Playboy casino in Las Vegas, but my daughter, Christie, looks after that side of the company. I focus on the magazine, which takes up most of the afternoon, then around five or six I have a light lunch – soup and cheese and crackers. I watch what I eat, but I do like chocolate, so I watch it, sort of.

I like to plan different events for each night of the week, like Monday night is manly night, where I hang out with the guys, old friends, and watch a classic movie in my screening room.

Tuesdays I take the girls out to dinner and they pick the restaurant. They pick from the menu, but I have lamb chops and a baked potato sent in from the mansion, so mine is set. The three girls – the last of them, Kendra, joined us about three years ago – and I spend a lot of time together, but most of my free time is spent with Holly.

As I was about to celebrate my 81st birthday, I thought seriously: "My 81st is going to be better than my 21st." That just seems unreal. I was just someone who wanted to publish a magazine, but I like to think I became somebody who played a part in changing

the social and sexual values of his time in a positive way, and had a lot of fun doing it.

I still like the big parties, but I have to admit, not as much as I used to. The best times for me are the quiet times, and the best time of all is, you know…in bed with Holly. Our relationship has become more and more serious, so she's the one that sleeps with me. Most nights we're up in bed by 10 or 11pm, but we watch a movie or something and Holly will usually fall asleep before I do. I usually turn in around 2am. It's as close as I've come to a soul mate, but I doubt I'll get married again. I'm not happy about what I see happening in relationships when you get married. Though I suspect Holly's the one I'll be spending the rest of my life with.

Interview by Tony Horkins

In 2008 Holly Madison ended her relationship with Hugh Hefner. He died in 2017, aged 91. Playboy magazine ceased print publication in 2020 and now appears only online.

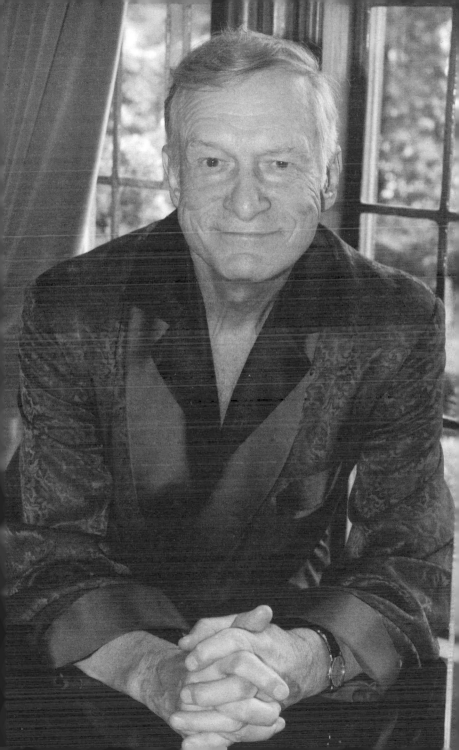

Damien Hirst

AUGUST 30, 1992

Damien Hirst, 27, a graduate of Goldsmiths' College of Art,
London, sold his 18ft shark suspended in formaldehyde to
Charles Saatchi for a reported £50,000. He lives in a flat in
Brixton, south London.

The light wakes me. I can't bear curtains. If I have
curtains I wake up at noon in a really bad way and totally
confused. I had a phase where I'd sleep on the balcony
listening to my flatmate's tape of the sea and all I could see was the
sky. But I'm always up by 9am even if I'm not working on a piece and
I've been out drinking.

I can get into a routine if I need to. When I was making a
fish-in-formaldehyde piece, called *Isolated Elements Swimming In
The Same Direction For The Purpose of Understanding*, I was getting
up every morning at 5am to go to Billingsgate. You can get any fish
you want at Billingsgate, but for the unusual ones you've got to get
there early. The work was in four cabinets, with 40 fish in each one. I
became a regular, and the fishmonger came to the Saatchi opening.

My flat's in The Barrier – a block built to protect Brixton
from the noise of a ring road that never got built. It's a lot easier to
live in than it is to visit. People stick these surreal unsigned notes up
in the stairwells— 'If you leave sh*t outside my door again, you dirty
scape [goat], your life won't be worth living.' That kind of thing. You
see cars in flames, and people being chased round by the police. You
wouldn't want people in Chanel suits turning up to visit.

It's a good home for my collection of pathology books. I
originally bought them and stole them when I was 16, for morbid
curiosity about burns, but now I just like them. I'm not self-
consciously eccentric, I've always been like this. I go to my mum's
house in Leeds and think she's completely barmy putting these
totally useless ornaments around the house. I pickle sharks, she
walks into a shop and decides whether to buy a little porcelain dog.

I'm not at all acquisitive. Eventually I'd like to live in a flat
with nothing in it. I want it to be white like a gallery. I can't usually

live with my work, but at the moment I've got my two butterfly paintings on the bedroom wall. I smashed one up in an argument with my girlfriend but I liked it, so I smashed the other on purpose. If I break something with that kind of fury I always consider it as a possible finished work.

Every day I get a cab to my studio. I spend £200 a week on cabs. It's my only decadence. I get my material buzz out of buying things for my work. When I make a piece of artwork, it's fine for me to buy three Armani jackets for a sculpture. In terms of what the sculpture's going to cost in the end, it's cheap.

I go into the studio each day but, unless I'm making something that's preplanned, I'll start deconstructing work and creating problems. So quite often I'll go out and look at steel, or find out how you get flies or how long it takes for a cow's head to rot. I know I'm not a stereotypical artist. With the fish piece I had assistants working with masks, gloves and hypodermic syringes. Then I suddenly remembered, "I'm making art."

For lunch I sometimes go to the pub with people who are working for me. People are surprised that I have assistants, but if I was to learn every skill that was involved in making my work I wouldn't have the time left to make it. I feel more like an architect.

My mum loves reading about me in the papers. I tried to explain my work to her when I was younger, but she just couldn't get it. She tried really hard, and said, "That's not art, I can do that." When I didn't get in to St Martin's she said, "I know why you didn't get in. Because you stick rubbish to bits of board." She'd love it if I moved back home and got a proper job.

When I go home to visit her in Leeds I always watch loads of telly because we don't have a telly in the flat. I don't do sport, but I do like watching the snooker. The weird thing that happens to the angles when it's on television really pleases my mind.

Every afternoon I have a business meeting with Jay, my dealer, where we discuss the offers we've had. I couldn't sell my work for the money it sells for if I wasn't with Jay, so it seems fine that he gets 50 per cent. He's very supportive. If I say I want to do a herd of elephants in formaldehyde, he'll say, "Let's find somewhere to show it."

When people say, "You can't do that," I always think I can find a way. I get a lot of energy from their negative approach. Like with my tiger-shark piece — I went to Harrods and I went to Billingsgate, but they all said, "No chance. Not a shark that big." Then I remembered this Australian surfer, and called him up.

He said telephone all the post offices round the Barrier Reef. So I did. They put up 'Shark Wanted' posters with my number on. The phone never stopped.

I'm always out in the evenings – parties, friends' houses, clubs, the pictures, or private views. When I go to a private view with Jay he'll say, "Talk to this person – they might buy a piece." We're like a double act. And I love going out for Thai food. You can make things taste great with very little – the same way I did using colour in my spot paintings. Eating is a biological function, but you can make it exquisite.

Having said that, the other day I rolled in at 3am, drunk, with nothing in the fridge except pasta and a tin of tomatoes. By the time I'd cooked something up I wished I'd never bothered.

I always clean my teeth before I go to bed. They're all my own, but probably not for much longer. I've got to have dental treatment because I grind my teeth in my sleep. My dentist says I've got the teeth of a 60-year-old. So I'm having full-mouth rehabilitation. And I'm giving him art in exchange.

Interview by Richard Johnson

After his early success and winning the Turner prize in 1995, Damien Hirst went on to become Britain's richest artist. In 2008 works by him sold for £110 million at a single auction. In 2020 The Sunday Times Rich List put his wealth at £315 million.

Tom Hollander

OCTOBER 4, 2020

The Bafta-award winning actor on insomnia and keeping himself entertained between jobs. Tom Hollander, 53, was born in Bristol and raised in Oxford. He was a member of the National Youth Theatre and read English at the University of Cambridge. He has starred in films including Pride & Prejudice and Bohemian Rhapsody and currently appears in the BBC TV series Us. In 2017 he received a Bafta for his performance in the drama The Night Manager. He lives alone in Notting Hill.

 I wake up generally at 3 or 4am. Not because I'm like Margaret Thatcher, but because I need to pee. I pee in the darkness using my phone screen to illuminate the target, then often take half a sleeping pill (antihistamine), turn on the World Service very quietly and try to go to sleep again.

Sometime between 6 and 8am I wake again, turn up the *Today* programme gently. If my girlfriend is there we hold each other in different positions. If she isn't, I wrap my arms around a pillow and continue listening to the bad news. Whoever gets up first will go downstairs and start baking porridge. It's like a savoury flapjack and was recommended to me by a very healthy-looking nutritionist. It takes about 40 minutes to cook and we eat it in such large quantities with olive oil and salt that we negate any nutritional benefits. But we enjoy it. And while it's cooking it gives us time to look at our phones.

Sometimes in this waiting period I try to do three slow sun salutations to stretch myself out, but often I don't. I brew the first of many coffees. Which mostly involves heating up the stuff in the cafetière left over from the day before. If it's a slow day I make it in one of those Italian alloy things that students always used to have that involve a lot of assembled parts and washing up. Owing to forces beyond my control, life has not been as busy as it used to be.

After we've eaten and my girlfriend has gone to work I look at myself in the mirror and try to see what others see. Examine my bald patch, weigh myself and pull my stomach in. Then let it

out. Then pull it in again. If I'm feeling positive I might get dressed at this point and go for my second coffee on the street below. I've lived in the same flat for 20 years and one of the rewards for this loyalty is that I know all the shopkeepers and stallholders on the street, for whom I have become like a piece of the old furniture they sell.

Hello Glen, hello Kris, Ghino!, hello Brendan, hello Fati, wave at Ray, turn the corner, *bonjour Raschid, ça va?* (keep going 'cause I can't really speak French), hello Hassan, hello Reg, morning Dave, yup still here Tony, hello Beatrice (she doesn't notice), slide into Porto: "Maya four-ter take away please" (phonetic Portuguese). Then take it home and leave it on the sideboard with any post that has arrived from my stalker.

Then I might call my agent. "Isn't she? No, no, nothing important… just checking in…"

Soon it's time for my midmorning nap. Followed by the preparation of lunch, which I start at 12.15pm. And at 1pm I turn on the radio again to listen to *World at One* and hear politicians lying or reports of the world ending.

Whatever I make for lunch I eat too much of, which makes me feel a bit lethargic, so I make some more coffee and turn off the radio as *The Archers* starts so I'm ready to begin the second half of the day.

The afternoon is time for hobbies and extracurricular activities. If it's sunny I might go for a cycle ride down the canal, if it's raining I might masturbate and doze, or speculate on the extraordinary injustice of Philip Green's knighthood, or look at that app that tells you which celebrity you most resemble (Tom Hardy). Sometimes I read long-form articles about the collapse of western society and the destruction of the planet.

From about 5pm, assuming I haven't mislaid my house keys or mobile phone, it's possible to surf through the rest of the day on the news feed while preparing food, eating it and digesting through *Newsnight*.

Then it's time to go to sleep again. Cracking a little sleeping pill in half in case I need it later, I turn on the radio very quietly. If my girlfriend's there we hold each other in various shapes. If she's not I put my arms around a pillow.

Written by Tom Hollander

In 2021 Tom Hollander filmed a series called The Ipcress File, based on a spy novel and 1965 film, which starred Michael Caine as the lead character, Harry Palmer. In the series Hollander plays Major Dalby, a Machiavellian baddie.

WORDS OF WISDOM	BEST ADVICE I WAS GIVEN	ADVICE I'D GIVE	WHAT I WISH I'D KNOWN
	Try to retain a sense of humour at all times	Really do try to retain a sense of humour at all times	How to handle myself in a fist fight

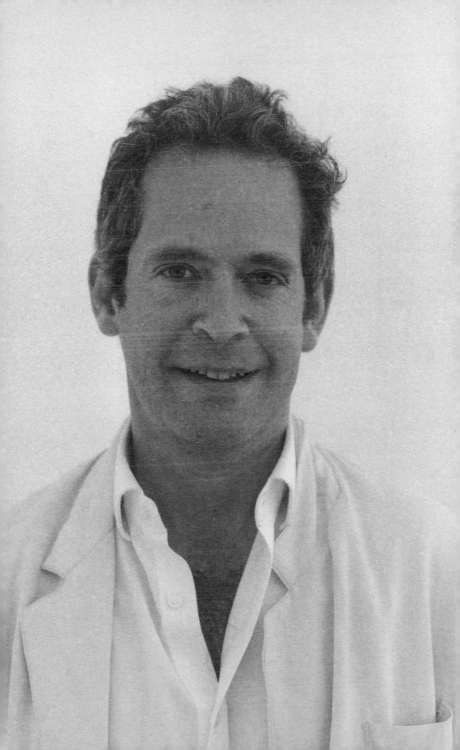

Jennifer Hudson

FEBRUARY 17, 2019

The singer and Oscar-winning actress on jet lag, Jacuzzis and being a judge on The Voice. Jennifer Hudson, 37, came seventh in the 2004 series of American Idol, but shot to fame two years later in the film Dreamgirls, for which she won a best supporting actress Oscar. In 2008, her mother, brother and nephew were shot dead by her brother-in-law. She has since set up a children's charity in her nephew's name. Hudson was engaged to the former WWE wrestler David Otunga, but the couple split in 2017. She lives in Chicago.

66 The first thing I do when I wake up is say a prayer, then I plug my music into the speaker system. Music puts me together, it's my life. When I was younger, I sang constantly, in my bedroom, at school, at church. I wait until 10am to have breakfast. I like eating the same things, though I go through phases. Last summer I had to have parfait every day, now it's salmon, cream cheese and toast. Some days I'll just have snacks, like boiled eggs. I love Splenda [the artificial sweetener] and put it on everything — on salad, in tea.

I worked at Burger King and on a Disney cruise ship before I entered American Idol. When you come off a show like that, you are trapped between two worlds. You have just a toe in the music industry, but to everyone in your regular life you are now a celebrity and they expect big things.

I live in a big old house in Chicago. Each room has a name. The master bedroom has pillars, a round bed and a Jacuzzi, and I do my make-up and hair in my "day room" because it feels like daylight. It's dedicated to my mother and has her sayings on the walls, like,

"If you think you've seen it all, keep on living." There's a painting of her too, which [the rapper] Missy Elliott gave me when my mom passed [Hudson's brother-in-law shot and killed her mother and brother at their home in a jealous rage, then kidnapped and killed her seven-year-old nephew].

The hardest part about working on The Voice is the jet lag. Last year I was flying from the UK to the US every week for filming. I worked like a slave. When I'm doing The Voice or on the road touring, it's complete craziness. Everybody needs me every second. I say to my team: "I want to have a drink and throw my head back and laugh, like the people sitting outside that restaurant." But I have to make an appointment to do that.

Lunch might not be until 3 or 4pm, maybe a salad. Growing up, we would have themed meal nights. Friday was fried catfish with spaghetti. We weren't allowed to eat out much. If you asked my mamma for more than a quarter, she'd go "You want 50 cents?" as if it was the biggest deal. My grandfather would give my siblings and me $5, which was a lot of money, and we'd spend every dime on junk food. Now, I'll sometimes fly to a city to eat a certain meal: London for tacos, LA for sushi.

Being a humanitarian was never something that I tried to be. It just happened. When I visit schools to give out food and supplies, I want to hug all the kids, I want to hear from them, I want to be hands-on. As a performer too, I always want to go beyond. If the set is 30 minutes, you're going to get a good 45 out of Jennifer.

If I am at home in the evening, I will have a bath and light candles. I'm a Chicago girl, but I feel the cold. My grandma used to sit over the heat vent and call it her "heat hole". Now I have fireplaces in as many rooms as possible. After my bath, I'll sit on the bed with my blankets, like my grandma.

I'm a night owl. It's the only time I really have to myself when it's quiet and I can think. How do I unwind? I'm obsessed with Instagram. It calms me and helps me to loosen up. Before I sleep, I try to think of something positive, and I always say a prayer.

Interview by Megan Agnew

In 2019 Jennifer Hudson appeared in a film version of the musical Cats (which, despite many star names in the cast, received a critical panning). Her latest film project is Respect, a drama about the singer Aretha Franklin.

WORDS OF WISDOM	BEST ADVICE I WAS GIVEN	ADVICE I'D GIVE	WHAT I WISH I'D KNOWN
	It's not always about how good you are, but how good you are to work with	If you keep at something, it has no choice but to give in	Not everyone has the same heart as you do

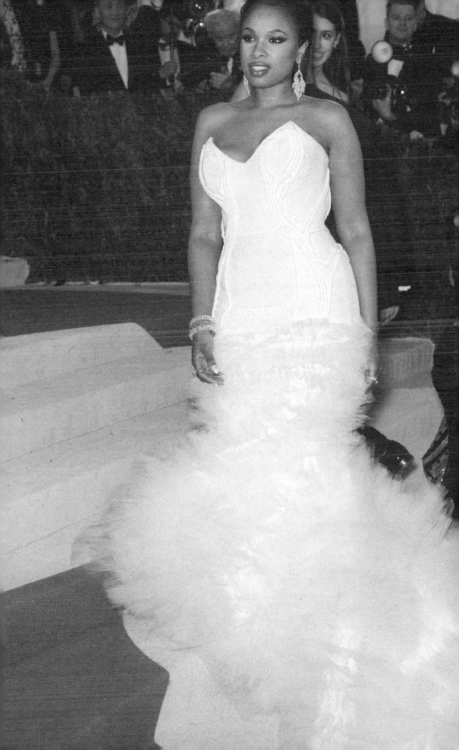

Maro Itoje

FEBRUARY 28, 2021

The England rugby star on big breakfasts, cauliflower ears and campaigning for laptops for deprived kids. Maro Itoje, 26, is a 6ft 5in, 18st Saracens and England rugby player. Nicknamed "the Pearl" for his rare skills at second row or flanker, he is tipped as a future captain of England and the British and Irish Lions. In the early 1990s his parents moved from Nigeria to northwest London, where Itoje was born. He won a sixth form scholarship to Harrow School, studied politics at Soas and is studying for an MBA. Last month he launched a campaign calling on ministers to get free laptops and broadband into the homes of 1.78 million deprived children.

Our longest day of the week in [Six Nations training] camp is Tuesday. I'm up at 6am for "Bacon and Eggs" — there's no bacon or eggs involved; it's a weights session that starts at 6.30am. After that I'll shower and breakfast is at 7am. I look forward to breakfast every day. There's quite a spread: salmon, ham, avocado, overnight oats, fruit, porridge, all kinds of eggs and an omelette station. No greasy sausages or bacon — well, maybe once a week. We have a rugby skills session at 10am. I get there half an hour early to warm up, tape anything that needs taping, look at any plays I need to know. We'll be done by 11.30am.

I wear a head guard because I don't want to get cauliflower ears. Do I worry about concussion? Not at all. I hope that Steve Thompson and all those players who are suffering as a result of concussion [Thompson, 42, and other former players with dementia are suing World Rugby and the RFU over an alleged failure to protect them] get the support they and their families need. The game is in a different place now than when they were playing; the culture has changed. The guidelines about dealing with concussion are a lot clearer. Previously you would get a concussion and the "admirable" thing would be to play on. You don't have that peer pressure now.

Lunch in camp changes every day. There's always a carb option, a protein option and a lot of vegetables. Around lunchtime

we have a squad meeting in an open-sided marquee — I'll wear about four heavy layers. All our meetings are in outdoor spaces. There's a fire pit here too. And a giant chessboard. I don't play, but quite a few do: Manu Tuilagi is like a grandmaster. Mako Vunipola, Owen Farrell and Jonny May have also started playing a lot.

Luke Cowan-Dickie, Ellis Genge, Ben Youngs etc — they spend a bit of time gaming, maybe *Fortnite*, *Call of Duty*; I don't really keep track. I'm one of the few who aren't into gaming.

The afternoon is rugby training. Any spare time for me is filled with studying for my MBA. It's all preparation for my life post-rugby, and it helps me think about things differently. From almost the day I came out of the womb my parents pounded into me and my siblings the importance of education — I have an older brother and a younger sister; I live with my brother in northwest London.

I went to St George's boarding school in Harpenden, where rugby was the dominant sport. Some of my closest friends are from that school — I speak to them almost every day. After my GCSEs I went to Harrow — the extracurricular activities there are second to none.

People often talk about education as a social leveller. But the result of these lockdowns is that children who don't have access to technology and data are being denied that opportunity. If nothing is done, the inequality between the haves and have-nots gets wider and wider. That's why I've been trying to lend a helping hand.

Dinner is at 6.30pm. I had a great seafood paella a couple of days ago. I'm not watching much TV at the moment, but I do listen to podcasts — there's a good one called *Pearl Conversations* — Ha! [This is Itoje's own podcast; guests have included his England team-mate Kyle Sinckler.] Kyle's my guy. I get on really well with him.

I try to go to bed by 10.30pm. I sleep OK, some nights better than others. I always have things on my mind — my degree, rugby, family. It's all part of life, isn't it?

Interview by James Palmer

England had a less than stellar Six Nations tournament in 2021, winning two, losing three and ending in fifth place. In a narrow England victory over France, Maro Itoje scored a vital try.

WORDS OF WISDOM	BEST ADVICE I WAS GIVEN	ADVICE I'D GIVE	WHAT I WISH I'D KNOWN
	The truth will set you free	Honesty is the best policy	Part of life is discovery — I'm happy to discover new things as life goes on

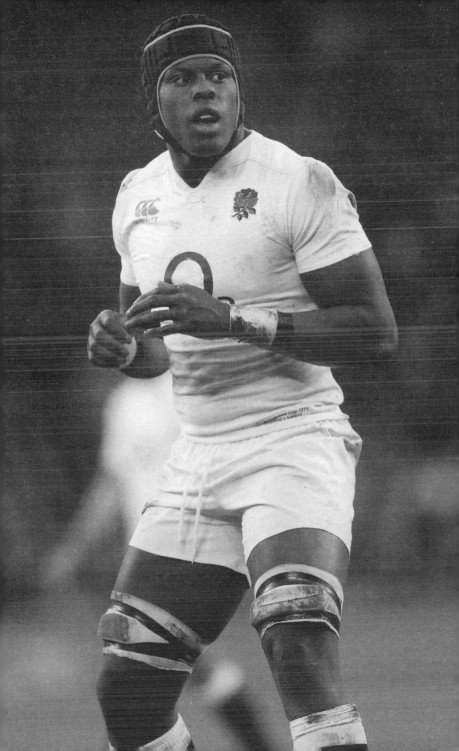

Alex James

AUGUST 6, 2017

The Blur bass player and cheesemaker on rock clichés and why happiness is a warm peach. Alex James, 48, was born in Boscombe, Bournemouth. He attended Bournemouth School, a boys' grammar, before moving to London in 1988 to study French at Goldsmiths. At college, he joined a band with fellow students Graham Coxon and Damon Albarn; they went on to have six No 1 albums as Blur. He lives on a 200-acre farm in the Cotswolds with his wife, Claire, and their five kids: Geronimo, 13, the twins Artemis and Galileo, 11, Sable, 8, and Beatrix, 7. He produces a range of cheeses on the farm, where he also runs the Big Feastival, a three-day food and music event.

I'm usually woken at 7.30am by one of our five kids practising a brass instrument. I tried to steer them to the bass guitar, but there's nothing like a seven-year-old playing a trumpet. Claire will make porridge for the kids, but I'm a coffee and fags man — the breakfast of champions. Then they'll go out and collect duck eggs. Our two geese and a dozen silkie hens, all called Dave, were eaten by a fox a few weeks ago. The kids were distraught. I wasn't so sorry about the geese — they do 12,000 poos a day and need to be followed with a pressure washer.

We moved to the farm from London in 2003. We couldn't resist it; it's a rambling property, like buying a village. It's the second time in my life I've been in the exact right place at the right time. The first was when I arrived in London and set eyes on Graham Coxon, Blur's guitarist.

After years of being in a band and living out of a suitcase, there is something wonderful about coming to a standstill. Also, playing bass isn't a decision-making role and I needed a challenge. I thought I was doing something daring by going from three window boxes of dead daffodils in London to a farm, but I've realised it's the next cliché in the book of rock clichés. It was absolutely terrifying to start with. We had to throw money at it, but the locals could see we were passionate and not just playing at farming on the weekends.

My days are filled with planning the Big Feastival. I'm excavating a bonfire pit to cook a whole cow on. Lots of festivals lose money, so you've got to have a niche and execute it well. I could write a song in half an hour, but it probably wouldn't be great, and it's the same with mozzarella. If you want to do anything brilliantly, it takes all your might. Feastival is like a three-day wedding: you see everyone you love and have the most fun. Geronimo is only 13, but he knocked it out of the park with his DJ set last year. Festivals have been my life, but singing Uptown Funk in the car with the kids feels just as good as headlining Glastonbury.

In summer, there's a tsunami of produce in the garden. Eating a warm peach from the tree is the ultimate gourmet experience, but often I don't get a chance to stop. If I'm lucky, I'll grab a few salad leaves for lunch with Claire. The kids love going out with a pot of cream to eat the strawberries. They also eat their weight in tomatoes, and there's always cheese.

People think going from musician to cheesemaker is strange, but monks have sung in the morning and made cheese in the afternoon for centuries, and I always requested local cheese on the tour rider with Blur. We've had a few misfires: the cheddar tikka masala came in for some stick, but it got us column inches.

At 4pm I'll make tea. I've had to build a cave outside the kitchen for all my cooking gadgets. It's handy having a rotisserie for three chickens because one doesn't touch the sides in this house. There's always room for guilty pleasures: bacon Frazzles sprinkled on a salad — now you're talking.

After story time with the kids, I'll do a bit more work. I'm happy to be in bed by 8 or 9pm. Claire and I lie next to each other, holding hands, watching different things on our laptops. I'm lucky to have done two things I really enjoy. I remember telling my mum I wanted to join a band and she said: "Don't be ridiculous." When I said I was going to make cheese, people said the same. I just hope my kids have got the balls to be as ridiculous.

Interview by Emma Broomfield

In 2019 the Big Feastival featured, among others, the band Elbow and the singer Lewis Capaldi, plus chefs Raymond Blanc and Prue Leith. The festival did not take place in 2020 because of coronavirus restrictions, but returned in 2021. On his farm Alex James also produces a cider called Brit Pop.

Michael Johnson

AUGUST 11, 2019

The BBC commentator and one of the greatest athletes of all time on the lessons he's learnt from having a stroke. Michael Johnson, 51, was born in Texas and won the first of his four Olympic golds in 1992, aged 24. His 200m and 400m medal haul also includes eight World Championship golds. At Atlanta in 1996, he became the only man to win the 200m and 400m at the same Olympics. He set up the Michael Johnson Performance training institution after retiring in 2001. He had a stroke last year. He lives in Malibu with his second wife, Armine.

66 I always get up around 6am. Having a stroke didn't change that. In the initial aftermath, I suffered from constant fatigue, but it had nothing to do with the stroke. As part of my recovery, I was doing three physical training sessions every day, plus brain training in between. I was approaching each day in the same way I would an Olympic final and it left me exhausted. We're 10 months down the line and all that hard work has paid off: I've made a full recovery.

I get up, take a shower, make breakfast — granola, yoghurt and fruit. I sometimes make breakfast for Armine, too. She's a chef, so I always feel anxious. I take the dog for a walk on the beach close to our house, then I call my company HQ in Dallas. Our business is sports performance. That might mean product development with Nike, training programmes for athletes or talking to the Japanese government about Tokyo 2020.

I also have a new job talking to people about my stroke and recovery. If you had a stroke, do you think you'd know? I didn't. There was no significant pain. Just a strange sensation in my foot

and tingling in my arm. At first I thought it had something to do with my workout, all I needed was a good night's sleep. But I've spent most of my life being in tune with my body and knew something was wrong, so I went to ER [a medical emergency centre]. That was a big contribution to my recovery.

Every day I have to take a blood thinner, aspirin, plus medication for cholesterol and blood pressure. Not because I have high blood pressure or cholesterol, I just need to minimise the risk of any cardiovascular issues. I've always been pretty good with what I eat, but the past 10 months have made me even more conscious. Armine decided to cut out meat a couple of years ago and I'm ready to join her. Fish and salad for lunch. Lots of vegetables.

In the afternoon I call my son, Sebastian. He's just finished his first year at a top music college over here. Jazz is his thing. Thankfully, he followed his own dream. My dream finished 18 years ago when I retired.

In the aftermath of the stroke, I decided I wasn't going to tell Sebastian or my wife the full story of what had happened. I was lying in a hospital bed, unable to walk to the bathroom. Was this my future? Going from Olympic medals to being a burden on my loved ones. I was more scared than I've ever been. And my natural instinct was to internalise those concerns. Be a man. Be strong. That's how I've always dealt with problems. Armine encouraged me to talk. I thought people would look down on me because I needed help, but the support I received made me feel even more powerful. That has been the biggest change: I'm no longer afraid of being vulnerable.

My evening training sessions are almost back to what they were last year. I do an hour in the gym, five days a week. Armine and I then sometimes go out for dinner, catch up on TV or walk down to the beach to watch the sunset.

I'm in bed by 10pm and often think about what happened. No one has been able to tell me why I had a stroke. Even though I did all the right things, it still happened. There was a time I'd have worried that I wasn't in control. But what's the point of worrying about things you can't control? You just have to move on and live your life.

Interview by Danny Scott

In mid-2021 Michael Johnson still held the US national records for the 200m and 400m sprints – more than 20 years after he set them.

WORDS OF WISDOM	BEST ADVICE I WAS GIVEN	ADVICE I'D GIVE	WHAT I WISH I'D KNOWN
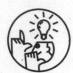	As I was lying in the hospital, my wife said to me: "Don't be afraid to ask for help"	Don't take your health for granted	When I retired that there was still so much I wanted to achieve

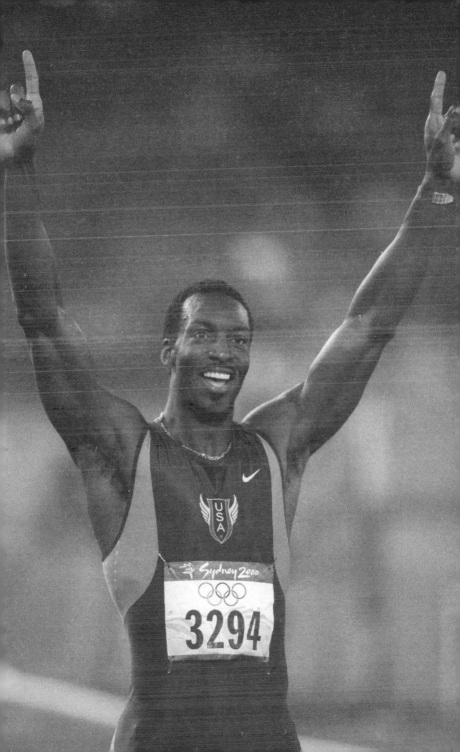

Kim Kardashian

JUNE 17, 2012

The American reality TV star, 31, talks about poignant dreams, her cleaning obsession, and why she doesn't think she's beautiful.

"I get up at 6.30am. My gym clothes are already laid out from the night before so all I have to do is brush my teeth, wash my face and collect my food delivery from the gate. My food is delivered every day in little freezer packs. I put those in the refrigerator and make sure it's all tidy. I can't shut the door if things aren't on the right shelf.

The gym is 15 minutes away, so I get in the car and listen to Kiss-FM or Power 106. If a song by my boyfriend [the rapper Kanye West] comes on the radio, I know it's going to be a good day. I'll be at the gym by 7am, work out for an hour, run for 20 minutes on the treadmill, then go straight home.

I try to eat healthily, so it's gluten-free and sugar-free meals, if I can. I never drink coffee, and breakfast will be in one of the freezer packs, so all I have to do is heat it up. It changes every day, but I love plain, simple food like... an egg-white omelette.

After breakfast I have a shower. My bathroom is full of shower gels, body scrubs and shampoos — at least 20 different ones — all colour co-ordinated, height co-ordinated and scent co-ordinated. And I can't take a shower unless the bathroom is absolutely spotless. I think I'm totally OCD... everything has to be immaculate. I have a cleaner who comes three times a week, but I always do cleaning on top of that.

I will admit that I'm a perfectionist. I want everything to be perfect, and I guess I apply that to myself. Even though I'm not!

Not at all! Nobody can be perfect! When I go places and people scream things like "Kim, you're beautiful", I don't see that. When I look in the mirror I see things I want to change and make better. In the past, I tried to live up to people's expectations of how I should look, but now I try to worry less about what others think.

Life at my house in LA can be difficult. The fans know where I live and the photographers know where I live. Fans buzz on the gate all the time. Sometimes I answer it, but there are times when I want to be private. I know that might seem strange because I live my life on a reality show ... I've asked people to watch everything I do.

I'm not complaining. I'm happy with the life I've chosen, but I think there's a balance. People want to know every detail about me and my boyfriend. In the past, I'd have shared that with the world, but over the last couple of years I've realised I don't have to be an open book all the time.

If I do want privacy, I go to my family home, which is in a gated community nearby. There are parks where I can go for walks and I often have lunch there. I might take one of my freezer-pack meals — usually a salad. For a treat, I might also have a little taste of Mom's frozen yoghurt — she has a yoghurt machine in the kitchen.

In the afternoon I catch up with friends. Most of them aren't famous. They're all married and have babies! But we've known each other since we were kids and I feel comfortable with them; they know the real me.

If there's a red-carpet event in the evening, I get home early because my glam team will be there: someone to do my hair, someone to do my make-up, someone to help me choose an outfit. It takes about two hours.

If I'm at home in the evening, I'm a terrible eater. That's when I'm likely to give in to temptation. I love Mexican food and pizza, so it's a struggle. But I try not to deprive myself. If I crave the bad stuff, I have a little bit of it.

I love real-life crime shows and I always watch Forensic Files and The First 48. I'm usually ready for bed by 10pm, but I might do a bit of tidying first. I often vacuum last thing at night! I also lay out my clothes for the following day. If I'm travelling, I pack my case and I can't go to sleep unless I know it's all ready. Sometimes I get into bed and think: "Did I pack my shoes?" I have to get up, unpack the suitcase, check it, then pack it all again. I'm a bit crazy that way.

I've been dreaming about my dad lately. I've had two dreams that were, like, so real. I started researching them and I read

that they're called "special dreams". Typically, one family member has them, and I'm the only one who's had these dreams since he passed away. It's like he's here, in the room. Talking to me. I totally believe in the connection between this world and the other side, so I love these dreams because it feels like he's watching over me... over the whole family. Thanks, Dad.

Interview by Danny Scott

In addition to her media activities, Kim Kardashian has valuable business interests, including KKW Beauty, a cosmetics company. Forbes magazine recently declared her a billionaire. She married Kanye West in 2014; the couple filed for divorce in 2021.

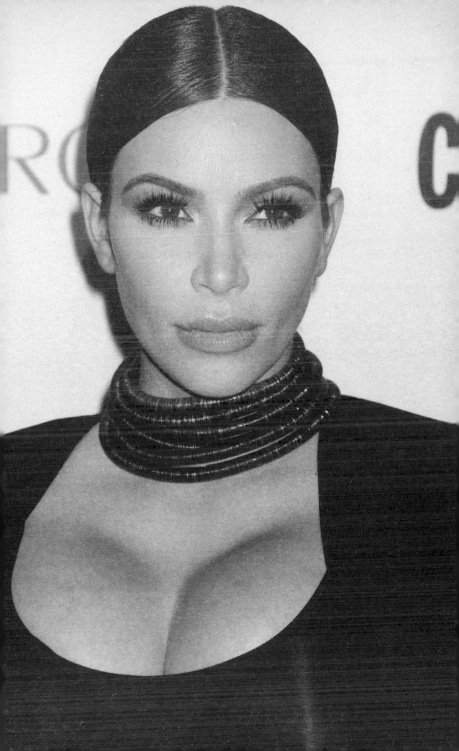

Kesha

NOVEMBER 17, 2019

The singer-songwriter, actor and rapper on her four cats, vegan lifestyle and huge bed. Kesha Sebert, 32, grew up in Nashville, the daughter of singer-songwriter Pebe Sebert. At 17, she dropped out of school to sign to a record label. She has sold 134 million records and her 2009 single Tik Tok has been downloaded and streamed more than 1.5 billion times. She lives in LA with her four cats.

My first ever extravagant purchase, after [my single] Tik Tok, was my huge bed — it's the size of two king-sized mattresses. I sleep in an oversized vintage T-shirt and wake surrounded by cats and cat fur. One sleeps on my feet, one in the far corner, another on my chest…I feed them before I even brush my teeth. My boyfriend [Brad Ashenfelter] is usually up and cooking me a vegan breakfast — avocado toast or fake meat patties. He gets real mad because I dip everything he makes in hot sauce.

I let the cat-children out to play, then most days I ride my bike down to the beach to look for sea creatures and have a swim. I'm Pisces, I'm so happy in water, I'm practically aquatic. If I have a day off, I panic. There are about a million voice memos on my phone — song ideas and melodies. Every day for the past six months I've been to the Village Studios, in west LA. It's an old masonic temple with the best vibe. I blabber to the sound engineer, Matt, for a solid hour and that's where the songs begin.

Being a young woman in the entertainment industry can be really difficult. For a long time I felt I had to please everyone. A woman who puts up boundaries, or says no, is a bitch; if you're a man, you're just a boss. I reject that, but I didn't always. I will probably never get over what happened [in 2014 she alleged she had been abused], but I feel stronger for having expressed what I've expressed. A lot of the shame I was holding onto silently has been lifted. I have found joy, but I've had help with that.

I grew up without a father, so I've had therapy since I was a kid, that's so normal for me. I still want everyone around me to be

happy, so I really have to practise self-care. Why are women so hard on themselves when men think they're so f****** fabulous all the time? I would love to know what life would be like if I was nicer to myself. It's the number one thing I'm working on.

There's always an argument about food in the studio — they want cheeseburgers; I'll order in a bowl piled with vegan mush. The studio has always been my safe place. I'd do my homework there as a kid while Mom recorded a demo. Growing up, I was the weird kid who didn't fit in. We lived on food stamps and all our clothes were from goodwill shops, but Mom made it feel like an adventure. I still talk to her every day. I thank God for her, my two brothers and the friends I've had since I was seven. They've been there for me through all the crap.

The thing I love and fear about writing music is that I'm just a conduit. Some days I feel I've been struck by magic, others, it doesn't come and we don't wrap in the studio until 2am. My man will have left some delicious vegan food in the oven because he's a sweetheart. He's honest and kind, and I love him as hard as a human can love.

I've been bulimic and you're never over it, but I have a new mantra: it's my body, other people don't get to tell me how it looks. When things got bad for me, I was listening to people's comments like they mattered. I'll not do that again.

When I sleep I talk a lot, and toss and flail. But I'm pretty happy right now. When you stop comparing yourself with other people, you're perfect as you are.

Interview by Caroline Scott

In April 2021 Kesha, who at one point was styled as Ke$ha, explained that the first syllable of her name was 'keh' as in 'kept'. She said on a social media video that her name was "Keh-sha. Not Key-sha, not Ketchup. Keh-sha".

WORDS OF WISDOM	BEST ADVICE I WAS GIVEN	ADVICE I'D GIVE	WHAT I WISH I'D KNOWN
	My mom told me, from day one, speak from the heart and be yourself	Try to be kind to yourself	When you're a woman in business, creating boundaries for yourself doesn't make you a bitch

Imran Khan

OCTOBER 24, 1982

Imran Khan, 29, captained the Pakistani cricket side in the last Test series. He read PPE at Oxford and now plays for Sussex County. He is unmarried.

I wake up about an hour before I have to leave for the cricket ground: about 10am in this country, 9am in Pakistan. I have a travelling radio clock. I take a shower, get ready and have breakfast – usually just eggs and cereals.

We keep water buffaloes in Lahore, but the milk is rather watery. Here I drink three-and-a-half pints of milk a day when I'm playing and I find it gives me a lot of sustenance.

An hour before the match I do some training at the ground to loosen up, stretching all the muscles that come under pressure while bowling: back, back of legs, shoulders and stomach. I get nervous, particularly before I go out to bat, just as I did when I started my career. You have just one chance; one mistake and that's the end of you. But once I get to the wicket, I'm okay.

In Pakistan we get two hours for lunch, but when I'm bowling I can't feel hungry. I get so dehydrated all I want to do is drink. But I force myself to eat, otherwise, by the end of the day, I feel totally drained. Even when I'm on holiday I don't like big lunches. And I don't like eating Pakistani food over here because most restaurants don't cook it very well. I like Italian and French food though, and really miss English steaks when I'm home.

I like to see my friends as much as possible. When I first came to England at 18, for the Test, the lack of strong male friendships here was what surprised me most. I arrived half-way through my A-levels, from Aitchison College, the best public school in Pakistan. It used to be called 'Chief's College'; it was originally designed for the sons of princes and maharajahs. They had a very high standard of sports and I was selected for my national team from there.

I went to Worcester Old Grammar School when the tour ended, and it was the toughest nine months of my life, mainly

because I'd never lived away from home before. I couldn't *believe* the English winter. I didn't like boarding. I was very particular about sanitation and had always been used to having my own bathroom. My parents both come from land-owning families and they live in a seven-bedroom house in Lahore. My father, Ikram Ullag Khan Naizi, is 57 and a civil engineer. Khan signifies that we're Pathans from the North-West frontier; Naizi is the tribe I belong to.

After Worcester I went up to Oxford and I loved it there. Fantastic place. I had a few minor shocks when I realised how much I had to study because at first you don't really know how to pace yourself. I made a few friends there – none of them Pakistani.

At no stage did I decide to make cricket my career. I just thought I'd do it for a year, go round seeing the world, and then get on with some work. I was aiming to go into the Civil Service in my country – maybe the Foreign Service. My two first cousins, both Oxford Blues, went into the Civil Service. But after 11 years in the game I find I'm at my peak. I wouldn't call myself the fastest bowler in the world – that's Michael Holding's crown. But on my day I can bowl as fast as anyone. I might continue for another couple of years.

At home I never shower at the ground after a match. We don't have very good facilities. I think the game's much more demanding there. But the rewards are greater too. It's a very glamour-game in Pakistan, you know. Fans wait outside the ground and a lot of people ring me up. They even come to my house.

In Lahore, there's always something planned for the evening. My friends come and pick me up at about 8.30pm. We go out but there are no such things as bars or discos. There's a lot of socialising, but it's always in people's houses. We go for coffee in one house, then move on to another. One knows everyone.

We usually end up watching videos. I like to escape into good films, like *On Golden Pond,* but I don't like Indian films much – all the same theme, very boring. At home, unless you're engaged, you hardly ever go out alone with one woman. We don't have places where single people can meet, fall in love. Girls would not normally even go alone to parties.

Here I take a girl out occasionally, to a film or to listen to music, but not as much as the publicity would say. The girls are mostly casual friends. Sometimes the whole party will move to a club afterwards. There are two which I like a lot – Tramp and Tokyo Joe's. They have a very nice atmosphere.

My family are very conservative. If I wanted to get married it would have to be an arrangement. Eligible women are pointed out

to you at weddings although, in the end, it's entirely up to you if you do or do not. I'm a very practical person, a realist. Inter-racial marriages don't seem to work unless the guy's prepared to live in England, and I'm so deeply rooted in my country that there's no way I'd live anywhere else. If I tried to make a foreigner live in Pakistan, with all the different customs, it just wouldn't work.

I'm often out until 3am. In country cricket I don't really worry about late nights, I'm so used to them. But I'm very careful during a Test Match. I neither drink nor smoke.

I don't eat pig meat and I wear a verse from the Koran in gold around my neck, which is supposed to protect me. I wouldn't call myself a very orthodox Muslim. I go to the mosque on Fridays, but in England I don't fast.

I pray before I go to sleep – my own small prayers, asking the Almighty for health and humbleness and for the health of my family. I'm so used to travelling, I usually sleep well wherever I am. But not before a Test Match.

Interview by Angela Wilkes

In 1992 Imran Khan led Pakistan to victory in the cricket World Cup. Three years later he married Jemima Goldsmith, daughter of the billionaire Sir James Goldsmith, and they settled in Pakistan, where he founded the Movement for Justice Party. The couple divorced in 2004. Khan, who went on to remarry twice, became prime minister of Pakistan in 2018.

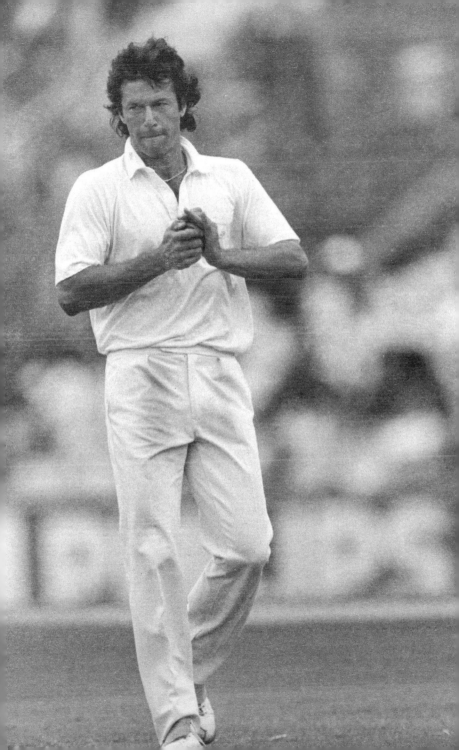

Marie Kondo

JUNE 4, 2017

The queen of decluttering on being obsessive, her chaotic children and how to live a tidy life. Born in Tokyo, Marie Kondo, 32, was tidying her brother and sister's bedrooms, as well as her own, from an early age. While studying sociology at Tokyo Woman's Christian University, she worked as an attendant maiden at a Shinto shrine and earned extra money by offering her tidying services to friends. In 2010, she launched a successful business advising clients how to declutter their homes. Her books, The Life-Changing Magic of Tidying Up and Spark Joy, have sold more than 7m copies. She lives in Tokyo with her husband, Takumi Kawahara, and their daughters, Satsuki, nearly 2, and Miko, six months.

 The best time to start tidying is early morning when the air is sharp. When I wake depends on my daughters, Satsuki and Miko. The first thing I do is open all the windows to clear what we call "chi" — a stagnant energy that has accumulated overnight.

Breakfast is cold fresh juice and perhaps toast or a Japanese-style breakfast, which would be steamed rice and miso soup. Before Satsuki was born I had heard that there would be mess, but I had no idea how much! My husband, Takumi, and I share all the childcare and chores, but it has been crazy. Miko is only five months, so she can't move, but Satsuki spreads her toys everywhere. It is a new experience and, at first, it was overwhelming. I just could not control it.

I was not an outgoing child. I lacked confidence and was inept at expressing my feelings. I would spend most of my time alone, tidying cupboards and drawers at home, even the mop cupboard at my school. I couldn't stop.

I was always upset by how mess escalated. I did not know about obsessive compulsive disorder, I just knew I was obsessed. I thought so much about it, I could not relax.

At some point, that changed. I feel much more in control now.

At lunchtime, I eat what my body tells me I need and it is often sushi with salmon. If I crave bread or a muffin, I have that.

It was years before I realised that tidying by room was a mistake. I sort by category and start with clothes, keeping only pieces that spark joy. I move onto books, papers, miscellaneous items and, finally, sentimental items.

The Japanese acquire a huge number of possessions. Many clients hold onto things believing they will "come in handy". Believe me, they never do. The average amount thrown out by someone using my method is 20 to 30 bin bags. For a family, it's double.

People's mess does not faze me, no matter how high the stacks of clothes and papers, but, five years ago, my waiting list was huge and I became exhausted. Now I focus on writing books and have a consultancy — KonMari.

I change my clothes every evening. By taking each item in my hands and folding it neatly like origami, I believe I am transferring positive energy. In Japan, we call this "te-ate" — literally, "to apply hands". I then sort the contents of my handbag, thanking it before storing it. This takes a total of five minutes. After, I go to the kitchen, make myself a cup of tea and relax.

Takumi is a great cook — pork chops with ginger and soya sauce is one of our favourites. We give the children a bath, eat dinner, then tuck them in. I have taught myself to block their mess out till they go to sleep, then I declutter everything into individual baskets: books, puzzles, stuffed toys... I always say everything has a home.

It is a Japanese custom to have a bath at night, to reset the body for sleep. I use sea salt for purification, then I do yoga stretches. I wear soft, organic cotton pyjamas, which make me happy, and I use aroma diffusers with scents such as kuromoji oil.

We do not have a TV and I have few interests outside tidying, so I will work a little on business emails before bed. Sometimes, as I lie there, I think how amazing it is that a simple method I came up with for having a tidy life has spread all around the world.

Interview by Caroline Scott

In 2015, Time magazine listed Marie Kondo as one of its 100 most influential people. In 2019 she launched a Netflix reality show called Tidying Up With Marie Kondo, and she now lives in Los Angeles.

WORDS OF WISDOM	BEST ADVICE I WAS GIVEN	ADVICE I'D GIVE	WHAT I WISH I'D KNOWN
	My grandmother would say to me to do everything with precision. It can be applied to everything	If you're ever unsure of what to do, choose the thing or action that sparks joy	If I'd known how hard it is to raise children, I would have communicated my appreciation much more to my parents

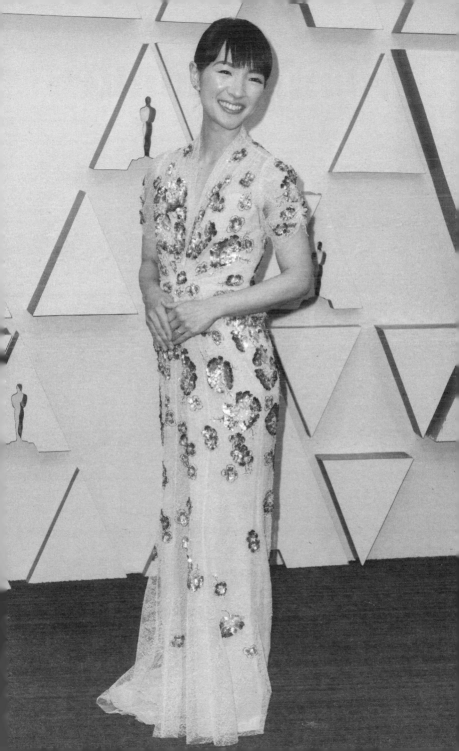

Joanna Lumley

APRIL 3, 2016

The actress, campaigner and former model on growing old, dealing with bullies and the key to a good marriage. Joanna Lumley, 69, was born in India, where her father served in the 6th Gurkha Rifles. She was educated at St Mary's Convent School in Hastings and the Lucie Clayton Finishing School in London. She has one son, Jamie, a photographer, and lives in south London with her husband, the conductor Stephen Barlow.

> I wake up at 6.30am and I'll have a coffee to start the day. Then it's either yogurt and honey or a tangerine. And, just for the record, I never exercise. I don't have the time or the slightest inclination.

Next, I'll put on my make-up — I like to be selfie-ready. It's discourteous to look tatty. People want a photo with Patsy or Purdey [characters she played], not a scowling old bat. They also want me to drive a Ferrari and have the Clooneys round for dinner.

Of course, it's terribly important to step back from your life and realise what fun all this is, because it's all bollocks, isn't it? I shop in Tesco and get the Tube like everyone else.

If you want to be happy, you have to work out how to be content, especially when things are messy or dull or hideous. How? Discipline. If you have a husband you adore, as I do, make things nice. Have coffee in a pretty cup, put milk in a lovely jug. It's self-taught mindfulness; I learnt it as a model, standing up to my waist in the Serpentine with someone shouting: "Look warmer!" Only you can do that.

Lunch makes me tired, so I often miss it. I've had one cigarette today, but I could easily smoke 40. If you have low blood pressure, as I do, you need salt, caffeine and nicotine. In other words, a packet of crisps, a cup of coffee and a smoke. If you want alcohol, nip that down too.

I'd happily wear black trousers and a plain top every day, but I often have to dress in a way that isn't me — I don't wear gorgeous, glittery clothes, but Joanna Lumley does. But I do think appearance is

important. Luckily, I love getting older: you're less fearful and you just do the best you can. This idea that you can deceive people into thinking you're younger is mad. I'm an old woman with f****** grandmother hands!

Of course, I love Patsy, I adore her, but she's not me. Pats lives like a succubus on Edina: good or bad, those two disgusting women are bestest friends and people love it. I've always loved men, because they're so straightforward, but my mother taught me how to deal with life ... how to be kind, how to make sure no one bullies you. No one would dare bully me. The second I see unkindness, I barge in.

Our house is crammed with things: books, paintings, stuff relating to my different interests — the Gurkhas, the Garden Bridge, Oxfam ... I support 80 charities, many of which empower women. I absolutely love making money — darling, you know I'm rich. I give as much as I can away, but the second I've got rid of it, more comes crashing in. It's fabulous.

I became vegetarian long ago, and in the evening I have green soup or red soup. Green soup's anything green in the fridge, thrown in a pan and cooked; red soup's the same, only red. Stevie and I might eat together, but there is no pattern: he's at a concert in Birmingham, I'm having dinner with the Duke of Edinburgh at Frogmore House — we're like ships. And messages between the ships are always good, because we never get bored with each other.

Having said that, if I'm away on a long trip, I won't phone him once. What do you say? "Hello darling, you all right?" What's that about? And my son, well, he'd go mad if I called him every day.

I have a bath at night and then Stevie and I talk like mad in bed; sometimes we'll read out bits from books. We couldn't be more different, but I admire him and he admires me, and I think that's as good as it gets.

Interview by Caroline Scott

As well as campaigning for the Gurkhas, Joanna Lumley supports Survival International, which defends the rights of indigenous and tribal people.

WORDS OF WISDOM	BEST ADVICE I WAS GIVEN	ADVICE I'D GIVE	WHAT I WISH I'D KNOWN
	Be punctual. If you're messy and scattergun and lazy, you're a bore to be with	It's important to be friendly. Kindness gets the best out of everybody	Women are like the goddess Kali. We can cook and rock a cradle and answer a phone. Men quite often can't

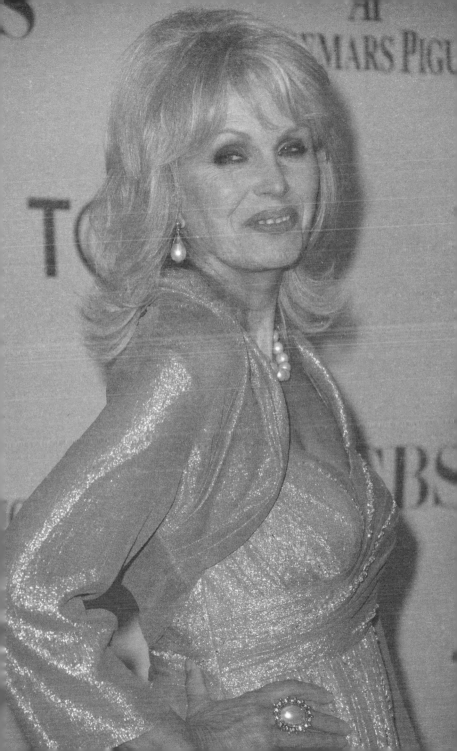

John Lydon

SEPTEMBER 20, 2015

The former Sex Pistol, 59, talks about sausages, impulsive shopping and turning his back on England.

I always sleep without blankets or pyjamas. It means I wake up as soon as I feel a chill, which is usually about 6am. When I was a kid, my dad would wake me up at the crack of dawn with the sound of the Hoover. He loved being up early. It annoyed the hell out of me, but now I love everything about the morning — the crisp quietness, the sun coming up. They say we all turn into our parents. I've definitely turned into mine.

Home is a house on the beach in Venice, Los Angeles. My wife, Nora [the German publishing heiress Nora Forster, 73], will stay in bed a bit longer, so I put on the TV in the kitchen and have CNN clattering in the background. I'm addicted to PG Tips, and am happy to say it's widely available in LA. Breakfast is Heinz baked beans, sausages and a cigarette. The constant nagging of my brain irritates me, but a ciggie seems to calm me down. I'm a Marlboro man. If I'm going to shove a nail in my coffin, I might as well make it a proper one.

Exercise doesn't agree with me. I've got a curved spine, I get constant headaches and my sinuses are shot. We've got a 12ft-deep pool at the back of the house, and being in that is all the exercise I need. I swim underwater and lie on the bottom for as long as possible. I don't need a shower, 'cos the chlorine kills all manner of nasty things living on my body. And f*** deodorant! I prefer to sweat, thank you very much.

I mess about with my hair a lot, though. Bleach, dye, gel… I'm trying to get it to stand up like a paintbrush, but the humidity makes it floppy. Nora says my hairstyle makes me look like a gay turnip, but I think it goes well with my $10 thrift-shop shorts and wifebeater vest. I rarely wear socks. I have a heel spur and it's bastard painful. Kids' socks are the only ones I can tolerate. The tightness seems to hold the pain in.

We are near the ocean, so we decided to buy a boat — a 32ft cabin cruiser that's moored not far from the house. Who'd have

thought it? An ugly, working-class git from north London, living the Californian dream. I'm really into all the GPS and the boat gadgets. After breakfast, we love sailing miles away from the shore and turning the engine off.

I don't usually bother with lunch. If there's a spare sausage at breakfast, I stick it in my pocket and gnaw on it while I'm watching out for big waves. Me and Nora have been together since the Pistols days, and we are tight; we love a good argument and we understand each other. Just me and her is how I like it. Her grandkids came to live with us a few years ago and it was hell. You've got to pity them, having me as their father figure.

I might do a bit of shopping in the afternoon, but I don't drive, so I have to rely on Nora coming with me. I drive like a grandma, which doesn't go down well in LA. I'm a Fatal Attraction shopper: I want that, that, that and that, and I don't care what it costs. I don't even look at the price. I've wasted a huge amount of money on stuff that doesn't even fit me.

Over the years I've acquired British, Irish and American passports, but, as of this year, I've become an American citizen and I'll be voting in the elections. America's been good to me.

I don't get the open hatred and hostility that I still get in parts of England. I love the place, but there is always somebody in England trying to pull me back into the crab barrel.

Yes, I still keep an eye on the news over there. Things about it still make me angry. A lot of hypocrisy and stupidity, but that's the same anywhere. Like Russell Brand telling people not to vote. Silly man! Soon changed his mind, didn't he? Go back 100 years and most of us wouldn't have even had a f****** vote. How dare he tell people to throw that away!

Nightclubs and going out to restaurants finished years ago. We come home in the evening, sit and watch the ocean for a bit, maybe have a couple of beers. I used to get through several crates of lager, but I don't need as much now. And I'm not bad in the kitchen. No celebrity-chef bollocks, but I make a decent scrambled eggs with chives.

After that I might put a bit of reggae on the turntable, no TV or DVDs. Or maybe I'll read. I love books about musicians; I always wonder if they went through the same stuff that I did. By about 10pm, I'm ready for bed. Sleep is difficult. I have this constant fear that I'll wake up with no memory, which is what happened when I got meningitis as a kid. It took me four years to get it back.

There have been times when I'm lying there and I'm convinced I'm depressed — losing both parents hit me hard — but I really have no right to be unhappy. Oh, no, it almost sounded like I was heading towards self-pity, there. F*** that! Never wallow in self-pity…it only arms your enemies.

Interview by Danny Scott

In an interview with The Sunday Times in 2021, John Lydon said he had become a full-time carer to his wife, who has Alzheimer's. He described the illness as a "wicked, debilitating process", but said they were "going through that together…She forgets everything but not me".

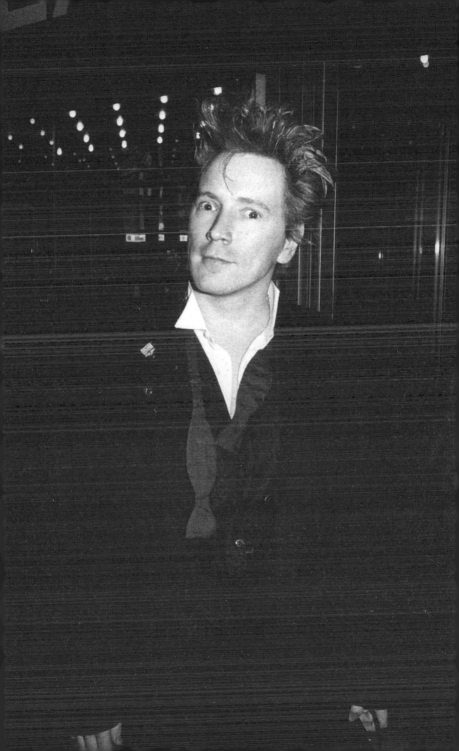

Vera Lynn

AUGUST 4, 2019

Dame Vera Lynn, 102, was born in East Ham, London. She made her name singing the wartime classic We'll Meet Again in 1939 and performing for the troops, for which she became known as "the forces' sweetheart". In 1952 she became the first British artist to top the US charts with Auf Wiederseh'n, Sweetheart, and in 2009, aged 92, became the oldest living artist to have a No 1 album in the UK. She lives in Sussex with her daughter, Virginia, and son-in-law, Tom.

 I might be of a certain vintage, but every morning when I get up around 8.30am I look forward to the day ahead. I've always been a glass-half-full person, and still am. When I was born [in 1917], King George V was on the throne, Lloyd George was prime minister, the Great War was still raging and women hadn't even got the vote.

I never thought I'd live to such a grand old age, and driving through the darkened streets of London in the Blitz, when bombs were falling all around, I sometimes wondered whether I'd make it through the war. I was one of the lucky ones. I've also been blessed with good genes: my dear brother, Roger, died on the eve of his 103rd birthday.

After doing my morning stretches, I'll have cereal, toast and a cup of tea for breakfast before adjourning to the living room. It looks out onto our lovely back garden with its still-green lawn, swimming pool and brightly coloured flowers. I love to breathe in the sights and sounds of nature: the little things in life give you so much pleasure in your later years.

Time is a funny thing and I sometimes find it hard to believe that it was really me who topped the charts all those years ago with We'll Meet Again, became the forces' sweetheart — though I never thought myself particularly good-looking — and travelled to the mosquito-infested jungles of Burma to entertain the troops fighting the Japanese. Was I really that brave? I wonder.

Then I look around at all the mementoes of my life dotted around the room: the pictures of my late musician husband, Harry

[who died in 1998], the honorary Burma Star I was awarded and the photographs of the Queen Mother and me — and it all comes flooding back. I remember our simple, 1941 wartime wedding, the way my lipstick ran in the tropical heat, and the jokes that Her Majesty and I shared at events we attended together. Having lived through the war, we formed a special bond.

I've never had a big appetite, as you can see from my slender figure in old photographs, and I usually have a light lunch. In the summer I'll have cheese and crackers, and in the winter a homemade soup.

In the afternoon I might relax by watching Antiques Roadshow or a whodunnit like Midsomer Murders or Agatha Raisin [a comedy drama] or a repeat of [Inspector] Morse. I've always loved a good murder-mystery. One of the day's highlights is afternoon tea with Virginia, Tom, any visiting friends and our cheeky little Jack Russell terrier, Digby, who likes lemon drizzle cake almost as much as I do. "Sit," I tell him, and he waits patiently until he gets his ration.

The three of us usually sit down for dinner at about 7.30pm. I cut out meat from my diet several years ago, but still love the occasional Dover sole. The one thing I miss is a glass of bubbly, but that had to go — doctor's orders. Occasionally we'll play music in the evening, perhaps even some of my old hits. I gave up performing publicly some years ago — every singer needs to know when to bow out gracefully — but I'll still hum along. When you've been a singer all your life, your love of music never dies. I'm usually tucked up in bed by 10.30pm and very often drift off thinking about Harry. I still miss him, even after all these years.

Interview by York Membery

Dame Vera Lynn died peacefully, surrounded by close relatives, in June 2020. She was 103.

WORDS OF WISDOM	BEST ADVICE I WAS GIVEN	ADVICE I'D GIVE	WHAT I WISH I'D KNOWN
	I can't remember anyone giving me any good advice!	Stick to your guns	That it sometimes pays to ignore the advice you're given

Charlie Mackesy

MAY 3, 2020

T he bestselling author and illustrator on how his characters are giving comfort to the NHS. Charlie Mackesy, 56, was born in Northumberland. He dropped out of university and, although he had never been to art school, landed a job as a cartoonist at The Spectator. He went on to work as an illustrator for Oxford University Press and to exhibit at galleries in New York, Edinburgh and London. Last year he published his first book, The Boy, the Mole, the Fox and the Horse. It still tops The Sunday Times bestseller list and has sold more than 1 million copies. He lives in Brixton, south London, with his dog, Barney.

 What time I wake up depends on how noisy the birds are outside or how insistent Barney, my dachshund, is about his need for a pee in the garden. If I'm lucky it's 8am, but usually more like 6am. I never set an alarm. The other day I woke to find a robin watching me from my bedside table. I've no idea how it got in but it seemed very relaxed about life.

My ideal day would be drawing and drinking tea. I've lived in my house in Brixton for 20 years. Since the publication of my book I've been quite busy. I've had to get a diary for the first time.

I normally go to bed in the clothes I was wearing the night before — maybe without my jeans — so getting dressed only takes a second. I go out to the garden and chuck out handfuls of sunflower seeds for the birds.

Drawing is my addiction. I can lose myself for hours in my studio. The book came about after I began posting the boy and his animal friends on Instagram, more than two years ago. People liked them and I got thousands of new followers. Around the drawings

are short conversations centred on the boy's questions about life and feelings. Their world is tender and without guile, where being honest and vulnerable is a strength. I'm terrible at small talk; you don't connect with people by being tough and pretending. We're all struggling through.

During the [coronavirus] pandemic the NHS has put up my drawings on their internal email system. I get messages from doctors and nurses telling me they have put them up in wards and staff rooms. I can honestly say this is the greatest privilege I've ever had. I am drawing lots at the moment, specifically for the NHS, but they are also taking pictures from the book, particularly one of the boy asking: "What's the best thing you have learnt about storms?" The horse replies: "That they end."

Sometimes it takes 50 attempts to get a picture right — the ink lines have to convey the emotion in the words, through the angle of a head or the swish of a tail. My studio is covered in rejects; you can't see the floor for the paper.

I find the idea of three structured meals a day alarming. Lunch might be soup or fried tomatoes and broccoli with garlic. I'm always disappointed by the sea of emptiness in my fridge — a bag of ancient goji berries and a bottle of stout at the moment — but it doesn't stop me checking several times a day in case some nice food has magically got in there.

Then it's back to my studio. It's important to face the blank page and start making marks. I also like to do cartoons based on things I've overheard: "I can't get over your new house, Marjorie." will have me sketching someone trying to clamber over a building.

Before lockdown I might have met a friend for something to eat in the evening. I've never had a dinner party. Sometimes I get a ridiculous amount of sushi delivered, which feels ostentatious.

I love a long bath. I might stay in for more than an hour with Radio 4 on the waterproof radio, prodding it with my toe while trying to make sense of that day. I sleep restlessly and keep a notebook by my bed to jot things down for those 3am awakenings. My sheets are covered in ink.

I can't think of a more moving thing to see than my marks on paper giving encouragement to people taking such risks for us all. What more can you ask of a career than being able to do that?

Interview by Caroline Hutton

Charlie Mackesy's book The Boy, the Mole, the Fox and the Horse was still riding high in The Sunday Times Bestsellers list in mid-2021. He now has more than a million followers on Instagram.

WORDS OF WISDOM	BEST ADVICE I WAS GIVEN	ADVICE I'D GIVE	WHAT I WISH I'D KNOWN
	Be kind	Be kind	I'm enough

Nelson Mandela

OCTOBER 13, 2002

Nelson Mandela, 84, who spent 27 years in prison for treason, was South Africa's president from 1994 to 1999. He lives in Johannesburg. His third wife is the worldwide literacy campaigner, Graca Machel.

The only thing I am scared of is waking up one day and not knowing what to do with the day. That would kill me. I wake at 4.30 every morning – after more than two decades of the same routine in prison, it is difficult to change your body clock.

The first thing I do is make my bed. I breakfast at 7am and read the newspaper. I left my village in April 1941, but it has not left me – I take a simple breakfast of hot porridge, with nuts and hot milk, then slices of kiwi fruit and banana. I feel my age only in the sense that I can no longer run around. But I use the treadmill daily.

Before I went to jail I used to be very particular about my clothes. All these colourful shirts I wear are gifts, especially from Indonesia. I don't like to tie myself up with ties and waistcoats. I argue with my wife when there are state occasions. She says: "Please put on a suit." I say to her: "What would you say to the president of Nigeria, then?"

My secretary, Zelda, decides my schedule. I am a stickler for punctuality – not only because it's a sign of respect to the person you are meeting, but in order to combat the Western stereotype of Africans being late. My appointments – I may have eight a day – range from summits in Barcelona, visiting the Lockerbie bomb victims' families, taking tea with Arnold Schwarzenegger or visiting squatter camps here in South Africa.

When I visit schools I love to sing Twinkle, Twinkle, Little Star, because it's about wishes and making dreams come true.

I always break for lunch, but I think if you are stimulated by what you do, you never get tired. I like vegetables very much, and salad. And beans. Now and again meat and fish. I do drink wine, although I'm a bit uncultivated, as I can only drink sweet wine.

In 1983, after I was transferred from Robben Island to Pollsmoor Prison in Cape Town, I was allowed to see my wife without glass separating us. I kissed and held her. I'd dreamt about this moment a thousand times. We were silent except for the sounds of our hearts. It had been 21 years since I'd touched her hand. Later, of course, we separated. It seems the destiny of freedom fighters to have unstable personal lives.

Am I romantic? Especially in my younger days, I did believe in love. You see, my father was a polygamist. He had four wives. I think you can meet your soul mate at any age. I'm married to a lovely lady now and I've never thought of anyone else. Graca is my life. She lives in her own country, Mozambique, but she comes to see me and I go to see her. When we are not together we speak to each other twice a day.

I try resting after lunch. In jail they thought we were so dangerous they watched us even when we slept. So we got used to napping under any conditions. I have felt fear more times than I can remember, but I hide it behind a mask of boldness. I go to bed at 9pm. If you are miserable, you will have horror stories in your dreams. But I am always positive.

In my autobiography I wrote that the secret after climbing a great hill is that one finds there are many more to climb. I can rest only for a moment; with freedom comes responsibilities. And I dare not linger for my long walk has not yet ended.

Interview by Marcelle Katz

Nelson Mandela died in December 2013, aged 95. During 10 days of commemoration, international leaders around the world paid tribute to the man who had fought apartheid, and tens of thousands of South Africans queued to pay their respects as his coffin lay in state.

Paul McCartney

FEBRUARY 5, 2012

The former Beatle, 69, on 50 years of fame, breakfast with Nancy and having fun with his eight-year-old daughter, Beatrice.

❝ If there is such a thing as a typical day, it might start in the local gym. I'll spend an hour or so splitting the time between running on a treadmill, stretching, or lifting what I'd once have called "girls' weights", but I wouldn't now because that's sexist. And I'm not telling you how much they weigh; let's just say they are not challenging. I'll end with a headstand. After 50 years I'm still performing on stage — playing and singing pretty much nonstop for three hours at a time — and I've realised I've got to keep fit, keep going, because I am getting older.

My wife, Nancy, tends to prepare breakfast. She makes a mean cereal, you know … not granola, but it's healthy enough. Then it's down to work, one way or another, preparing, recording … I'm not a workaholic, but I do have a strong work ethic. When we were in the Beatles, I was the one who always wanted to make a record. I had fewer distractions than the others, as they were all married and bringing up kids in the suburbs. I was single — well, for most of the time, before I married Linda — and living in the city, going to exhibitions, concerts and stuff. So it would be me ringing up, saying: "Come on, guys, time we made a record."

The work ethic hasn't changed but other things have made a difference to the pattern of my life. The main thing is that after my divorce I have a joint-custody arrangement. I'm luckier than many divorced fathers because I have half the time with my

youngest, Beatrice. I had a word with my promoter, and said: "From now on I'm only going to be able to work here, here and here." So instead of long, gruelling tours we do more hand-picked events. And that means the dates can actually be more enjoyable, and we're always hungry to play. I much prefer it. You'll have a little time to look around the place, too. We were in Bologna not long ago and it was really nice to be able to see a city I didn't know. I'm sometimes bothered by people when I'm out, but there are places where I can just melt away. I made a decision long ago, when the Beatles thing was clearly building. I said to myself: "Look, you either give up now or you keep going and you just better get used to it." So I've learnt to live with it.

It's great having a small child again. I've always loved children. I have five kids and eight grandchildren — all very Italian. I often do the school run. I gossip with the mums at the school — and dads as well, by the way. Quite a few come these days. At school I'm just another dad. When I first went there, the head said: "Let's just see if you can blend in." In the playground I don't talk like I'm a big shot. I talk about the next school trip, or homework, or the next swimming gala. People aren't stupid, they get it.

In the studio I'll probably start about 11am. I've always preferred recording during the day. For the new album I worked with the producer Tommy Lipuma at Capitol Studios in LA. We had these lesser-known songs and we kept it intimate, a small jazz-combo thing. The album took about two months to record. On an office day I'll get in about midday, probably start with my PA, then have meetings. It could be with the guys from Apple, the Beatles organisation, bringing me up to date on Beatles projects. It might be to do with charity work. I do get lots of letters and requests for autographs. My PA suggests things I might do, and it all gets selected down.

I don't really use email or the internet. I prefer to travel light, so I have a slim mobile phone, and I can text, make phone calls and send photographs. All I use a computer for is music. Otherwise I tend to avoid it. I'd rather walk in the real world than look at the countryside in a virtual world. In my studio I use an Apple Mac for composing orchestral music. It's quite a nice thing, with a big screen, and I use a program — very simple — called Cubase. It's addictive; I can sit there for hours. For writing songs, I use my old method — just a guitar with a pencil and paper. I try and get away from people a little bit, to a space where I'm kind of on my own. A

few hours thrashing at it, then I just give in, and I've either won or lost. If I've lost, I'll attack it another day. There's always another day.

In the evenings, Nancy and I might go to the theatre and to dinner with relatives or friends, or we might stay home and watch TV. My evenings are pretty much the same as anyone's. I go to bed around midnight. I've always slept well — and no, I don't wake up the next morning thinking how famous I am. I wake up feeling extremely ordinary. Then I hit the high street and I'm reminded I am not.

Interview by Mark Edmonds

Still making music as he approaches his 80s, Sir Paul McCartney recounts his life story in a new book through the words of more than 150 of his songs spanning his long career. The Lyrics: 1956 to the Present is due to be published in 2021.

Malcolm McLaren

SEPTEMBER 23, 1984

The creative entrepreneur Malcolm McLaren, 37, lived up to his motto, 'Cash from chaos', in his work with the designer Vivienne Westwood and the Sex Pistols. He lives alone in London and New York.

"The first thing I do when I wake up is make a phone call and find out what's happening everywhere. I might sit in bed for two hours talking to friends on the phone, then toddle off to the bath and then rush out and have lunch. I don't get up early. I'd like to, but it's normally late-ish. I don't really eat breakfast.

The reason it takes me two hours to get out of the house is because I never know what to wear. I like new things all the time. I can't wear anything old. I get bored very fast so I buy things and end up never wearing them.

I buy my clothes, or I get them given to me, and sometimes I make them, though less than I used to. I go on mad clothes sprees. I'm a brilliant consumer. When I go into a shop I'm the world's best customer because I buy everything. Someone says, "Take the scarf, it goes with the jacket", so I take it all. I'm a sucker for that. But I love the buying – I get excited on the spot. I don't go to regular shops: I go to hot spots like anyone else, whether it's South Molton Street or an army surplus store or a private tailor who's cooking. I buy fast, on impulse, because at the same time I'm very shy so I buy it all quick so I can get out of the shop. Then when I get home I'm not so sure. It's a very expensive habit. I don't buy regularly but in spurts – I might spend £1,000, maybe more, sometimes I've spent £3,000 quite easily.

I don't really change my image much. I look the same to most people as I did 10 years ago. But I like to change the air around me a bit, freshen things up, get a different mood going. If I was wearing the same things I was four years ago, I'd feel like I did then. Like leather's gone, over, finished.

I'm a fashion designer by virtue of my upbringing. My parents were fashion manufacturers in the East End. My grandfather was a tailor and my grandmother, who really brought me up, hated it all. She was a brilliant story-teller, one of those women who was never allowed to be an actress, and she was married to a tailor and regretted it. So I was someone she was gingering up to do something else.

I've just finished making my opera album. The fact that I don't play anything and I don't sing is really very funny. So I'm making a record and everyone else is doing the work. I don't have a group; what I do is cast. I take people off the street and throw them in a recording studio and come out with a record. It's easier to do that in America than in Britain where people are more uptight, musicians are very frigid and precious about their position. In America people don't care; they'll do anything for money and as music is such a mercenary, vulgar business, that's the best place to execute it.

I got into opera about a year and a half ago, inspired by the mood. It's one of the last places in music to pirate and plagiarise. Because that's what pop music is, it's all about pirating ideas. I don't listen to music much. I don't like music much. In fact, I can't stand musicians – they're very coarse types. Actually being in a recording studio is the most boring thing on Earth, but I do it. Back in the Seventies I got on a certain boat and managed groups and finally decided that was boring and I'd rather do the bloody records myself, so I got involved in recording. I suppose if I'm casting characters I might as well go the whole way and make films.

The only thing I'd say was regular in my life is that I live in Bloomsbury. It's the sanest place to live in London: streets full of bookshops which don't annoy you. I like the sanity of Bloomsbury and the fact that it's classless. I like the British Museum plonked in the middle of it; it typifies the whole idea of England being a marvellous research tunnel and I live next door to the biggest bit. I go in quite regularly, but sometimes it's enough to stand there and watch all the tourists going in and then I walk round the corner to my office in Denmark Street and Tin Pan Alley and my business. I'm a great walker of Soho.

At night I'm always out on the street. I finish work – at the office or the studio – at six, sometimes seven or eight o'clock. Work drifts over into a bar or it goes down into Soho.

Pubs are OK but they're very claustrophobic these days and you can't conduct my sort of business in a pub. That's one of the intolerable things about London.

Seven to 11 o'clock is the biggest problem of your life in this town: that's why restaurants are so packed. It's not bad from 11pm to 2am depending on the night of the week. I go to clubs because I can't go home. It's too boring. I chop and change with clubs a lot. The whole of London street life does that. You can't go to the same club more than once a week; people take club venues in London and create an event on a particular night so you go from night to night, you move around. I'm never usually home until after midnight. Maybe I'm up for two hours; I might work.

The most private thing I do is to go off on my own and design a collection of clothes. On my own, just drawing. I've got this room that no one knows in the backwaters of King's Cross; a little cabin-in-the-sky job at the top of a warehouse, with drunks outside and iron railings. It's a tiny little room with a little sewing machine and a cutting table and I draw away and create things. I might call someone in New York and then I sleep.

Before I go to sleep I have the opera on. Not any big opera. Puccini's Greatest Hits is my favourite now; narrow it all down and get the juice! I've got this old Decca £1.99 job and I listen to Madam Butterfly. Just brilliant.

Interview by Hannah Charlton

As well as promoting punk rock and many other artistic ventures, Malcolm McLaren stood as a candidate for mayor of London in 2000 (he was unsuccessful). He passed away from cancer in 2010, aged 64. His coffin was spray-painted with the words "Too fast to live, too young to die."

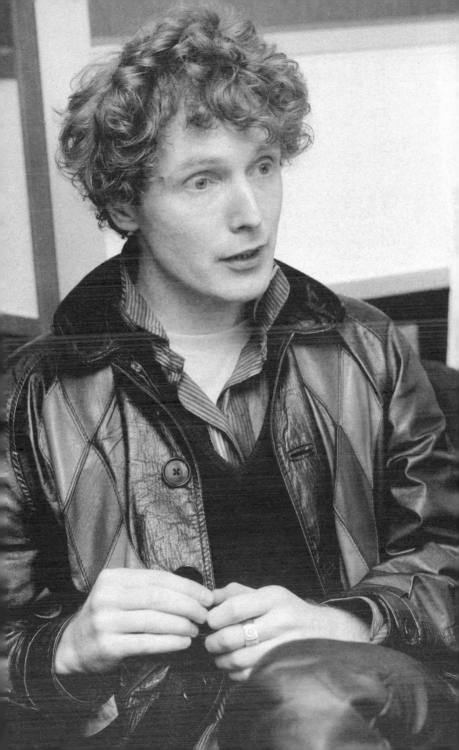

Helen Mirren

MARCH 19, 1989

Helen Mirren, 41, was brought up in Surbiton and educated at a convent. She began her theatrical career when still at teacher training college, playing Cleopatra in Anthony and Cleopatra with the National Youth Theatre at the Old Vic. Since then she has been an accomplished actress both on the stage and in films. Her latest movie is Pascali's Island; next she will star opposite Michael Gambon in The Cook, The Thief, His Wife and Her Lover, directed by Peter Greenaway. She lives for half of the year in Los Angeles with her long-term companion Taylor Hackford, the film director, the other half in a flat which overlooks Battersea Park in London.

 I always set the alarm for an hour before I need to get up. If my chap is here, we make love. If he's not here, but around, then at some other time during the day. It's part of one's life. Then, half-dozing, half awake, I reconstruct my dreams and try to analyse them. Some are good while others are profoundly disturbing. But I love returning to such incredible adventures.

When I'm rehearsing I have frantic bouts of activity. If I'm not, I'm totally idle. Sometimes I spend as much as three hours at a stretch just getting up. I have a bath, wash my hair, curl it, paint my toe-nails. Anything. I do suffer from niggling guilt and I often feel that I should be doing something, but it's never enough to stop me from feeling languorous. When I'm rehearsing flat out, I'm crazed.

I don't eat breakfast. I drink a king-sized cup of tea. I love it with a dash of long-life milk but no sugar. I take it back to bed. Once downed, I get up and shower. I have one with a heavy duty head which I had installed, one which makes me get up and go. It's something I learned to appreciate in LA. As I'm always running late and leave everything until the last minute, this means I'm normally in a terrific rush. I read a newspaper sometimes. It's usually *The Guardian*, but I don't have it delivered. To save time, while I'm dressing, I go through my words aided by a tape recorder with the voices of other members of the cast – in *Two-Way Mirror* it was just

Bob Peck – this way leaves room on the tape for me to speak my lines. It's immensely helpful, and it enables me to swan around and do the housework while I go through my part. Usually, I'm a good study, and I don't have to concentrate so much on my lines as I do on interpretation. I was walking to work a few weeks ago with earphones clamped to my head answering the tape. There is a slice of very vulgar dialogue which goes a bit like this : "You f... ing liar, you whore, you sh..., you f... ing bitch." When I looked up I found people were staring at me. I realised that they thought I was loony, but as it happened around Waterloo, I felt that they'd probably heard it before.

I don't have time to get back to my flat during the lunchtime break, so I have a bite to eat wherever I happen to be, something easily digestible; a sandwich or some hot soup. The real therapy is just walking around looking at the stuff in the shops. I'm dotty about shopping. I can spend over half an hour in somewhere like Boots just comparing sweeteners, trying on shoes, picking over underwear. When I was at the Young Vic, I haunted The Cut. I know that it's silly, but when she's not playing bridge, my mother loves shopping too.

Basically, I adore eating. At night after a show I'll pig out on something like bubble and squeak. I've just gorged on a plate of potatoes and broccoli. Luckily, my weight stays constant at around nine stone. Alone I go for simple food, but if Taylor is over here, we go to our favourite place, the Tandoori restaurant at the Oval.

I still think that it's a treat to go out to dinner though I don't think that I ventured into a proper restaurant until I was about 19. Naturally, along with the rest of my profession I was familiar with the greasy spoon caffs of this world. But I was far too timid to try something more adventurous.

When I get home I love to watch television. Over here it's superb. It's an important part of our British education and culture. In the States I don't switch on much as it's interrupted so often; 30 channels and nothing to watch. Even the ads are creative. I wouldn't mind doing one — the right one that is. I find watching it especially enjoyable when I'm alone here. I have tellys everywhere, in the sitting-room, the bathroom, in the bedroom, all over the place.

I like to read but I don't get a great deal of time. I can't do it when I'm on location, as I'm usually stuck waiting for my call in my caravan. But when I get back to some strange hotel, then I enjoy all kinds of books. At the moment, it's *Tolstoy* by Martine Courcel.

Strangely enough I'm hopeless at reading scripts. I used to skim but I have improved a lot since I started to work in America.

It's only when Taylor is over here that I rush around. Being an American, when he comes to town he's a tourist, so we dash about seeing things. We go to plays, dinner parties, and drink do's with close friends. When he's not, I don't get that lonely, really. I like spending time in this flat, it's so comfortable. A close girl-friend found it for me. I told her the approximate location I wanted and she set out and discovered it when I was away filming. It was exactly what I wanted, what I had imagined. After I got back I closed the deal, then she took over again and had it painted and decorated for me. When I returned again from LA, everything was shipshape apart from the tiling and the carpets.

Being pre-war, this roomy old place has fire grates in all the right places, and I'm thinking of having one of those gas-fired jobs in the bedroom. This flat is now so comfortable; I feel I'll be here until I'm 70.

Like most English people, I'm very stoical. It took me ages to install a washing machine, years to get a dishwasher, and years more to get a cleaner, though I could afford all three. Now I have both machines plus two ladies to whizz through the flat at a rate of knots. I found one doing the hallways and she recruited a friend. The other night I got home after the show and found the bed made-up, clean sheets and the washing up gone from the sink. It was heaven. I could have hugged them both. In LA I don't touch housework. I do nothing except gardening.

Recently, Taylor was filming in Louisiana for three months so then I did everything myself, I made dinner every night, went out with him and was all-round supportive. You might describe me as 'the little wife' but I loved it. One thing I did which you might say was an indulgence was to exercise in the gym every day for at least three hours. I did it until I burned; it really hurt. I didn't lose weight but I firmed up.

In America, I occasionally give dinner parties, and over here quite often. In Los Angeles I don't get caterers in like most American hostesses do: they give the most impressive parties. On the whole they are style-conscious, perhaps because they've no style of their own. I think the English are more relaxed about such things, more casual. The reason I like to do it, is it's the only way I can have fun; because I'm the hostess and it's my territory. People have to be nice

to me. I'm the Queen Bee. In LA Taylor's important – I suppose you might call him a mini mega-mogul. He's influential enough for people to elbow me aside to talk to him. It's so rude. They dismiss me as a nonentity. That's one reason why I like being here. Everyone recognises me.

When I get back at night, if I've eaten with friends, I clean off and go to bed. I can't wait to get a fire in the bedroom. In LA I insisted on one. I love the luxury of going to bed with the television on, and flames licking up the chimney.

Interview by Meriel McCooey

Among many awards, Dame Helen Mirren won an Oscar in 2007 as best leading actress for her role in The Queen; and in 2004 she was named "Naturist of the Year" by British Naturism. She has been married to Taylor Hackford since 1997.

Captain Tom Moore

DECEMBER 27, 2020

The centenarian fundraiser on testing time, raising millions of pounds and gaining at knighthood at 100. Captain Sir Tom Moore was born in West Yorkshire. He served with 9th Battalion the Duke of Wellington's Regiment during the Second World War and later became managing director of a concreting company. In April this year he began to walk around his garden, aiming to raise £1,000 for the NHS by his 100th birthday. He has now generated £39 million and was knighted by the Queen in July. He lives in Bedfordshire with his daughter Hannah, her husband, Colin, and their children, Benji, 16, and Georgia, 11.

I'm always up and dressed early. For the past 50 years I've enjoyed porridge for breakfast every day — I like it milky and sloppy and make it myself in the microwave. My father was a lovely man and we were great friends, but there was a point growing up when I realised he was entirely dependent on my mother; he couldn't even boil an egg. I thought: "Tom, you are never going to be dependent on anyone."

Until two years ago I cooked Sunday roast for the family, did the shopping and was fully occupied in the garden, driving the tractor and cutting the grass. Then I tripped over my own feet unloading the dishwasher and fractured my hip, and that was the end of it. The hardest thing was accepting there were things I'd never do again.

When I left hospital I ordered a treadmill off the internet to strengthen my muscles, but that was too painful so I decided to do some walking — first in my room, then up and down the drive, which felt a bit daunting. Colin said he'd give me £1 per lap and the

following day I had a renewed sense of purpose. I wondered if I could raise £100 for charity. Hannah set up a Just Giving page, but none of us imagined where it would lead. I think people wanted something to believe in.

You might say I was a late starter. My first marriage was unconsummated and why I put up with it for so long I don't know. My second wife, Pamela, suffered terribly from anxiety [she died in 2000]. Mental illness was hidden in my day; you didn't talk about it. So I've gone through some very dark times, but I knew things would get better. The moment we had Lucy [his eldest daughter, born when he was 48] and Hannah, my life got better and better. People often mistook me for their grandfather, but I wasn't offended. I did everything for them and they were the happiest days of my life.

I have my own rooms at home, but I'm never alone. We make our own meals in the same kitchen and there's always someone to talk to. After some soup I'll have a sleep. I read the paper from cover to cover, then watch the news. I'm very attached to my big-screen TV and I treated myself to a special Bluetooth gizmo that blasts the sound straight to my hearing aid.

I admire the Queen more than any living human being. Being knighted was the greatest joy and I'll never forget it. If truth be known, the world saw only 20 per cent of what happened to me this year. I had 225,000 birthday cards, 150,000 letters and 7,500 gifts, which keep coming, and millions of emails. Benji and Georgia willingly gave up their summer to help. It's been a true family effort.

I felt younger rather than older when my grandchildren were born. That's because I still remember what it feels like to be young. I cook my own dinner, always something mushy, and we eat together. Teenagers are not easy, but old people aren't easy either: the trick is to keep your mouth shut, even when you're right.

I don't know what 100 is meant to feel like, but I don't feel very old inside. I don't sleep well, but I'm sure it will get better because things generally do. I keep telling my grandchildren: the world is your oyster. Don't be afraid of opening it.

Interview by Caroline Scott

The Queen knighted Captain Tom Moore at Windsor Castle in July 2020. He died in February the following year, aged 100, after suffering from pneumonia and testing positive for Covid-19.

WORDS OF WISDOM	BEST ADVICE I WAS GIVEN	ADVICE I'D GIVE	WHAT I WISH I'D KNOWN
	Tell the truth, so you don't need to have a good memory	Be honest, keep a positive spirit and try to see the best in everyone	About the past, from my parents — when they are gone, you can't ask them

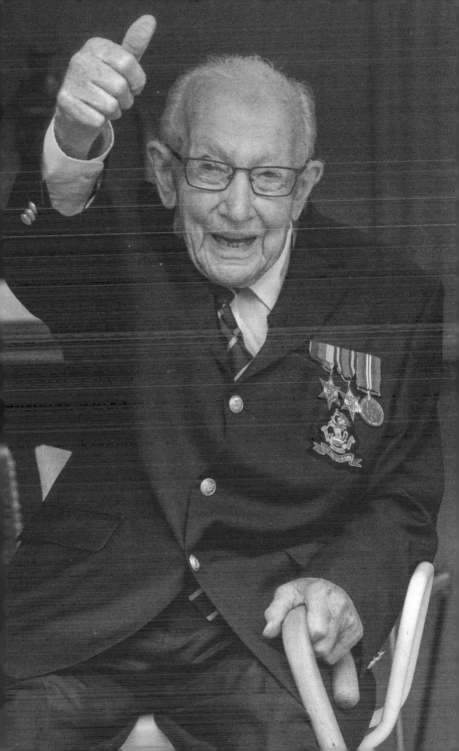

Olivia Newton-John

JULY 7, 2019

The singer and actress on her battle with cancer, and opting out of the Grease fantasy. Olivia Newton-John OBE, 70, has sold more than 100 million records, including her 1978 No 1 hit You're the One That I Want from the film Grease. Born in Cambridge, her family emigrated to Australia when she was six. After performing on talent shows, she signed her first record deal in 1966. She has a daughter, Chloe, from her first marriage, which ended in 1995. She has been married since 2008 to John Easterling, founder of the Amazon Herb Company, which sells plant-based remedies. They have homes in California and Florida.

66 There's a wonderful peace and quiet to early mornings. At our house in California we have chickens, miniature horses, a cat and a dog. Sorting out the animals around 6am is my favourite part of the day. It gives me time to catch up with the real me.

I usually exercise too, but I fractured my sacrum recently. This was part of the after-effects of the breast cancer I was supposed to have left behind in 1992. I had treatment and managed to get past 10 years, then 20. You think you've won, but it came back in 2013 and again in 2017.

My body seems to be getting stronger. I had a walking frame for a couple of months, then a cane. I'm able to walk around and swim now. Life knocks you down, but you have to get on with it. Without adversity, you don't realise what you're capable of.

I stick to a healthy diet — not too much meat. I always cook breakfast for John. We'll have waffles and eggs straight from

the hen house. John knows a lot about plant medicines, and he's introduced me to medicinal cannabis — it's helped wean me off the morphine I was taking for the pain after the sacrum incident. Opiates kill you; cannabis doesn't.

Although I'm semi-retired, I still do a lot of work with the Olivia Newton-John Cancer Wellness & Research Centre, the hospital I set up in Melbourne in 2008. Yes, I've enjoyed making records and films, but the hospital gave me a purpose in life. My dream is to defeat cancer in my lifetime.

If I go out for lunch, I can guarantee that someone will mention Grease. People still love it, even after 40 years. I'm going to auction off the jacket and trousers I wore in the film later this year, raising money for the hospital.

Somebody asked recently if the Grease story is still relevant today — shy girl becomes sexy because she wants to be popular. Oh, for goodness' sake, it's just a movie. I mean, the car takes off at the end! I'm not saying there isn't pressure on women to look a certain way. In this age of social media, there is a danger that women end up feeling like they need to be perfect all the time. But, as a woman, I can also choose not to buy into that. I don't read all the rumours or look at the pictures. Why would I want to fill my days with all that negativity?

It sounds like a cliché, but positivity works. Sure, there are days when I cry, but I also laugh a lot. My husband makes me laugh. My illness makes me laugh. You have to find the humour in every situation because it takes the edge off the pain and sadness.

I'm not the greatest chef in the world, but my dog has never complained! In the evening, I cook simple food. We watch TV, but we're not bingers. I always make time to call Chloe, who lives in Oregon. I meditate with my Buddhist friends and go to mass with my Catholic friends. I hope this doesn't sound too glib, but I have an open mind about belief systems. Isn't it crazy that we fight because of what we believe or how we choose to live? When I meet patients at the hospital or think about what I've been through, it really puts things into perspective. Can't we just respect our differences. Wouldn't that make life easier for everybody?

Interview by Danny Scott

The leather jacket and skin-tight black trousers worn by Olivia
Newton-John in the movie Grease sold at auction in November 2019
for $405,700 – more than twice the predicted price.

WORDS OF WISDOM	BEST ADVICE I WAS GIVEN	ADVICE I'D GIVE	WHAT I WISH I'D KNOWN
	Don't read your own press releases	No matter what life throws at you, never give up	That people would still ask me about the pink leggings in the Let's Get Physical video

Paddington Bear

SEPTEMBER 8, 1985

Paddington Bear, Peru's most famous expatriate, was christened in 1958 after the station near which his 'minder', Michael Bond, then lived. He describes his day, with help from Mr Bond.

I have an alarm clock set for 7.30 each morning. As soon as it has stopped ringing I get out of bed and draw the curtains. If it's raining outside I put on my Wellington boots and get back into bed for an extra five minutes, but if it's nice and sunny I start planning my day. Sometimes, if there isn't an 'R' in the month, I take a bath. Otherwise I have what Mrs Bird calls "a lick and a promise". Bears' fur goes soggy very easily, so I have to be careful.

For breakfast, I have a boiled egg followed by toast and marmalade. Mrs Bird always takes the top off the egg because it's a bit messy with paws. At weekends I sometimes have a sausage. I like home-made marmalade – the sort without any artificial preservatives. Some of the marmalade you buy in shops these days isn't worth preserving.

I also like chunks that are big enough to be used for other things. If there are any left over after breakfast I wrap them up and put them under my hat in case I have any emergency repairs to make during the day. Once, Mr Bond, who writes my memories, was giving a talk to some children in a library and one of them asked what I did with my old chunks. He said I used them to mark where I'd got to when I was reading a book. The librarian wasn't very pleased.

After breakfast I go into the kitchen to see what is happening and collect the morning shopping list from Mrs Bird.

Then I get my basket on wheels out from under the stairs and set off for the Portobello Road. Bears are good at shopping. They drive a hard bargain, so I often save money for the Browns: they met me when I first arrived at Paddington Station from Peru. Because I'm well known in the market and most of the traders let me squeeze the fruit and vegetables before buying, just like they do in Peru. They can still say it's untouched by hand. Being a bear has lots of advantages.

The Portobello Road has changed a lot since I first went to live with the Browns. There are more cars for one thing, and it isn't easy crossing the road, let alone finding anywhere to leave my shopping basket on wheels. Mrs Bird says I shall get a parking ticket one day.

There are a lot of strange people about these days. Some of them have funny coloured hair like a parrot's feathers. I tried dyeing my fur once, but it all came off on the pillow. Perhaps theirs does, too! I often wonder about things like that as I'm walking along.

Every day I call in at the baker's where I have a standing order for buns. Then I go and visit my friend, Mr Gruber. Mr Gruber keeps an antique shop in the Portobello Road and always has some hot cocoa ready for our elevenses. In the winter we have it on the horse-hair sofa at the back of his shop and in the summer we take two deck-chairs out on to the pavement so that we can sit and watch the world go by. I always look forward to my visits and I think Mr Gruber does, too.

When I get back home I have a snack and then I go upstairs to answer my mail. Often there are as many as 50 fan letters a week, mostly from America. A lot of the letters are addressed to me at 32 Windsor Gardens, but some people simply say 'Paddington Bear, London', on the envelope. One came from Australia the other day and all it said was 'Paddington Bear'. It's better than having a postal code.

If I have time, I send a postcard to my Aunt Lucy, who is in the home for Retired Bears in Lima, but I don't do it as often as I would like. It now costs 26p for the stamp alone.

I sometimes go on outings with Mr Gruber. He always makes things sound interesting. I expect it's because he was born in another country. Other people's countries are always more interesting. English people know more about Darkest Peru than I do. Every year lots of expeditions go there and they write to me asking for help. I usually send a contribution and a list of useful addresses in case they get stuck in the jungle. Darkest Peru must be full of English people raising their hats and saying, 'Buenos Dias'.

In the evening I have dinner with the Brown family. My favourite is stew with dumplings and jam. I also like steak and kidney pudding and roast joints, all the things the English are good at.

I went to France once and ate something called 'novel cuisine'. It didn't seem very novel to me. There wasn't very much of it and what there was kept falling off my knife. Mr Bond goes to France a lot because he is busy writing a series of detective books about a food inspector called Monsieur Pamplemousse. He says he has to do a lot of food-testing himself in order to make sure he's got his facts right. I think one day I may write a book set in a marmalade factory.

People sometimes ask if Mr Bond and I are alike. I don't think we are. I'm much shorter for a start. Also, he has *two* baths a day, which is not like me at all. He thinks I have a very good life. I have two birthdays a year, like the Queen. I have a few good friends, whom I see regularly. I don't want for anything and I don't have to worry where my next meal is coming from. Mr Bond says he wouldn't mind being a bear in his next life.

After dinner I usually watch television. I like quiz programmes because you learn a lot that way, except that by next morning I've usually forgotten what they were about.

After that I go upstairs and wind my alarm clock for the next day. Before I go to sleep I write up my scrap book and if I've been on any outings I stick the bus tickets in as well. I sleep very soundly and I never snore. I stayed awake one night to find out and I didn't do it even once!

Written by Michael Bond

Since the first Paddington Bear book appeared in 1958, more than 35 million copies of Paddington stories have been sold around the world. Two Hollywood movies have been made based on the character. Paddington's creator, Michael Bond, died in 2017.

Elliot Page

Life

(Known as Ellen Page at the time of this interview)

JUNE 30, 2019

Ellen Page, 32, shot to fame in the film Juno (2007), about a teenager who becomes pregnant accidentally. She has since starred in blockbuster films including X-Men and Inception. She publicly came out as gay in 2014, revealing how movie industry pressure to keep her sexuality hidden had affected her mental health. She lives in New York with her wife, Emma Portner, a dancer and choreographer, whom she married last year.

> I usually wake up at six — I just love the morning, I'm way more productive then. I have coffee, maybe with a touch of oat milk, read non-fiction, then take my dog for a walk. He's called Patters and is almost four. When I got him I assumed he was a terrier mix, then I gave him a DNA test — it turns out he's a small poodle crossed with a Chihuahua!

For breakfast, I eat toast, buckwheat or oatmeal. My wife and I live in a little two-bed apartment. We're high up in the building, so we have this really beautiful view. I absolutely love being married. And I love how my wife's mind works — I'm jealous of it, in a good way. When I'm away, I always have this sense of home. She fills my heart.

Acting sort of came out of nowhere when I was 10. I always liked drama class and school plays, but the idea that I could become an actress just wasn't a thing in my family. Then, when I was 15, I really started to love film, art, books. I became committed to making it happen. When Juno came out I went from mostly anonymous to not anonymous overnight. That is a very interesting thing to adjust to. It puts you in this place where you can get control, and it changes financial elements of your work, but it also came with a lot of things that weren't very healthy for me. But now I feel I'm falling in love with acting again because I'm comfortable in my own skin.

If I'm not working, I'll probably go to look at art or something. Lunch is normally salad or burritos. I've been a vegan since my late teens, mostly for environmental reasons, though I've sometimes shifted.

I was raised in Nova Scotia. It wasn't always easy [growing up gay there]. It was one of those situations where it wasn't really talked about a lot, and there was barely any visibility, and if there was, a lot of the time there would be negative energy. But it is extraordinarily beautiful, with people who are just so down to earth and real and special.

I wasn't educated about the history of marginalised people and I should have been. I remember maybe we talked about Harvey Milk [California's first openly gay elected official], but it was so limited. I think education is crucial to help get rid of queerphobia and transphobia. Children are hearing the heterosexist narrative from the first moment they even hear a narrative, and that's what I grew up with — Sleeping Beauty, for instance.

To say that at a certain age you basically can't know about LGBTQ people, or that they even exist, means you're demonising LGBTQ people. You're saying that something about us is wrong and incorrect. Here's the thing: any religious influence that has an anti-LGBTQ element leads to serious suffering. I've seen the pain it causes. Religion has been used to justify so many horrors — it can't be used to justify treating LGBTQ people as second-class citizens.

Because I wake so early, I tend to go to sleep around 10ish. One reason I talk about mental health is I think the stigma and pressure not to do so leads to it being much worse. I've been able to receive help, but the fact it's unobtainable for so many people makes me so upset. A lot of people struggle with anxiety — what a beautiful thing if we could talk to each other about our trauma.

Interview by Leaf Arbuthnot

In December 2020 Ellen Page (now Elliot Page) published an announcement that began: "Hi friends, I want to share with you that I am trans, my pronouns are he/they and my name is Elliot. I feel lucky to be writing this. To be here. To have arrived at this place in my life."

WORDS OF WISDOM	BEST ADVICE I WAS GIVEN	ADVICE I'D GIVE	WHAT I WISH I'D KNOWN
	I'm blanking ...	It sounds so clichéd, but absolutely love who you are	You don't need to believe the narratives that are being placed on your life

Dolly Parton

JUNE 10, 2001

Dolly Parton was born in Tennessee's Smoky Mountains, the fourth of 12 children, and rose to become a legendary country singer and actress. She lives in Nashville with her husband, Carl Dean.

I'm almost always up by 3am. I was born at three in the morning, so my mother says she thinks that's why. First thing, I go straight to the coffee pot. I've got to get my coffee going. I brush my teeth, brush my hair and just kind of get the morning out of my face.

If I have mail or birthday cards to send, I do my paperwork, but I've already put on something to cook. I still cook like the old country women back home: big pots of stuff like chicken and dumpling and roasts. Then I'll call my sisters or friends and go: "Do you want to come by and get some?" It's therapy for me. I keep a notepad, a tape recorder and a guitar close by, because while I cook, I think. You can tell what creative mood I'm in by how good my cooking is. If it's good, my songs are going to be good. It intermingles.

By my first cup of coffee I'm ready for anything. My husband will come staggering down. It takes him a few hours to get his head going. I wanna chat, and he'll say: "Just be quiet. You've had too much coffee."

I have to have a big breakfast. I don't like doughnuts and cookies and stuff like that – I like to make biscuits and fry sausages, eggs and grits. Anything rich and hearty. Of course, I have to put on a little make-up because I never know who's going to stop by. At least if my husband's running in and out of the house all day, he don't have to look at a tacky woman. But I'm not always totally done up.

I love wigs, but I don't usually wear them at home because my own hair is blonde and shoulder length. But wigs are handy because I don't like to fix my hair the way I like it to look – I don't like spending that kind of time under dryers. When I go out I just look at my shelves of wigs and say: "I think I'm in the mood for the short one today."

I travel with my junk. I'm very gypsy-minded and so free-spirited, and I think, well, what if I decided I wasn't going to come back? Period. For a year. Or never! I'm serious, I carry everything: my microwave, my coffee pot, my candles, my incense. I don't pack neat, either, I just cram it in. I must have my electric blanket, summer or winter. I'm just one of those people that has to feel cosy, even if I have it on low. Right in there now, in my little motel room, my bed's as warm as toast.

If I'm in Nashville, I go to the office a couple of times a week. I order lunch from one of the restaurants nearby. There's a place called Arnold's that makes soul food, and on Thursdays they have my favourite – chicken livers over rice with mashed potatoes, pinto beans and macaroni. I bring it up to the apartment next to my office. I can stretch that over two or three days if I'm working. Just heat it back up in my microwave.

I can honestly say that I enjoy all of my lives – travelling and being home. Some of my sisters are the best friends I have in the world, and I love spending time with my nieces and nephews. But the thing I love most is my songwriting. That's my personal time, when I feel closest to God, in a place I call the "God zone". Not that my songs are all that great, it's just that I feel close to that source, that thing that feeds me and guides me.

In the evenings, I love to read. Nothing is more relaxing to me than to get me a big jug of Kool-Aid or Coke, curl up under my electric blanket with a big bunch of pillows and just read and read. If I find a great book, I'll sometimes just stay up all night.

I don't watch much television. My husband does, but he's got his own end of the house and his den. He may beat me to bed or he may come later. We just kind of do our own thing, and I'll usually be asleep by 10pm. I wake up every three hours, even if it's just to pee or get a glass of milk. I don't require a lot of sleep, and the older I get, the earlier I seem to wanna get up. If I was a deadhead I don't think I'd have gotten near the stuff done in my life that I've accomplished.

Interview by Lauren St John

Dolly Parton released her debut studio album, Hello, I'm Dolly, in 1967, performed at Glastonbury in 2014 and released her 47th solo studio album, A Holly Dolly Christmas, in October 2020. The following month she told The Sunday Times: "I don't know why I'd ever want to stop … I'd rather wear out than rust out."

Luciano Pavarotti

SEPTEMBER 3, 1978

Luciano Pavarotti, 42, was born in Modena, Italy, and has sung in leading opera houses all around the globe. His only rival for the title of greatest operatic tenor in the world is Placido Domingo.

I've been sleeping completely naked with the window wide open – even in winter – ever since I saw a film in which Anthony Quinn lived happily in an igloo. My wife, who feels the cold, didn't like the idea of wearing nothing in bed, but when she noticed how warm I was she was convinced that it was a good idea. Early in my singing career I used to wrap up night and day, and I even went to bed with a scarf on. Yet I caught more colds than ever before. Now I wear causal, open-neck shirts even in London. It's great to feel comfortable.

When I'm on tour I make sure I get 12 hours' rest the night before a performance. I take no phone calls and wear ear plugs. When I wake I practise exercises at full volume for half an hour, which must be heard by many hotel guests. Still, it's never before nine o'clock.

I never have breakfast on tour or at home in Modena. I go for a short walk when I'm on tour and relax in the morning. For lunch before a performance I have roast beef or steak, both underdone. And a little wine. Then I sleep for 20 minutes to digest peacefully. Generally, I don't talk before a performance, but today is an exception.

I always tell the taxi driver that I'm late so that he'll hurry to the opera house. I arrive an hour and a half before a performance. I test my voice for five minutes – scales, arpeggios, a few exercises – then I

do my own make-up. It's not hard. For years I watched the experts, so now I can do it myself. It takes about half an hour at most. My beard hides weaknesses around the chin.

Do you see this (a large cushion belonging to the Savoy Hotel, London)? If I put this on my tummy you can see how much weight I have lost in a few months: 36½ kilos (about 80lb.) to be precise. I followed an old diet introduced 200 years ago into Italy from Holland. It's not a very punishing diet, but very effective. Of course I'm not supposed to eat sugar or fat or drink wine or spirits, but today I'm having a biscuit and sugar because I have a performance. Any weight I put on today won't stay for long because I lose four pounds during a performance from a combination of energy expended, the heat in the opera house, perspiring inside heavy costumes, and, of course, nerves.

I eat after a performance, never before. A salad without meat refreshes me, and if I can't get my local wine – Lambrusco, which sparkles and is drunk cold – I add ice and soda to Valpolicella or Chianti and imagine I'm at home in Italy.

The great Ferraris and Maseratis are made in my home town of Modena. They're fast and beautiful. But I don't have either. I drive a Mercedes. Not an automatic – have you ever seen an Italian without a gear stick? Automatic drive doesn't exist for Italians. I need a stick for I'm surrounded at home by women: my wife, three daughters, my sister, my wife's sister and two dogs.

I have a perfect life. I love my work. I travel. In Modena I visit the espresso bars and chat to friends I used to play football with. I used to be in Modena's soccer team till I took up singing at 19. My daughters are lovely. I miss my wife when I'm away, but a mother is needed at home.

I am away 40 days at a stretch, then stay home 15 days. I am faithful to my wife. Why not? I said this once on a live TV programme in New York. I suppose no-one believed me, but it is true.

It's hardly restful at home in Modena at present. I've just bought a 400-year-old villa which has 30, maybe 35, rooms. My voice has enabled me to buy it; my voice is paying for the reconstruction of it. No, I can't tell you how much the villa will cost, but I make a lot of money, although much of it goes in taxes and travelling expenses.

And now I must shut my mouth or else I shall not be able to sing well tonight at Covent Garden. I shall sleep for about 20 minutes and then gargle with Listerine before leaving for the Opera House.

Interview by Lailan Young

Luciano Pavarotti was divorced from his wife in 2000, after 35 years of marriage. His subsequent partner, Nicoletta Mantovani, 33, gave birth to their daughter, Alice, in 2003. Pavarotti found global fame in the 1990s and 2000s as one of "The Three Tenors", alongside Placido Domingo and Jose Carreras, who performed at several football World Cup Finals. He died in 2007.

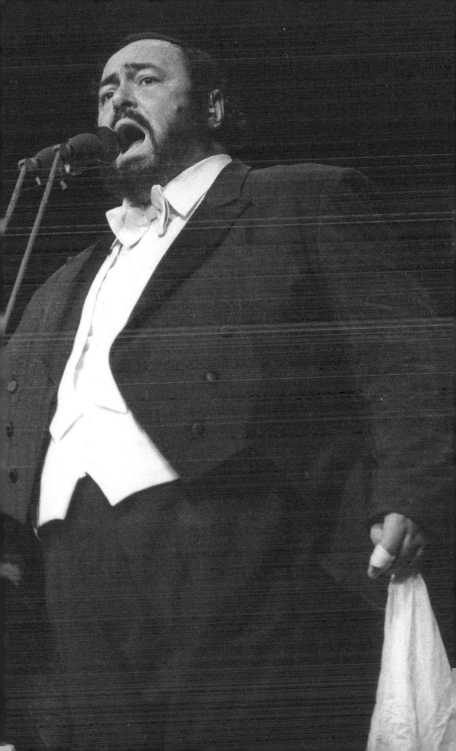

Zara Phillips

APRIL 19, 2015

The Queen's eldest granddaughter, 33, talks about marriage to Mike Tindall and getting fit for the next Olympics.

❝ My day begins at 7am when I get up and let out our puppy, Pepper, along with our two other dogs, Sway, a boxer, and Pepper's mum, a black labrador called Storm. She gave birth to six pups just before Christmas. We've found homes for five of them, but my husband, Mike [Tindall], couldn't resist keeping one for himself.

All three are named after female characters in adventure films — Halle Berry was Storm in X-Men, Angelina Jolie was Sway in Gone in 60 Seconds, and Gwyneth Paltrow was Pepper Potts, in the Iron Man movies. I expect when my daughter, Mia, grows up she will think the puppy was named after her favourite cartoon character, Peppa Pig.

We live at Gatcombe Park in the Cotswolds, next to my mother's [Anne, the Princess Royal] house, where the horses are based. We moved here from Cheltenham two years ago, to a cottage right next to the stables.

Mia has only just turned one; she usually doesn't wake up until 8am, so I try to work out on an exercise bike first thing. What surprised me about having a baby is losing all your fitness and how tough it is to get it back to that level again.

I've been riding all my life. I won individual and team gold at the European Eventing Championship in 2005, then individual gold and team silver at the World Equestrian Games the following year. I also won team silver at both the 2012 Olympics and the World Equestrian Games last year — and that was after coming back from having a baby.

For breakfast I'll eat something like Greek yoghurt with honey, a piece of fruit, or toast. If Mike's here, we try and sit down all together. However, he has been away a lot lately, filming for two TV adventure shows — The Jump and Bear Grylls's Mission Survive.

He stopped playing rugby last year and I thought I might see more of him, but he's been trying things which he has never had an opportunity to do before, like going to the jungle, racing in a bobsleigh and snowboarding. I think he's having the time of his life.

I keep eight eventing horses, owned by various people, and in the morning they are exercised here at Gatcombe. It's a great place for horses, it was also a special place for me growing up. I hope to be part of the eventing team that goes to the Olympics in Rio, but first I need to qualify. The games are in 16 months, which seems a long way off, but they will come around very quickly.

I have missed out on the Olympics in the past. Once was when my horse, Toytown, was injured. It's one of the low points of the sport when your horse gets hurt or killed [in 2008, her horse Tsunami II broke its neck in a freak accident in France]. You develop such a special partnership with them. I still find it devastating.

I do have help with Mia, otherwise I wouldn't be able to ride. Jane, our PA, helps plan our busy lives and look after Mia, and she does go to a nursery one morning a week. I often drive her in, but I am usually late.

Lunch is quick and simple, like soup and a sandwich, or eggs on toast. I don't diet but I try to eat well, and not eat too many carbohydrates, or sugary things. In the afternoon I'll do extra exercise, like swimming and cycling.

We all went to Australia in January and it was great to have time to train with Mike. However, cycling with him is a lot harder — he is way more powerful than me. At least I don't have to worry about Mike riding a horse. He had a go 10 years ago when we first met. Galloping was his favourite speed. I used to watch him hanging on, but luckily the horses would always stop at the top of the hill.

Although Mike isn't a rider, he's the person I talk to most about eventing when I finish for the day. He's picked up quite a lot about horses over the years. Most of all, he knows how my mind works. He knows me inside out and has had the experience himself of being at the top of his sport.

I put Mia down about 7pm, then Mike and I will have supper. This will be something healthy, like fish and vegetables. In the evening I enjoy watching crime dramas. Mike used to tease me for being addicted to old-fashioned ones, like Murder, She Wrote and Diagnosis: Murder. I'll also then get out my iPad, but I'm notorious for not answering emails.

Mia won't wake again until morning and I usually head up to bed at 10pm. I tend to sleep well, too, which is great because I've got a big year ahead of me what with training, competing and looking after Mia. But at least the eventing circuit is great for kids; I expect Mia will grow up with horses all around her, just like her mum did.

Interview by Jeremy Taylor

Zara Phillips, who now uses the surname Tindall, reached the required level in competition for the 2016 Rio Olympics but was not selected for the Great Britain team. In 2018 she and Mike Tindall had a daughter, Lena, and in 2021 a son, Lucas.

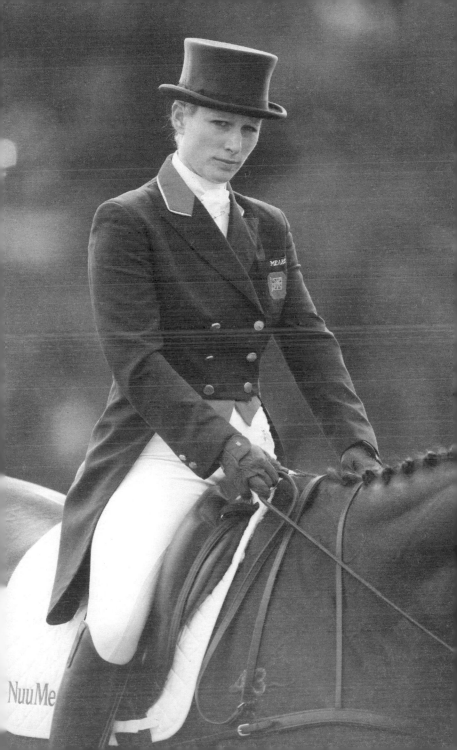

Gordon Ramsay

JANUARY 14, 2001

The chef Gordon Ramsay, 34, recently voted Chef of the Year 2000, now runs his eponymous restaurant in Chelsea. He lives in Battersea with his wife, Tana, their daughter Megan, 2, and twins, Jack and Holly, 1.

" " I remember walking into the kitchen absolutely shattered one morning. The chef said: "How long did you sleep last night?" I said: "About five and a half hours." He said: "Too long." He went on to say that by the time I was 60 I would have wasted 20 years of my life. I've slept less since then. Which is why I look so rough-and-ready in the morning.

Tana brings up tea and toast before 7am. Tana burns toast. I dedicated A Chef For All Seasons [one of his books] to Megan, Jack and Holly, hoping they follow in their father's footsteps, not their mother's. What's holding her back is cooking for infants. It's all puree. And 90% of it ends up on the floor. People say to me: "Why do you never feed the twins?" If I was a traffic warden, maybe I would. But I'm a cook; I'm not interested in seeing my food go everywhere.

I'm at work by 8am on the dot. There's no start-up process — this kitchen functions 24 hours a day. The night cook has already been in to dip the chocolates, make the bread and pipe all the macaroons. First thing is a cup of tea, then I go through the produce. We all have cheese on toast at 11am. As a rare treat we'll splash out and have beans on toast.

Between 12pm and 3pm, it's controlled madness. It's air traffic control. Somebody phoned up once and said: "I'm bringing my 15-year-old son to the restaurant tomorrow. Will Gordon do

him an omelette?" I just went: "Tell him to f*** off." Will I do him an omelette? If he wants an omelette, go to McDonald's. These calls come in the middle of service. You've got six guests at table, and their main courses need to be served at the same time. One spanner in the works, and the whole lot gets put in the bin.

After lunch there's a huge 45-minute clear-down. An untidy, messy kitchen produces untidy, messy food. Sometimes after that, I'll disappear to play squash. As a chef, if you don't keep fit, you can fill out quickly. We have our main meal in the kitchen at 5.30pm. The new cooks in the brigade will cook that. I always ask them to do a pudding – something simple like a leftover-fruit crumble. But for all 38 of us. Just so they don't get blase with the expensive stuff like sea bass, foie gras and truffles.

It's been well documented that I need to spend more time in management training school. But I don't give a fig what people say. I'm running a kitchen, not some wuss-hole for has-beens that want to appear on Ready Steady Cook. Having worked under Marco Pierre White and the late John Wallace, I got my arse caned if I made a mistake.

I don't go home. Tana and I cut off Monday to Friday. But then I close the restaurant at weekends. That's when we relax. Tana tries to entice me with a bellini. It's moreish because it's got peach puree in with the champagne. I end up pissed. The weekend is special – that's why I'd never marry a chef.

But during the week, every night is our busiest night. At 7pm, the curtain goes up – bang! There's only one winner. It's like boxing: you can't afford a mediocre bout. I faced huge disappointment at the age of 19, when I got rejected from Rangers FC. I was never going to come second best again. My restaurant isn't cheap. It's booked a month in advance. And I still have to deliver the food on the plate, no matter what the hype is.

I'm sick of the label "celebrity chef". About 99% of celebrity chefs don't even have restaurants. All they've got to worry about is when they're next appearing on Ready Steady Cook. Sitting there in make-up for half an hour and getting paid £500 a show. I did appear in OK! once – but I was in a rush to make my new restaurant more successful than the last.

Before I leave for the night, the ordering starts. That's about talking to the boats and getting the best of the scallops. There's always something to keep me interested. Recently I've been rowing with my neighbour. Her front door is almost part of our shop

front. To be awkward, she painted it pea-green – a different colour from the purple we've got at the moment. Every time she paints it pea-green, we will be painting it purple again.

I leave at 1am and go for a run. It always ends over Albert Bridge. With its lights, it reminds me of the Eiffel Tower and my time in Paris. At home I watch Sky News until I'm tired. I sleep in my pants because I'm fed up of Megan jumping on the bed and playing ding-ding-daddy with my willy. To be honest, I wouldn't mind a weekend away from her. Tana and I would be able to sleep without our pants on for a change.

Interview by Richard Johnson

As well as winning numerous Michelin stars for his restaurants, Gordon Ramsay has cooked up storms on television in the UK and US with Ramsay's Kitchen Nightmares, Hell's Kitchen and Masterchef. In 2021 he told Hello magazine that one of his parenting secrets was not to let his children swear.

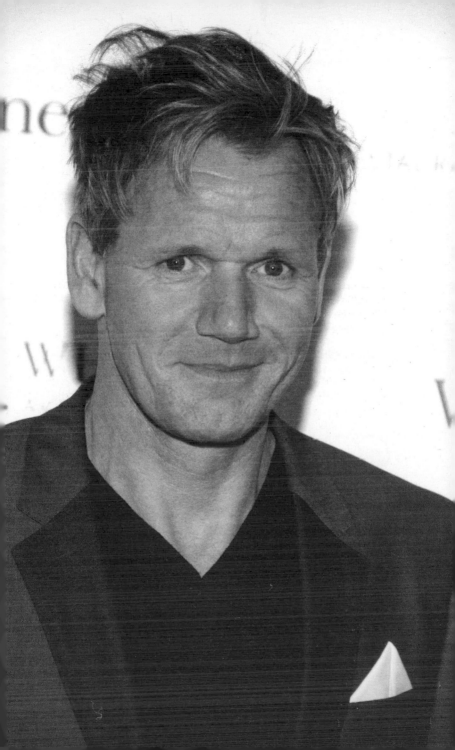

Esther Rantzen

JULY 12, 2020

The journalist and TV presenter on giving up Botox and the naked joy of octogenarian life. Esther Rantzen, who turned 80 last month, was born in Berkhamsted, Hertfordshire, and read English at Oxford University. She presented the BBC television series That's Life! for 21 years and founded the charities ChildLine, supporting young victims of abuse, and Silver Line, to combat loneliness in the elderly. She had three children with her husband, the producer and film-maker Desmond Wilcox, who died in 2000. She lives in a village in the New Forest with her eldest daughter, Miriam.

" On my 80th birthday last month I dived out of bed and ran round the garden stark naked. I highly recommend it. The early morning breeze wafts around bits of you that are normally enclosed and it just feels lovely. It was my personal protest. No one's going to ask me to pose for *Playboy*, but I feel very happy in this 80-year-old body, especially jumping around wearing nothing but a chiffon hat.

In my old life the alarm would go off at 6.45am and I'd hurtle about slapping my face on, forcing my way through the school-run traffic to get to a four-hour meeting. Now I've discovered Zoom, I'll never go back to that.

I have a foamy bath, then straight to emails and Zoom calls in my study with my carefully curated bookshelf. I refuse to do meetings without my face on and my hair done, but I've given up Botox — I don't need to now. I understand why my friends and colleagues keep themselves unblemished, it's part of the job — for women, not men. Studio lighting ages you 10 years.

I still miss being part of a team. On my birthday, 60 "Lifers" — people who worked on *That's Life!* — created a virtual extravaganza loosely based on the programme. They made me laugh until I cried. We campaigned for police interviews to be recorded, for children to give evidence in court via video link, for seatbelts and safe babies' cots. But I'm proudest of being part of the family of clever, creative people who made it all happen. I was fortunate to be a pioneer working wife and mother. But if the programme had failed, I'd have been booted out and the gates clanged shut for other women.

Lunch is a sandwich, but I do forget to eat. I was fat from the age of 16–25 and forever dieting. I think I made up the revolting grapefruit-and-cottage-cheese diet and I stopped enjoying eating. Then, as a presenter, adrenaline often fought appetite.

I'm pathologically gregarious. Suddenly not to have company after Desi died and the children left was devastating. I got a second lightbulb moment with Silver Line [the charity combating loneliness among the elderly] and it took over my life. Things have improved for some older people because Covid has revealed to the rest of the population what it's like to be isolated. But lockdown has also imprisoned children in dangerous settings. I get so many emails telling me they've reached a place of safety through ChildLine, it's inspiring.

There are always challenges. I've just become trustee of a new charity, Silver Stories, where children phone older people and read to them. It's delightful but I've got to raise money. Sometimes your own conviction infects others, so I'll ask friends. One calls it being "Rantzened".

I have tea in a china cup and I might catnap watching antiques programmes. And there's always a bit of writing to do. M [her daughter Miriam], who has ME and is shielding with me, cooks a casserole and we'll watch *Downton Abbey*. It's like immersing yourself in a bath of milk chocolate.

I might go to bed early, but I'm a news junkie — the TV is always on. I often wake around 3am when thoughts pop into my head. I've realised that whatever you think are the main events of your life, what really matters are the people who were there with you.

Interview by Caroline Scott

In a 2021 interview with The Big Issue, Esther Rantzen was asked what she'd say if she could give advice to her 16-year-old self. She said: "When it comes to the most difficult things in life, I'd tell my younger self, strap your tin helmet on and keep going".

WORDS OF WISDOM	BEST ADVICE I WAS GIVEN	ADVICE I'D GIVE	WHAT I WISH I'D KNOWN
	Michael Grade said you have to earn the right to say no	I'm not entitled to a coat of arms. My motto is: if not now, when?	My mother used to say: "It will be better in the morning." I didn't always believe that, but it's true

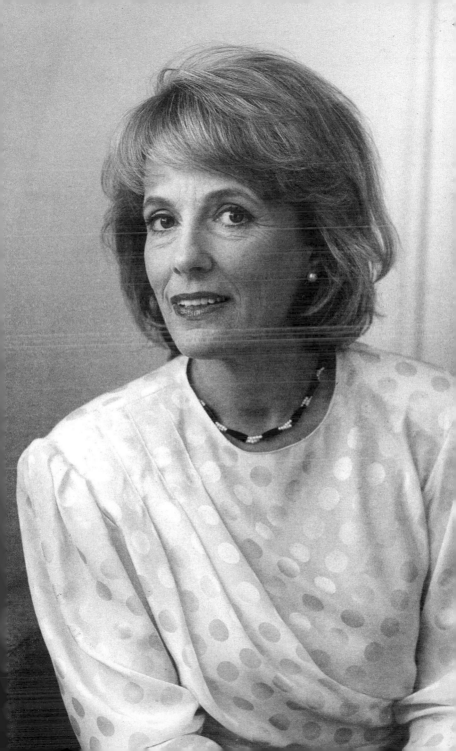

Christopher Reeve

APRIL 14, 2002

The actor Christopher Reeve, 49, was paralysed from the neck down in a show jumping accident in 1995. He runs the Christopher Reeve Paralysis Foundation from his home in upstate New York, where he lives with his wife, Dana, and son Will, 9.

> I wake up about 6.30am, feeling more like stone than flesh because I've lain rigid all night. I use the hour between then and when Dana gets up to adjust between my dreams and the reality of my situation. I've never been disabled in my dreams – I'm sailing, riding, travelling, making films.

At about 7.30am, the morning nurse and an aide come in and we do exercises that help turn me back into flesh. Being unable to do things for myself has taken conscious effort to accept. I have to be washed and dressed.

I have a bowl of cereal and half a grapefruit, and then my day depends on whether I'm at home or travelling. Over the past five years I've flown to almost every state. I speak at schools and colleges, rehab centres and meetings of neuroscientists. You really only have two choices. One is to admit defeat. The other is to say: "This appears limiting, but let's see what can be done."

The accident itself makes no sense. I remember going out to the starting box, and then I'm a complete blank until three days later. My first reaction was acute embarrassment that I'd had such a serious injury because of a very simple mistake. The jump that my horse refused was easy, and why I didn't stay on I don't know. It was not as though I was trying to jump the Grand Canyon on a motorbike.

I have a gym at home, and three times a week I'm lifted onto a special bike with electrodes to stimulate the muscles. Just after the injury, I could only "cycle" for 5 to 10 minutes. Now I last an hour and cover over 10 miles. At 11.30am I go into my office, which looks onto the woods and a pond. I use a voice-activated computer. We set up the foundation, to support research into spinal-cord injury, in 1999. The work is overwhelming, so I have three full-time assistants. I spend most of my day on the phone or giving dictation.

I work through till 4pm, when my son Will comes home from school. Often he joins me in the office and I set him up with his homework. Will plays on a local hockey team, and if it's still light he'll shoot against the goal we have in the driveway and I'll coach. He was under three when I had my accident, so I missed a lot of activities with him. It's a gift to have my older children – Alexandra, who's at Yale, and Matthew, who's at Brown – nearby.

Then comes the most difficult part of my day: for at least an hour before dinner I take the hose off. In 1995, I could only breathe unaided for 90 seconds. I used to have to pull with my neck and shoulders. Now I breathe just by using my diaphragm.

I usually eat dinner at seven. Dana and I have a rule: never talk about medical issues at the dinner table.

Three times a week we go into the city, to the movies, or to visit friends. I have a nurse with me 24 hours a day, as the ventilator can fail at any moment. It's happened so many times, I don't really stress out about it any more. We park and I'll wheel down the sidewalk. I do this to encourage other people in wheelchairs not to be ashamed.

I go to bed at 9.30pm, as it takes two hours to be put to bed. There's a nurse downstairs listening to my breathing on a monitor during the night. There are times when we turn it off, so Dana and I can have our own time together. An injury like this either drives a wedge or draws a family together, and I'm glad that it brought out the best in us.

Interview by Kathy Brewis

In 2003, Christopher Reeve, who had played the lead role in the 1978 film Superman and three sequels, had electrodes implanted in his diaphragm to stimulate regular breathing. He also regained his sense of smell. He died in October 2004.

Little Richard

APRIL 25, 1999

The singer, 63, first came to fame in the 1950s with his 6in pompadour and a string of hits such as Tutti Frutti, Long Tall Sally and Good Golly, Miss Molly. He lives alone in a Hollywood hotel.

I wake up every morning and get on my knees and pray. I thank God for letting me get out of bed. I thank him for the blood running warm in my veins. Then I order up room service. The chef does great grits. Y'all call it hominy. Then I have oatmeal, two eggs with American cheese, and wheat toast. Very seldom I change.

My hotel suite is just like home. I used to have my platinum discs on the wall, but now I just have a picture of my band. I've got a piano in there. In the old days I would sit and write 20 or 30 songs a day, but it's not so many now. There's a big living room, two baths, a bedroom and an area for you to get dressed. I can see the whole of Los Angeles from my balcony. I enjoy just watching people – boys with their girls. I don't even have to leave my room. I don't have to go no place.

Round my suite I wear gold and silver. Everything flamboyant. I don't like sweats. I like biker shorts. Real tight. I wear those around the place. And I always do my hair. I still wear it up – high at the front. I use hair spray to keep it that way.

I have people I will visit. My sisters and brothers live near – there's 12 of us. And I like to visit rest homes and talk to people. Sometimes they don't believe it's me, because they have so many lookalikes in America.

I drive around in my 99 Lincoln custom limo. It's got smoked glass, so that people can't see in. It looks like a house. It's beautiful. My name is written on the back in little letters – Little Richard, the Architect of Rock'n'Roll. If I see people looking sad, I have my chauffeur stop. My bodyguards get out (I have bodyguards 24 hours a day), and I talk to people. I hug their necks and they go to smiling. I like stuff like that. Everybody go to running around and screaming: "I can't believe it!"

Mercifully, my health is still good. The Lord has definitely blessed me. I've always had a little limp in my walk. I'm deformed in my right leg – it's shorter than my left. Way shorter. But I throw that leg on the piano quick. I throw it up there so fast you would never know it was shorter.

The adrenaline on stage lifts my soul. It sends chills through me, from my toes to the top of my head. I scream like a white lady. And when I get through performing there's a pool of sweat right round my feet.

I've been on the road since I was a boy. I'm on tour all year round. It keeps me young.

I love playing England. England means something very special to me. I remember years ago, back when Jimi Hendrix was my guitarist, and Billy Preston was my organist, and Brian Epstein brought me to Liverpool. He asked me, could these little boys called the Beatles open my show. Nobody know them then. They didn't have no records. They wanted to sing Good Golly, Miss Molly. Paul wanted to show me how good they could sing it. But I told him I couldn't let them sing it before I did.

When people come to see me these days, they see history alive. Before Elvis, I was here. The Tutti Frutti man. If you look at Prince you see a copy of Little Richard. Look at Michael Jackson – you see me. Mick Jagger idolised me.

Even on tour I keep the Sabbath. And I don't drink any more. I don't smoke or take drugs. The days I've got left, they will be clean. I don't throw wild parties – not no more. At my age, I'd better relax – or else I'll be on the floor. In the evening I play some soft songs on the piano. I listen to some strings – some classical music. I can't tell you no composers' names, but I love the music – it's soothing to my soul. And I sleep easy. I can sleep anywhere. Having got used to the loudness of rock'n'roll, ain't nothing going to keep me awake.

Interview by Richard Johnson

Little Richard announced his retirement in 2002 and died, aged 87, in 2020. In a tribute, Rolling Stone magazine described him as a "founding father" of rock 'n' roll whose "fervent shrieks, flamboyant garb, and joyful, gender-bending persona" embodied the art form.

Nile Rodgers

MAY 2, 2021

The pop super-producer on working with Madonna and owning 11 televisions. Nile Rodgers, 68, was born in New York. He learnt to play the guitar as a teenager, and after working as a touring musician for the Sesame Street stage show, formed the Big Apple Band with the bassist Bernard Edwards. In 1977 the group were renamed Chic and went on to become one of the biggest-selling bands of the late-1970s disco movement, with global hits including Le Freak and Everybody Dance. He has also produced songs for Diana Ross, David Bowie and Madonna. He lives with his partner, Nancy Hunt, in Westport, Connecticut.

❝ Me and Nancy both wake at 6am and spend the first two hours of every day in bed with our laptops checking emails to keep on top of all the projects we're involved in.

My life is completely full. I run a charity, the We Are Family Foundation, I'm producing, composing and recording music, I'm the chairman of the Songwriters Hall of Fame. Every day I have things to fix, and love it.

Breakfast is usually the leftovers of what I cooked the previous day, which is normally a humongous pot of whatever ingredients are sitting around the house. My family has West Indian lineage, so I'm pretty adept at cooking these potpourri soups and concoctions that I always think are going to last three or four days but are gone within 24 hours.

I injured my toe recently so I'm taking a break from exercise, but usually I'll go for a five-mile walk and do a whole programme of exercises on the same whole-body vibration machine that Russian cosmonauts use.

Music is at the heart of everything I do and it never leaves my day. I think in music, not words, and I have this hyperactive music machine for a brain, which is a blessing and curse. It's always composing, but don't get me wrong: it's not always good stuff. Most of it is ridiculous stuff but, boy, does it have me interested.

I need a distraction to narrow my focus, so I have televisions switched on all over my house 24 hours a day, creating a white noise in the background. The cable company says I have the most TVs in one house — it's 11 right now — of anyone they've ever known, but I just can't function without that distraction.

After a quick lunch with Nancy I'll get stuck back into the afternoon's projects. I rarely have time to reflect on what I've done in the past, although it still makes me smile to hear music I've been involved with — whether it's *Like a Virgin* by Madonna or *Let's Dance* by David Bowie. What really excites me is when I hear an idea that I had originally has inspired someone else to create an even bigger idea. How cool is that?

I think about my own mortality too and I'm lucky to have made it this far. I've survived cancer, there have been overdoses, I crashed as an amateur boat racer and an amateur race car driver and flipped both vehicles and walked away without a scratch. When I fell over and broke my nose a couple of years ago my doctor told me if I'd connected an inch higher I'd have been brain-damaged or dead, so maybe I'm blessed in some way.

Some people's days wind down gradually, but I've never been like that. I take vacations to relax — or holidays as you chaps say — but my day only slows down by accident. I might just fall asleep by accident, but usually, even after I've eaten — more of yesterday's increasingly delicious leftovers — I'll be answering emails or indulging in my only hobby, which is practising my guitar, which people might be surprised that I still need to do.

My head never hits the pillow at a set time as I'll always be trying to clear tomorrow's email backlog today while the bedroom TV is on and set to the same decibel level as Concorde. I always fall asleep with the TV on, only to wake the next morning when I just laugh and think to myself: "Jesus, how the hell did I sleep through that?"

Interview by Nick McGrath

Pandemics permitting, Nile Rodgers and his band Chic plan to tour in Britain in the summer of 2022

WORDS OF WISDOM	BEST ADVICE I WAS GIVEN	ADVICE I'D GIVE	WHAT I WISH I'D KNOWN
	Any record that's in the Top 40 is a great composition because it speaks to the souls of a million strangers	Please don't take advice from Nile Rodgers because I work purely on instinct. And mostly it's wrong	Not to trust everyone

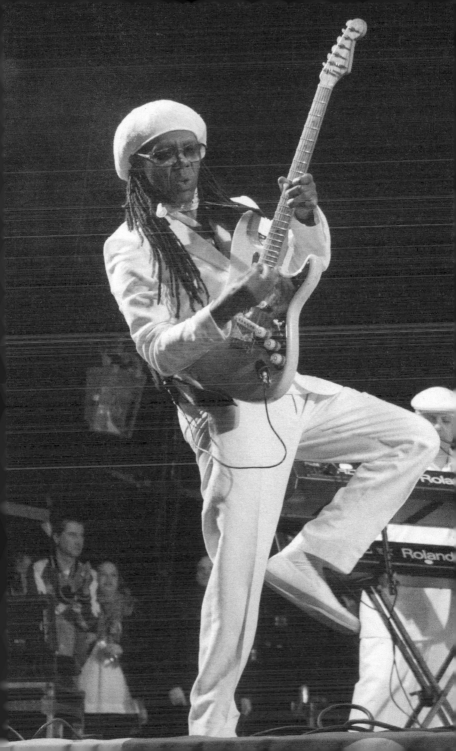

Joe Root

AUGUST 9, 2015

The England cricketer, 24, talks about lazy mornings in bed, annoying his team-mates and his very famous school friend.

"I'm not a morning person, so when we're not in the middle of a big tournament, I'll often sleep until 10am. The England squad has a nutritionist to advise us on what to eat, but I don't stick to a strict diet. For breakfast, it might be Weetabix with chocolate chips on top or a nice, tasty bacon sandwich. It just depends what I feel like.

I live in Sheffield, close to Dore, the village I grew up in — I have a modern detached house I bought a year ago. The first things I got for it were a big telly and a sofa — everything else fitted around them. I'm really enjoying the freedom, but my mum and dad are nearby, so I still see them all the time. I also rent out a room to a friend of mine and my girlfriend, Carrie, is often here. We've been together for about a year now. She's a medical rep; she lives in Leeds.

Once I'm ready, it's off to training at Headingley, in Leeds, which is where my county team, Yorkshire, play. I used to drive a small car, but I swapped it for a four-wheel drive, which is perfect for all my kit and cricket bats.

We'll train for two or three hours, and it can be intense, but I concentrate on batting and catching. I got two Australians out in the first Ashes Test at Cardiff, but batting always comes first. I also dropped a catch in that game and I'd be lying if I said it didn't annoy me, but you just have to pick yourself up, don't you? You have to stay level-headed, stay focused.

My sporting hero is Michael Vaughan, the former England captain. He's a fellow Yorkshireman who won the Ashes in 2005. He grew up playing for the same teams as me. When I first played for my country in 2012, he gave me his mouldy old thigh-protection pad as a good-luck charm. It goes with me everywhere.

We're spoilt rotten with lunch. It's usually pasta, or my favourite, roast beef and yorkshire pudding. If I'm not training, I'll go to the nearest Nando's. In the afternoon, I like to chill out, maybe go

and see my parents. My mum's a nurse and Dad's a medical rep. He's also a keen cricketer and played for a team called Sheffield Collegiate.

Growing up, Dad was my biggest influence. When I was a kid, my younger brother, Billy, and I were so keen on cricket, we'd sit in the car waiting for him to leave for a match. We practised all the time in the garden, on the driveway — even inside the house. Let's just say we broke a lot of ornaments. He's now at Leeds University, studying sports management, but he's also on a summer contract with Nottinghamshire cricket club. Unlike me, he's a left-handed batsman.

Even as a young lad, I wanted to play cricket for England. I went to King Ecgbert secondary school in Dore and I loved doing sport, of all kinds, but I wasn't alone. One day I came home very disappointed because this girl had beaten me to the school award for Sports Personality of the Year. Admittedly, she was just great at everything... her name was Jessica Ennis.

I left King Ecgbert after my GCSEs to concentrate on cricket. It was a gamble, but I thought I would continue my education later. Fortunately, it didn't come to that, and I made my first team debut for Yorkshire when I was 19 years old. The other subject I really loved was art, and had the cricket not worked out, I might have gone on to study it further. I still like to draw and sketch when I'm away on tour. I also play guitar. I used to carry a ukulele around with me in my hand luggage because it was small and more manageable. Now I have a guitar, but this doesn't always make me very popular with the other players. There have been a few times when they've knocked on my door at midnight and asked me to keep the noise down!

I got my big break with England in 2012, playing against India. We've had our ups and downs since then, but it all came right for me this year. I scored a century against Australia in the first Test at Cardiff and was man of the match. I've also been made vice-captain and was named England Player of the Year.

In the evening, I actually enjoy cooking, but my girlfriend is much better than me. My favourite supper is a barbecue, so I love having friends round. I tried barbecuing scallops the other day and they were great.

When I went to the Caribbean to play the West Indies, the chef Levi Roots actually taught me how to prepare fish parcels, with chillies, herbs and lots of spices. I have a bit of a sweet tooth, too. My biggest weakness is a bag of pick'n'mix on a night out at the cinema.

Even though I'm a regular England player now, I still find it hard to sleep the night before a big match, so I'll often stay up watching a gripping detective drama, or something that will take my mind off things. That usually does the trick.

As a kid I dreamt about playing for Yorkshire, and it came true. I then dreamt about playing for England. That came true, too. Now, I dream about England winning back the Ashes.

Interview by Jeremy Taylor

Joe Root was made captain of England's Test cricket team in 2017. Having lost one Ashes series and drawn another, he's looking for a win in Australia in late 2021. He's scored more than 8,700 Test runs and was a member of the England team that won the 2019 Cricket World Cup. He's now married to Carrie Cotterell and they have a son and a daughter.

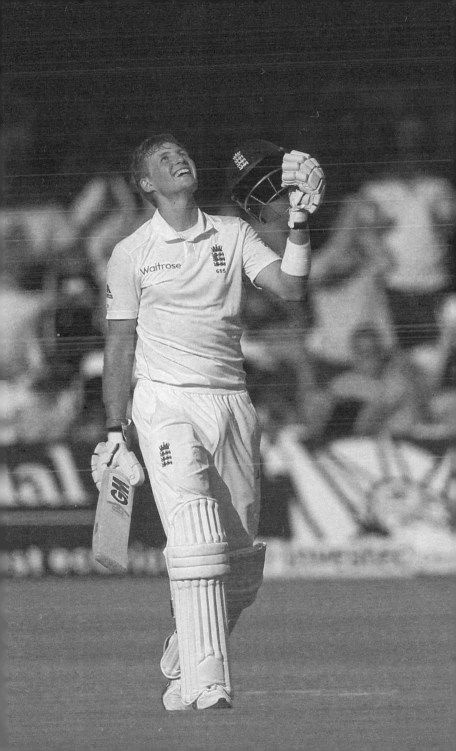

Jennifer Saunders

JANUARY 26, 2014

**The actress, 55, on wussy breakfasts, wardrobe dramas and
her secret naughty habits.**

" Getting up has become a two-stage operation. I wake at
7.30am, get out of bed, put the TV on, make a strong
espresso, fart-arse around on the computer, then go
back to bed. I can easily laze around until 9am, but if I hear the
theme tune to Homes Under the Hammer, I know I'm in trouble.

For breakfast, my husband, Ade [Adrian Edmondson],
makes real porridge — mine's a wussy, Southern porridge with
maple syrup, followed by a multi-vitamin. I've always been a bit
suspicious about breakfast: I worry that if I start eating, I'll just
carry on all day. I attempt to do a bit of exercise, even if it's just
taking the dog for a half-jog/half-walk around Hyde Park.

We are currently living in our house in central London
— we still have a place in Devon — and we've just installed this
amazing tiled shower that turns into a steam room. God, I can
spend hours in there! The only drawback is that it makes me look
like a rather overripe, sweaty tomato.

Someone bought me a magnifying mirror for the
bathroom — the worst thing you can give a woman. Yes, it's a
necessary evil, but you start looking at every pore and now I can see
all these bloody great hairs growing out of my chin. Why didn't
somebody tell me?

I've got my make-up routine down to 10 minutes, but my
hair's a pain, so I tend to just keep it messy. Choosing something to
wear is harder. I fret over outfits, just in case I look like shit.

I don't mind buying expensive clothes, but as I've got older, I've found myself thinking: "Am I really going to be wearing this in 15 years?" I've always thought it would be easier if we were all just given a uniform when we were born and had to wear it forever.

Lunch is light — maybe tomatoes and mozzarella with a bit of bread, while I'm watching Bargain Hunt — unless I'm going out to meet girlfriends. Then it'll end up involving a few glasses of wine, too. I don't call myself a smoker any more, but if I see my mates huddled round a door, I'll end up having a sneaky one.

After the last couple of years with the chemo and everything [Saunders was diagnosed with breast cancer in 2009], I thought I'd get this urge to look after myself more. Sadly, it's not worked out like that. I could be healthier, but you've got to have a bit of fun, haven't you? Lunch, followed by a bit of shopping with my grandson, Fred, is my idea of heaven. His mum — my eldest daughter, Ella — lives in Devon and I get real pangs of grandmotherly love when I don't see him. Being a granny is just the biggest joy. When your kids grow up, you miss them; you miss their smallness. I feel so attached to Fred and so responsible.

We go down to Devon a lot. It still feels like home, but after the kids left, it did seem rather empty. That's why we moved back to London, where our other two daughters, Beattie and Freya, live. They often come round in the evening — usually when they hear the words "free food".

I'm not bad in the kitchen, but Ade's fantastic. If you were coming round for dinner today, we'd probably cook corned beef and boxty, which I discovered while I was filming Blandings in Fermanagh. It's cured beef, boiled for a couple of hours, then roasted quickly and served with veg and a kind of potato cake made with grated potatoes, flour, baking soda and buttermilk.

While Ade's cooking, I might dig out the hand-held Dyson and vacuum up a few of the crumbs lurking on the kitchen floor. Then it's time for a glass of white wine, pyjamas and my Margaret Howell dressing gown. God, I could wear that thing for the rest of my life. I'm sure I'll be found dead in an old people's home, clutching at its gorgeous woollen sleeves.

I always watch EastEnders — even when it makes me angry — or Ade and I will get stuck into one of those huge box sets. But I'm terrible at wasting entire evenings doing nothing: Googling for rubbish and playing games like Jelly Defense.

We're in bed by midnight and I lie there for half an hour, trying to do a crossword. Like most people, I often find myself thinking about life... it's been an odd couple of years, but when I look back, I just feel really happy. Happiness is all based on how much you worry, and what have I got to worry about? Nothing!

Interview by Danny Scott

Jennifer Saunders created the hit 1990s comedy series Absolutely Fabulous and published her autobiography, Bonkers: My Life in Laughs, in 2013. For many years she appeared with Dawn French in the sketch show French and Saunders. The pair are to host a documentary in 2021 celebrating women in comedy.

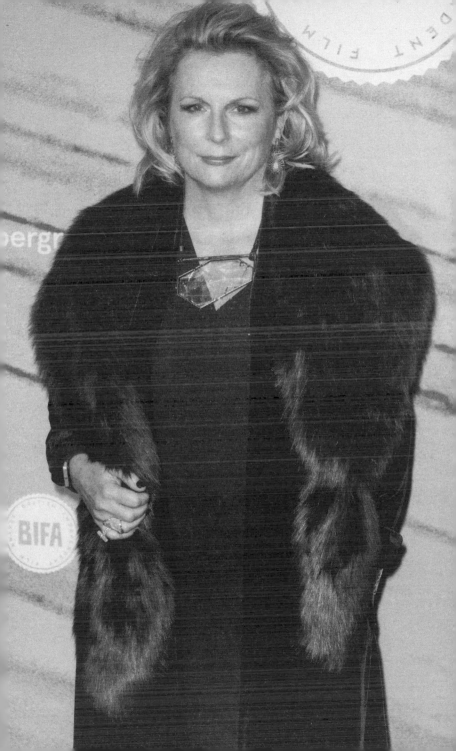

Seal

JULY 3, 2016

The singer-songwriter on his new house in LA, throwing everything out and life after Heidi Klum. Born Henry Olusegun Adeola Samuel, in London, Seal, 53, shot to fame in the 1990s with hits such as Killer, Crazy and Kiss from a Rose. He has sold more than 30 million albums and in 2005 married the model Heidi Klum. He adopted her daughter, Leni, 12, and they have three more children, Henry, 10, Johan, 9, and Lou, 6. They divorced in 2012.

My bedroom looks out onto the ocean, so every morning I wake up to this wonderful view. I recently moved from Malibu to the Palisades, and home is now a Californian ranch-style house, open-plan and full of light.

I'm a creature of habit and the first thing I do is have a cup of hot water with the juice of one lemon. Then I'll FaceTime the kids before they go to school. They live with their mother, not too far away, and they come over every week. I might then drive down to the beach and do a four-mile run. When I get back, I'll put a load of fruit in the Vitamix and make a shake.

I live on my own and have a daily called Loreno who comes in every morning. She's no doubt shocked at what I've just done, which is to get rid of two-thirds of my stuff. It's a big change in my life — I used to be such a hoarder, it was disgraceful. But I've been a fascist in the clear-out. The only things I kept back were anything to do with the kids — photos, videos, birthday cards, things like that. The only clothes I didn't get rid of were by Carol Christian Poell. His clothes are like wearable art.

Now all the clutter's gone, I can breathe. I love it, lots of space. If I'm at home at lunchtime, I'll make myself a turkey and provolone cheese sandwich with mayo and maybe listen back to material I'm working on. I use one of my living rooms as a studio and it's got a beautiful Fazioli piano, a Wurlitzer, a few guitars and my computer.

I'll never forget the first song I sang in public. I was 11, I was on the school stage and it was Johnny Nash: "I can see clearly now, the rain is gone ... It's gonna be a bright, bright, sunshiny day." It was the first time my parents had heard me sing and they were shocked — they didn't know I had it in me.

I grew up in Kilburn, northwest London, and my schools were basically shite, but I did have one great teacher, called Mr Wren. He was a huge influence on me. I was quite an introverted child, but I wanted to be like him. He could sing, he knew I could sing, and he encouraged me. If it wasn't for him, I might have been doomed. Music saved me then. It saves me now.

While my kids are at school in LA I need to be here but I'd love to move back to the UK one day. I still have a London accent; you can take the boy out of London, you can't take London out of the boy.

Lately I've been involved in a few projects. I even did a bit of acting, but acting is absurd! Actors just pretend to be anyone other than themselves. Singing is different.

When I sing, I'm re-enacting a personal experience and my voice is me, not someone I'm pretending to be. You have to reveal your true self, otherwise it's just all shite.

Most evenings I go to Nobu for dinner. I love their black cod with miso, yellowtail jalapeño, uni with teriyaki sauce and shishito peppers. If I'm having a night in, I'll dig out a box set. At the moment, I've got three on the go: Peaky Blinders, Penny Dreadful and Better Call Saul, the spin-off from Breaking Bad. I do have a girlfriend [Erica Packer, ex-wife of the Australian billionaire James Packer], but I don't want to talk about her.

Before bed, I like to read. I've just finished Proof of Heaven, which is about a neurosurgeon who has a near-death experience and turns into a believer. And I love poetry. Rumi [a 13th century Persian poet] is a favourite — I love his poem Become the Sky, which starts: "Inside this new love, die. / Your way begins on the other side./ Become the sky./Take an axe to the prison wall. / Escape."

My own mantra right now is: accept what is, have faith in what will be, strength in vulnerability.

Interview by Ria Higgins

Seal released his 10th studio album, Standards, in 2017. His relationship with Erica Packer did not last.

WORDS OF WISDOM	**BEST ADVICE I WAS GIVEN**	**ADVICE I'D GIVE**	**WHAT I WISH I'D KNOWN**
	You can never go back and do things over again, so make the most of them the first time round	Try to enjoy every minute of your life	I don't think I fully listened to the advice given to me, so I would tell my younger self to listen more

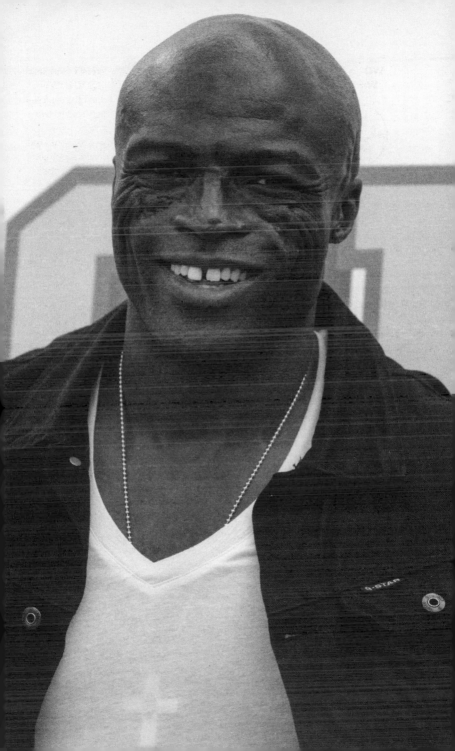

Delia Smith

MAY 4, 1986

Delia Smith, best-selling cookery writer, lives near Stowmarket in Suffolk with her husband, Michael Wynn-Jones, editor of Lloyds of London magazine. 'Delia Smith's Cookery Courses', which she presented on BBC television, have sold nearly three million copies and her latest book, Food Aid, is a collection of recipes sent in by the public and various celebrities, with all proceeds going to the charity Band Aid.

I'm a morning person definitely. I'm at my brightest and best in the morning, and I wake up at the same time, which is between half past six and seven, and if I don't wake up for any reason, I never need an alarm clock because one of my cats jumps on me. I lie on my side as a cat settles down on my shoulder and purrs in my ear because it's her breakfast time. I've got two cats and they seem to take turns.

After I get up I make a cup of tea and feed the cats, then I have an hour's prayer. Now I'm not holy, and I don't want to give the impression that I am, but I find that this is a very wonderful way to start the day; just to be still, to be tranquil if you like. I'm not any good at prayer, but I find that it's very important to me. Then after that I take Michael a cup of tea in bed at a quarter to nine to wake him up. He's a night person and he doesn't want to speak to anyone in the morning, at least not before 10am. Then I go in my car to Mass, which is in Bury St Edmunds, about 25 minutes away, and that's when I have my pop music every morning. My great love is pop music. I record the rundown of the Top Forty on Radio One just to play in the car. My favourites at the moment are Phil Collins and Dire Straits. I'm back at my desk at 10.

My work brings me into contact with a lot of people and I love people, but I like them more in the work context than the social context, so I don't have a big social life at all. One of my most treasured friends is my agent, Debbie Owen.

I was brought up in the suburbs of London, just in Kent, but I love the countryside. Right from a child I always wanted to live in

the country. I don't know why I had this ambition, but when I started to work I was always saving so that I could live in the country. I was about 20 when I took out an insurance policy that would mature when I was aged 50 or something, just for that reason. When we got married we had a flat in London. We were working on the Daily Mirror colour magazine. It was my first cookery column ever, and Michael was the deputy editor, which is how I met him. Then we were made redundant when it folded after a year, and with some redundancy money we bought this little cottage. We started to come down at weekends, but we liked it so much that in the end we built on to it, gave up the flat in London and decided to live here, which we can do easily with the help of our club, the Royal Automobile Club, when we need to be in London.

Living in Suffolk has fulfilled all that I wanted it to. I really appreciate living here. I feel very strongly rooted and I have no desire ever to live anywhere else.

The only friends we have in this area are the friends that Michael has made through cricket, because he is the captain of the local team, and the friends I have made are through the Church because I'm very much involved in that. We never give dinner parties or anything like that; we just invite people to meals when we happen to be cooking a meal.

It's rather difficult for me, because people do expect something special. But when they get to know us and they find out we eat very simply, then they kind of calm down a little bit. One good thing is that because the cooking I do on television is pretty simple, people are not expecting a gourmet feast, but they do expect things to be done really well.

Of course, when you're cooking on television you're rehearsing three times before you do anything, but when you're just normal like everyone else, you've got all the other distractions to cope with, like the telephone ringing, and all sorts of things can go wrong; you could just forget to put a crucial ingredient in something. It happens all the time. My great complaint is that because I can't have gas here I find it difficult to make a perfect omelette.

Cooking used to be something I was very interested in. Learning and discovering it used to be like a hobby, but now the terrific turnover of work I've done in the cookery field has kind of played itself out. I enjoy good food, but it never dominates me. I hate it when people get intense about food and it starts to become a cult and everything has got to be terribly pure. It's just a part of life.

I enjoy going to restaurants, but then again I think that food in restaurants has become a bit precious nowadays. You've got three different coloured sauces and so on, and I don't like that kind of food.

My real gift, I suppose, is communication and that's what I enjoy doing. I enjoyed discovering things that had never been put in cookery books and making it simple and accessible for people. I wanted someone to pick up that cookery course book and be able to say, 'Right, I've never cooked anything in my life and now I can cook with this book.'

Each day, if I'm working at home at my desk, I go for a walk for half an hour across the fields where I'm not likely to meet anybody. I think violent exercise is unnatural; I've never been sporty at all. I like walking more than anything, and it's a good reflective time. I love nature, and it's very beautiful here.

We have a kind of snack lunch, and we have somebody here who looks after the house and does the housework, and she has lunch with us – bread and cheese and soup, those kind of things. After that I'll carry on working until I go for another walk, and then come back, do some more work and make the dinner.

I think I've got something in me that compels me to work. I couldn't see myself not working at something. If I wasn't working to earn a living I'm sure I'd be doing something – learning a language, taking an A level.

The thing I enjoy doing most of all is writing and reading something spiritual. For about the last five years I suppose you could say my hobby has been studying the scriptures, but it's only in the last few years that I've begun to write books on spiritual subjects.

I've signed a contract to write what I hope will be the first of three books, and what I want to do is try and give people the whole spiritual journey from day one, from very simple beginnings. I think there are a lot of people who want a spiritual life; they want to develop the spirituality that's within them. I want to try and help them to do that on a one-to-one level in their own home, if they happen to be unable to find it within a church community or whatever.

I tend to go down with the sun, I can get rather grumbly and grumpy at the end of the day. The later on it gets in the evening the worse I get. Especially now I'm older I find I really do get very tired and I don't like late nights. In fact, I hate them. I seem to need that eight hours. If I don't get it I'll have an hour's nap sometime in the afternoon. I have to catch up otherwise I'm just no good...

Interview by Danny Danziger

Delia Smith's cookery programmes and books were so successful they created what was known as the 'Delia effect': a jump in demand for certain ingredients. In addition, she and her husband have long been majority shareholders in Norwich City Football Club. She stopped running the club's catering when she turned 70.

Patti Smith

FEBRUARY 7, 2021

Punk's poet laureate on her love of golf, British detective shows and doughnuts. Patti Smith, 74, was born in Chicago and grew up in New Jersey. After dropping out of college she moved to New York, where she became renowned for her spoken-word performances. In 1975 she released her debut album, Horses, which saw her acclaimed as "punk's poet laureate". To date she has released 11 studio albums and 25 books. She was married to the musician Fred Smith for 14 years until his death in 1994 and together they had two children, Jackson and Jesse. She lives in New York with her cat, Cairo.

❝ I'm a very early riser. When I first had Jackson and Jesse, I got into the habit of waking at 5am to have some solitude and work in peace. Breakfast is brown toast with olive oil, a little yoghurt and fruit, with black coffee. I can't live without my coffee.

I like to write in the mornings every day, from 8 to 11am. I'm currently working on my 26th book. I'll often be working on two books at the same time because if I hit a wall on one I just move on to the other. I have a great imagination but it took me years to hone my writing skills. It can be a tortuous process.

When I was at a low point in my career in the 1970s, I was working in a bookstore and struggling, while my poetry performances were gaining popularity. [The club owner] Steve Paul had just started his own record label and offered me a contract for a huge sum of money. His commercial vision was to turn me into something I wasn't — a leather-clad Liza Minnelli/Cher hybrid without the poetry or character. But my friend and mentor [the Beat Generation icon] William Burroughs counselled me never to compromise, no matter what the cost, because building a good name when you're starting out will pay dividends later. Hold on to your integrity and imagination.

My work over the past 50 years has spanned music, art, poetry, writing and acting. A combination of enthusiasm and

curiosity motivates me. I'm always trying to uncover something new and better myself. Like my golf game, once I've shot a par I think about hitting a birdie or an eagle, or even a hole in one. It's all about challenging yourself.

Fred and I had a long-distance relationship before we married in 1980 — he lived in Detroit and I was in New York City. We didn't have the money for regular long-distance calls, and sometimes a month or two would go by and I wouldn't hear from him. It was very challenging but love did prevail.

When I'm on the road I'm always eating out, so I enjoy doing my own cooking at home. Lunch could be a piece of cod with green salad and little Russian potatoes drizzled with olive oil. Every so often I crave pizza and doughnuts, then I go for a long walk after eating them.

I've been in New York for the entire lockdown. I'm a vagabond and have been going crazy because I don't like staying in one place. My main vocation now is writing, so I've had plenty of time for that, but sometimes it's hard to write when you're restless.

I need to be Covid-disciplined because I have a congenital bronchial condition. This past year my principal companions have been my 19-year-old cat, Cairo, and my daughter, Jesse, who lives nearby. Sometimes she'll just hang out at mine and we'll play the piano together.

I eat dinner while watching TV on Britbox, which allows me to get British programmes. I especially love detective shows and had a cameo in *The Killing*, playing the brain surgeon Dr Ann Morrison, after writing them a fan letter.

I'll aim for bed by 11pm, but since lockdown my sleeping patterns have been erratic. I have a skylight and don't like pulling the shades down, so sometimes I'll wake up in the middle of the night and see the moon. If I can't get back to sleep I'll write. Many people have commented that moonlight appears in a lot of my books. The best work comes when you least expect it.

Interview by Sarah Ewing

In May 2021, Patti Smith recalled in Rolling Stone magazine how she first met Bob Dylan, who is now in his 80s, in 1974. He wandered backstage after one of her shows and said: "Hey, any poets back here?".

WORDS OF WISDOM	BEST ADVICE I WAS GIVEN	ADVICE I'D GIVE	WHAT I WISH I'D KNOWN
	Be true to yourself and build a good name	Stay curious	We're all more resilient than we think

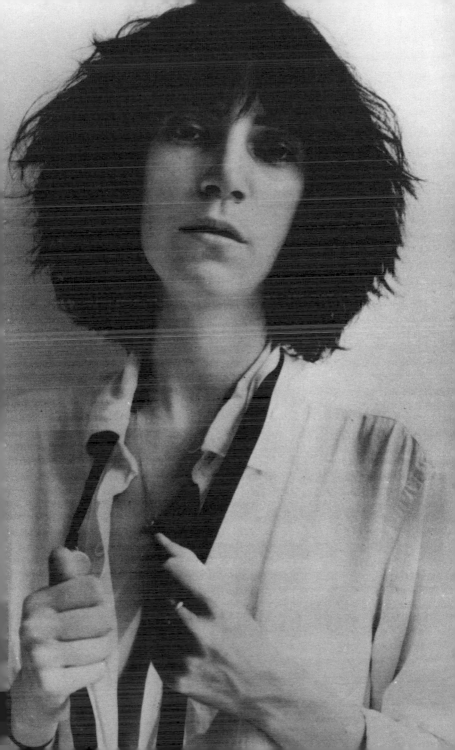

Philippe Starck

MAY 18, 1997

The pioneering designs of Philippe Starck, 48, range from toothbrushes to hotels. He lives mainly in France with his fiancée, Patricia, and their baby, Oa.

" I sleep naked as I don't possess pyjamas or underpants. I don't have a use for them, because I dispute the idea that human beings are not perfect and that we leak and smell bad. I wake up at 4.30am, quite naturally, alas. I'll either be in a hotel, a plane or one of my four habitats: my house, in Paris or Provence, my secret forest cabin or my houseboat on the island of Formentera in Spain, where I have no telephone, fax or wine. The first question I ask myself each morning is, "Where am I?" My primary abode is a suitcase, as I'm constantly darting across the world.

Every morning I indulge in a meticulous ceremony. If it's disrupted, my creative energy short-circuits. I lost six months when Patricia got into the habit of giving me our newborn son to hold while she prepared his milk. I was very happy cuddling him but after 15 minutes the entire rhythm of my day was destroyed.

After breakfast I soak for one hour in a large, white antique bath. In every house I insist on identical taps, towels, cylindrical toothbrushes and the best scent in the world – from Diptyque on the boulevard Saint-Germain.

My dressing room is split into two sections. The left-hand side holds all black clothes for work. The right side used to be all white, but is now beige. I can't work in beige, so I know when I'm wearing it that I mustn't take the day too seriously.

I am not interested in design; I'm bored to hell with chairs, even my own. I don't consider myself a designer. I am a

producer of fertile surprises. A wall is a wall. A piece of wood is a piece of wood. In everything we make, we must give a third dimension, which is life. The important thing is the joy an object gives to the person using it.

In my conscious state, I have a tendency towards vulgarity. I say things which are of absolute no interest, spew out idiotic jokes and am the least funny and cultivated of all my friends. But my unconscious is potent, and I am its schizophrenic receptor. I get flashes of a finished object, and because I am amnesiac I immediately draw what I see. I use a notebook with indestructible tracing paper and I always have 28 Japanese pencils close at hand.

Once, in a restaurant, this vision of a squid-like lemon squeezer came upon me, so I started sketching it on the place mat, and four years later it became quite famous. But for me it is more a symbolic micro-sculpture than a functional object. Its real purpose is not to squeeze thousands of lemons but to enable a newlywed to engage in conversation with his mother-in-law while she is preparing the Sunday roast.

My lunch consists of dried fish eggs from Somalia or a rice cake. I hardly converse, in fact, I am so uncommunicative that my entourage say I could die standing up and nobody would notice.

After lunch I have a siesta. Then it's back to the drawing board with my infrared headphones. I can't work without music: the best of my designs originated at rock concerts, like Patti Smith or the Velvet Underground. The louder the concert, the freer my imagination.

My CDs range from modern Japanese music, opera and reggae to whale songs. I'm crazy about singing, too, and I drive everyone nuts by la-la-la-ing out loud.

I am brutally demanding about my environment. I could not live in an incoherent place. I've tailor-made my world to be smooth and harmonious, and in the process annoyed everyone around me. According to my entourage I have an enormous ego – but that is not really true. The fact is, I live with a gnawing fear that I'm going to disappoint. I am riddled with anxieties, which is the motivating force behind my frenetic activity. But I have started slowing down, because I will soon be 50 and I don't have to prove anything to myself anymore.

At 6.45pm I break for a glass of organic, colourless champagne, and later drift into the kitchen to cook something macrobiotic.

I work or read at night, with the mad hope that I'll be able to sink into bed at a reasonable hour. My fiancée and I have two goals in our lives: to go to sleep early and to bore ourselves silly. Neither ever happens.

I have copies of the same books and CDs in every residence, so I don't have to transport them. Whichever of my houses I'm in, I sleep on a mattress of natural latex with Jour de Venise linen sheets. The beds are all the same optimum height of 67 centimetres, and face south. Man Ray lamps on each side spread a gentle, silky glow. They are the simplest lights ever made and thus most elegant.

Once in bed, I gaze at Patricia, stare at the ceiling and then blank out because I'm so exhausted. I tend to wake up two minutes later, which is a bit of a problem. I'm a slave to my brain, and as soon as one idea is finished, another one just sneaks in.

Interview by Marcelle Katz

The design universe of Philippe Starck knows no bounds. It ranges from humble chairs to electric cars, superyachts, buildings – and even the interior of a space station planned by a private company. He married his current wife, Jasmine, in 2008.

Raheem Sterling

APRIL 12, 2015

The Liverpool and England striker, 20, on uprooting from Jamaica when he was five, his indoor pool and home barber.

"The alarm is set for 8.30am, but I put the snooze button on for five more minutes. I have training nearly every day, and I live near Southport, 45 minutes from Melwood — Liverpool's training ground. I live in a house I bought when I was 18, with my girlfriend and various family members who come and go.

I'm the second oldest of four, and get on really well with my siblings. Mum lived with me until about a year ago, but she's moved back to London now. She thinks I'm old enough to look after myself, but the food was much better when she was around. For breakfast, it's usually Weetabix with hot milk, and juice. I try to eat healthily, but I can't do without sugar on my cereal.

I drive to training in my Range Rover and have been listening to the same reggae dancehall mix for about two months. The facilities at Melwood are amazing. There are three pitches, rehabilitation and recovery rooms, a massive gym, a pool and teams of physios and masseurs. We do warm-up exercises, and inter-technical drills, like passing the ball round mannequins, and practising different turns and movements. All the while we are monitored for speed, distance, heart rate, acceleration and deceleration.

I was 15 when I signed to Liverpool's youth team, and I have to admit I was starstruck. The first time I saw Stevie [Gerrard] I thought he was a fake! I couldn't believe he was real and not a waxwork. Football has been the focus of my life since I got scouted for QPR at the age of 10. Until then, I'd just played kids' football.

My family came to England from Jamaica when I was five. I never knew my dad. He was murdered out there when I was two, so Mum has been everything to us. She's a nurse at a Jewish community centre and she's a very determined lady.

As a young kid I had anger issues, so was sent to Vernon House, a special school in Neasden. I liked it there because the classes were small and I did well, so I soon transferred back to mainstream school. Signing for QPR was a turning point. I trained twice a week, had matches twice a week, and spent every spare hour trying to improve.

By the time I was 14, I had trials lined up at Arsenal, Chelsea and Fulham, but my Liverpool trial at Anfield came first, and when I saw the stadium and the training ground, I thought: "Right, I'm not leaving here until I've signed." For the first couple of years I lived with Peter and Sandra, who I called my "house parents". They were the nicest people you could ever meet and treated me as a son. They will always have a warm place in my heart.

My debut for Liverpool's first team came when I was 17, against Wigan. I was first out on the pitch. I couldn't wait to get on the ball. I did four stepovers and a half-cross half-shot, and every time I got on the ball I ran at the defenders. It was a good day for me.

After training I have lunch in the canteen with the team. My favourite is mac and cheese with caesar salad. I'm not in the fat group, so I can eat what I want, but I always choose vegetables and fruit. It's a laugh being with the boys, and we usually hang out to play pool or table tennis. Then I'll try and see my two-year-old daughter, Melody Rose. I saw her four times last week. She lives close by with her mother and she's at the hide-and-seek stage. She came to a match last season, but cried — the crowds were too much. She likes coming to training, though. Everyone says what a sweet baby she is.

Getting called up for the England World Cup squad at 19 was an amazing experience. The crowds in Brazil were massive, and I loved every minute of it. I don't really get nervous. I'm always impatient to get on the pitch. Once I'm dribbling and in motion I'm so focused the adrenalin blocks out all the noise. Of course, when the crowd's with you, there's nothing better. My ambition is to have my own song from the Kop.

Last season I loved the song for Luis Suarez — Gerrard and [Philippe] Coutinho have good ones too.

In the evenings I prefer to stay home. If I go out I'm always asked for selfies, so I've spent money making my house a fun place.

I've got an indoor pool, a half-basketball court, a games room and my own barber's area.

My girlfriend usually cooks dinner and it will be something like barbecue ribs or chicken wings. Friends come round and we download movies or play Fifa. I used to play as myself at Liverpool, and would never pass the ball! I've grown out of that.

The best part of earning so much is spending it on my family. I bought Mum a beautiful house in Jamaica last year, and it was lovely to see her so excited. I don't take anything for granted, so every morning and night, I get down on my knees to thank God for my blessings and my family.

Interview by Michele Jaffe-Pearce

In 2015, Raheem Sterling transferred to Manchester City, which won the Premier League in the 2017/18 and 2018/19 seasons. After agreeing an extension to his contract in 2018, he earned up to £300,000 a week, according to media reports. He was regarded by many as England's best player in the Euro 2020 tournament.

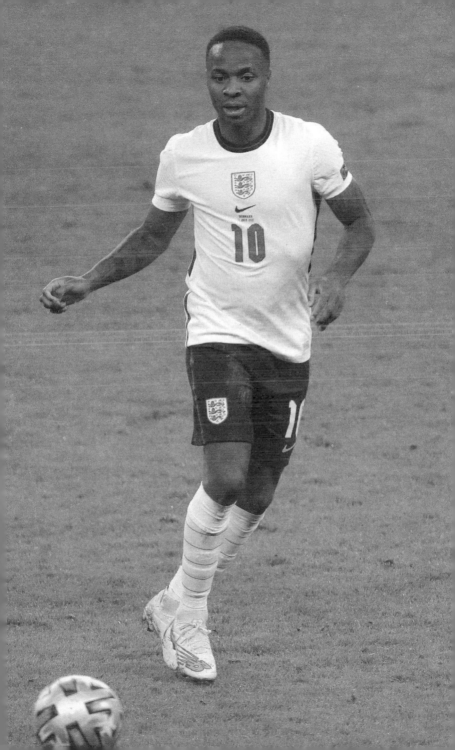

Sting

JANUARY 9, 2000

Sting, 48, left the band the Police in 1984 to go solo. He and his wife, Trudie Styler, have four children (he has two from his first marriage). They live in Tuscany, Wiltshire, London and New York.

I'm usually out of bed by 6.30am. My dad was a milkman, so early mornings have never been a problem. First stop is the steam room; it's better than a bath or shower. I don't like soaps and I don't use anything like shampoo or deodorants. I have a wash but I hate to smell like a product – I actually like my own smell. Then I clean my teeth, wipe my arse and get ready for a few hours of yoga. I've been doing it for 10 years now, and I can do things with my body at 48 that I couldn't do when I was 20. Breakfast – fresh fruit salad and carrot juice – comes after yoga, otherwise I end up with half-digested food all over the floor. We bought this house in Highgate about 13 years ago. It's got a lot of good memories. I remember taking my son Jake down to the cellar one day and we found all the Police 7in vinyl singles. He wanted to know what these funny round black things were. I told him our entire fortune was based on the sale of these artefacts. He wouldn't believe me.

My housekeeper, Maria, made me some fish for lunch. We have a housekeeper and a butler in Italy, too. Well, it's not like Jeeves and Wooster; he just answers the door. Trudie and I are quite sociable people. Some nights in Italy, we might have 30 or 40 people over for dinner. I never cook, I'm terrible. The last time was about 1974 – baked beans, I think. After lunch, I'll be jumping into a record company car to go and record the Des O'Connor Show.

After Des, I'll grab a sandwich in the dressing room, then I'm flying back to Italy. We've hired a private jet today, but I have been thinking about buying my own plane. With luck, I should be back about 11-ish. If the kids are off school and staying with us, the first thing I'll do is go and see them while they're asleep.

I'll probably have a quick drink with Trudie just before I go to bed. We've got a 1950s bar installed at the house, with proper

cocktail shakers and bottle openers. I always play the barman at parties – "Yes, sir. What can I get you?" That's one of the great things about this job, you can indulge yourself a little bit.

There's a nice balance to my life today and I'm just sad my parents aren't around to enjoy it. I never got on that well with them. They loved me, and I loved them, but we found it difficult to communicate. I don't think they could get their heads round what I was doing with my life. Nobody in our street had been a pop star before.

I'll certainly be in bed before midnight. I hope I dream tonight. I had a great one the other night. I met up with my dad and we had a wonderful chat about life. I woke up feeling very much at peace with the world. Tonight, like most nights, I'll lie awake wondering, "How the hell did I get here?" I'm worried that one of these days this giant hook's going to appear out of nowhere and yank me back to reality, "Sorry, Sting, your time's up." If it did all end tomorrow, I'd like to think I could still get on with life. As long as I got to keep my family, I'd be happy. Well, perhaps one of the houses too. And maybe an estate!

Interview by Danny Scott

In addition to making music, Sting has acted in numerous films and television shows. The Sunday Times Rich List estimated his wealth at £220 million in 2021. He continues to own an 800-acre estate in Wiltshire.

Tanya Streeter

JANUARY 2, 2000

Tanya Streeter, 26, holds four world freediving records, her deepest to 113 metres. She was formerly social secretary to the governor of Grand Cayman, where she lives with her husband, Paul.

" If the alarm doesn't wake me at 7.30am, it'll be hunger that gets me up. I suffer from low blood sugar, which means I go from feeling peckish to being shaky within minutes.

Breakfast is kiddie cereal, like Coco Pops. If I'm training, or going for a record, I'm not allowed dairy products because they produce phlegm in the airways. But it's always a battle to eat on a record day. The moment the toast goes into my mouth, it turns into blotting paper and is a real effort to swallow. After I breakfast I might sit on the bed doing some deep-breathing exercises, where I'll hold my breath for a minute at a time.

If I'm going to the pool, I don't shower. I'll throw on a bikini, a pair of denim shorts and, if I've got time, waterproof mascara.

On a record day, I generally avoid everyone, especially my mother. She gives me those lingering "Are you going to be okay?" looks. I've got friends who still think diving to 113 metres without air is a death-defying challenge. That kind of wide-eyed attitude does nothing for my mental preparation. My husband, Paul, knows when to get out of the way. He says things like: "Hey, baby, it's no big deal – you've done it before." Most dives are in the middle of the afternoon, so from midday it's countdown time. I read, or watch television, but all the while I'll be making up my mind that everything is going to be okay.

From the moment I see my support crew – there might be two or three boats, with seven scuba divers – I start to enjoy it all. Once I know the crew is okay, I put on my wetsuit. It gives me some protection from the jellyfish, but doesn't stop me getting stung. I once got stung so badly on my face that my lips looked like they'd had surgical implants. We always carry a bottle of cider vinegar to

take the pain away. It certainly beats having someone pee on your face, like we did as kids.

If I'm diving for a record, it's important to keep the boat's rope in view – it keeps you going vertically and also has the tags to mark the depth. I kick for the first 15 metres, then my body becomes negatively buoyant and I'll start to free-fall.

Everything a free-diver does is slow and relaxed. You can't descend quicker than your body allows, because you need to keep equalising the air in your ears. Once I've reached the required depth, I won't have breathed for over a minute. The oxygen in my muscles will have been conserved during the free-fall, so I have just enough for the ascent. I only need oxygenated blood for my legs and brain, so it'll drain from everywhere else.

I kick like mad until I'm 20 metres from the surface, then I have to slow down. It takes an inordinate amount of control to stop kicking when you've been without air for nearly three minutes – particularly if your legs are burning from lack of oxygen and you see sunlight above. The last 20 metres are the most dangerous part of a free dive. I've seen many divers panic and start kicking. They've got no oxygen left in their blood, so their body begins to pump carbon dioxide around the system. That's when they pass out.

I once rescued a diver at that depth – it was horrible. We call it doing a Samba. Their body goes into spasm, like they're dancing, and in the worst cases they'll lose it altogether and start scrabbling for the surface. All you can do is keep eye contact, so they know you're there, and wait until they pass out. Blacking out is the body's safety mechanism. Our vocal chords constrict over the trachea and our windpipe closes, which stops us swallowing water and drowning.

If you rescue an unconscious diver, you take them to the surface and turn their face towards the air. In a few seconds they will usually start to suckle at the air, then they gasp and come round. Waiting for someone to breathe is very traumatic. It happened to me half a dozen times when I was training.

If I'm not diving, I'll be in the gym from 6 to 9pm most nights. Before I turn out the light, I make sure I have a clear airway. I can't have pillows or sheets next to my face. And I can't stand my husband exhaling in my space, so I tell him to "go exhale somewhere else."

Interview by Fiona Lafferty

In 2002 Tanya Streeter broke both the women's and the men's No-Limits Freediving World records with a 160-metre dive. After giving birth to a daughter in 2008, she retired and later also had a son. She has appeared in several documentaries, including *A Plastic Ocean*, which examined pollution of the seas.

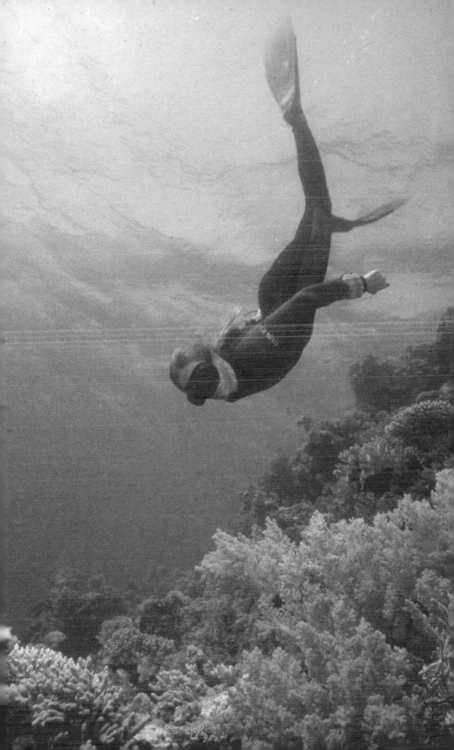

Daley Thompson

DECEMBER 9, 2018

The Olympic decathlete on his dad's murder, being a trailblazer and looking for love at 60. Born in Notting Hill to a Scottish mother and a Nigerian father, Daley Thompson, 60, was sent to boarding school aged seven. When he was 12, his father, who ran a mini-cab firm, was shot dead in south London by the husband of a woman in his taxi. Thompson went on to win Olympic golds in Moscow in 1980 and Los Angeles in 1984. He has five children, three with his ex-wife, Patricia, and two with his former girlfriend Lisa Clayton. He lives alone in Hove, East Sussex.

I'm an old guy now. I usually sleep solidly for eight hours from about 9.30pm till six or even earlier. I'll cycle for an hour or two before breakfast, which tends to be cereal of the sugary kind. My kids keep saying it's not good for me, but I would rather do half an hour more exercise and eat what I like. Kids are really boring these days.

After a shower I'll drive the 80 minutes from home up to my gym, Daley Fitness, in Putney, and I'll listen to Magic FM or TalkSport or catch up on the news. I spend four or five days a month doing punditry or public speaking, but otherwise I'll be at the gym, often six days a week from 10am till the evening. I like to keep an eye on the business and I spend most of my time taking classes or showing prospective members around. I'll also do four or five intense 15- or 20-minute workouts a day.

Forty years ago, my physical fitness was like life and death. Now it's just … life and death, but in a different way. Age doesn't have to be a barrier to good health.

I was from a single-parent family and my mum had two or three jobs for the first 18 years of my life, so I understand the value of hard work. I've always aimed high. You might not make the moon, but you can still make it into space.

I don't think my dad's murder had an impact on my attitude. Obviously it's pretty traumatic, but it happens. People close to you pass away. People get killed, but life goes on and you've got to make the best of it. I don't spend much time dwelling on my mental health and I don't look back, either.

For lunch I'll grab something from the local cafe, maybe a baked potato or pie and mash. You'll never see me tucking into a quinoa salad. I'm not a drinker, though, as I'm not sure the world could cope with a drunk Daley Thompson. It can barely cope with a sober one.

I rarely talk about my Olympic past. That part of my life is done and dusted, and I genuinely don't recognise the old descriptions of myself that say I was arrogant or rude or difficult. I started competing before the first black person had even played football for England so maybe subliminally some of the negativity I received was because of the colour of my skin. The most important part of my life is the bit I'm in this very second. Loads of my friends live in the past, but I try not to. I'm too busy making the future bright.

Back then it was all about the individual. Now I'm much more about the collective of family and friends. I don't want to waste time because none of us knows how long we're going to be around.

If I'm doing school pick-up, I'll get back for that, take the kids for some food, let them do their homework, then drop them back. Afterwards, I'll just head home and collapse into bed.

As a single man who goes out in the evening probably only once or twice a year, sometimes I have no idea how that's going to change. But then other times I think, "It's definitely going to happen. The next Mrs Thompson is going to walk into my gym or I'm going to meet her on the Central line."

I don't aspire to much as I've already had the best life anybody has ever had. I want all my kids to be happy and to always have 10 fingers and 10 toes. That's it.

Interview by Nick McGrath

On top of winning Olympic gold, Daley Thompson broke the decathlon world record four times. He recently gave an insight into his diet as an athlete, saying he avoided vegetables and water, and mostly drank "Sprite, Coca-Cola and Gatorade".

WORDS OF WISDOM	BEST ADVICE I WAS GIVEN	ADVICE I'D GIVE	WHAT I WISH I'D KNOWN
	You have two ears and one mouth. Use them in the same proportion	The point of exercise is trying to make it part of your lifestyle	Nothing. That would have taken the surprise away

Donald Trump

SEPTEMBER 26, 2012

The multibillionaire, 66, talks about being a rebel, tricky marriages, and why he hasn't ruled out running for the US presidency

66 I get up at 5am every day. If you want to run a successful business, you can't lounge around in bed all morning. And as soon as I'm up, I turn on the TV and watch the daily news and the business news. I have the papers delivered too.

From the moment I'm awake, I'm thinking about my business. If you're an executive working with Donald Trump, you're never allowed to sleep on the job. I pay 'em a lot of money, so even if it's 5am, they have to expect a call.

I've got five kids, four of them are grown-up, but my youngest son, Barron, is six. If he's still sleeping, I try not to wake him too early. But he's an active kid, and once he's out of bed, he definitely lets you know he's around.

I sit at the breakfast table with Barron and my wife, Melania, but I almost always skip breakfast. I don't really drink tea or coffee, either. People tell me this is bad, but I guess my body's used to it.

Each week, I play tennis or golf, but I don't have an exercise routine and I hate treadmills. I shower, shave and splash on a little cologne — my own, called Success — and, because I'm old school, I like to wear suits at work; dark blue with white shirts and solid-colour ties.

My office is on the 29th floor of Trump Tower on the corner of 57th and 5th [in Manhattan]. We live here, too. Our apartment is on the 66th, 67th and 68th floors, so getting to work is easy. I take the elevator at 8am and I'm in my office 30 seconds later.

I've always said entrepreneurs are born — something I'll talk about when I come to Britain for the National Achievers Congress. But when I was a kid I wasn't interested in business. Dad made his money from real estate, but I wanted to be a film-maker or a baseball player. I guess I had got rebellious genes; I just liked to do things my own way. I'm still like that. A rebel entrepreneur.

Entrepreneurs have to know how to kick ass, too. Don't get me wrong, I'm a good guy. But if you're an idiot, I'm not nice. We've got a company worth $8 billion and we employ thousands of people. They and their families depend on us. We can't afford to make mistakes.

Unless I've got a meeting, I skip lunch, too. I don't plan to, but business takes over. It consumes you. It can make life difficult, it can make relationships difficult. I've been married three times and I know lots of other successful guys who've run into the same problems. I was watching a documentary on John Paul Getty a while ago. He was married and divorced five times, and he was asked if he'd rather be John Paul Getty or have a good marriage. Getty said: "Many people have a good marriage, but there's only one John Paul Getty."

I don't completely agree with him, but being around someone who's successful in business isn't easy. Sure, if you're well known, you can meet girls ... you can meet lots of girls. They know there are benefits to being around success. But you've gotta find the right girl. Someone who's there for the right reasons — like Melania.

In the evenings, there are business meetings and charity events. Some of 'em I enjoy, some of 'em I can't stand. If I'm lucky, I can get home for 7pm and have dinner with my family. I like steak, pasta ... food you're not supposed to like.

I spend time with Barron before he goes to bed, then Melania and I settle down to watch TV, mainly more news, more business.

Obviously, it's all about the election at the moment and I've thrown my weight behind [Republican Mitt] Romney. He'd be better for America. The Republican Party is better for America.

The best president we've had in my lifetime was Ronald Reagan. Obama? There's a very small, elite group who make up the worst presidents America has ever had and Obama's right in there. Polls always say I should run for office, but we've gotta see what happens over the next four years. Who knows what the future holds?

If there's no business stuff to deal with, I'm in bed by 11pm or 12. I know I can be forthright. I say what's on my mind and sometimes, I lie there and think: "Donald, why on earth did you say that?" but I never regret things. I do what I do and I do it with honesty. Maybe some people don't like that.

Even in bed, I'm still thinking about business. I get a lot of ideas in the horizontal position. And some of the best ones would probably get me in a lotta trouble!

Interview by Danny Scott

Six weeks after this interview, Barack Obama was re-elected as US president. Four years later Donald Trump won the presidency, thanks to the US Electoral College system, despite receiving almost 3 million fewer votes than Hillary Clinton, his Democrat rival. He became only the third president ever to be impeached.

Kathleen Turner

MAY 4, 2014

The film and stage star, 59, who appears in the West End this summer, talks about age, drink and rejecting Hollywood.

I try to get at least seven hours' sleep, but Simon, my cat, comes everywhere with me, and likes to be fed at 5.30am, no matter what time zone we're in. He's black and is the sleekest creature I've ever seen. At the same time every morning, he'll rub me to say: "Hello, wake up, feed me."

When I'm on stage, it's all about being ready for the curtain. And that means how much sleep I get, what and when I eat, how much I talk, how much I work out. At home in New York, I've a gym in my building so all I have to do is go downstairs. But on show days, I go back to bed until 7am, then give myself two hours of lazing around when I'll have eggs, coffee and almond yogurt.

Fifteen years ago I developed severe rheumatoid arthritis, so both knees are titanium and I've had four operations on my feet. Doctors told me I'd never walk again so I said: "Really? You're fired." Now I credit Pilates with giving me back a range of motion they said was gone forever. So I do at least two sessions of that and yoga a week.

Being ill left me fearful in a way I'd never been before. I used to be such a confident girl, I even did my own stunts. This shook me and I began drinking because it helped blot out the pain, but you know that's OK. The film industry's happy to employ a drunk, because they figure they can control you. It's age and illness they fear.

I never liked LA and when I had my daughter Rachel, I swore I'd never bring her up there. "Is she the right weight? Does

her mom pick her up in the right car?" Kids in LA are prisoners. In New York, you give a kid a metro card [a pass for the subway and buses] at 12 and say: "Check in once in a while."

Rachel [now 26] takes after her father's side. She's an hourglass girl: we're talking tits and hips — I never had those. She's a singer-songwriter now, and she's so confident on stage — I will take some credit for that. She grew up backstage. She knows the work doesn't just happen.

I love to eat and I love to cook, and lunch is my main meal. At home there's a great restaurant on the Upper West side called Cafe Luxembourg, which I consider my local. It's not fancy, just good bistro food. I eat a lot of protein so I often order a steak. They also make the best tunaburger in town.

I hate it when people come up and say: "You look so good!" C'mon. Why are they so surprised? Americans are so screwed up about sex — the British aren't much better. When I did the Graduate on Broadway, the script said Mrs Robinson was "aged 37 but still attractive". I thought the hell with that! I was 48 and I stormed it. Afterwards I got a letter from a woman who said: "I haven't undressed in front of my husband in 10 years, but I will tonight."

I don't have many dates. I seem to intimidate men. Come on, guys! Step up to the plate. I've had some fun, but I haven't met anybody who gives me that... thrill, you know? My girlfriends say I should do online dating. Right. Like the New York Post isn't going to pick that up right away. They say: "No! You don't give them a photo and you don't tell the truth." Then what's the point? I'm not good at this at all.

I'm happy alone. My ex-husband and I have holidays and celebrate special events together, but I don't want to live with him. And I don't think he wants to live with me — 22 years was enough. When I open my apartment door, I breathe a sigh of relief there's nobody else there.

Between 3.30 and 4.30pm I nap, then it's into the shower and ready to go. I've totally honed my evening routine. I get to the theatre two hours before curtain and I do 20 minutes of t'ai chi and yoga. Whenever I meet a new cast and crew I get them to add new songs to my iPod. That way I'm exposed to new music and I have memories to take home.

I steam for 15 minutes to loosen my vocal chords and do another 15 of vocal exercises. During the second hour I do my

make-up with the door open so people can stop by and chat. I like that and if they don't come to me, I go to them. Then, I close my door. There are no nerves, I'm just excited. Every night is unique.

After the show, I'm usually as high as a kite and I'm not hungry. To come down, I just like to head home and read, but my performance will play on a loop in my head. Then I'm off to bed and luckily, I'm a good sleeper. It's just as well: Simon has destroyed my ability to have a lie in.

Interview by Caroline Scott

Kathleen Turner has twice won a Golden Globe for best actress, and has twice been nominated for a Tony award for her theatre work. She's a longstanding campaigner for Planned Parenthood.

Lars Ulrich

JUNE 22, 2014

The founder and drummer of Metallica, 50, talks about giving up cocaine and how having kids saved the band.

I wake up about 7am and take a pill for my stomach — I've had some issues with acid reflux recently. I have a very peculiar way of eating. I drink about two full bottles of water, then I'll have a yoghurt or two, spread out over 30 minutes. About an hour later I'll eat some oat-bran pancakes, which are really good for my stomach.

I run on the treadmill, religiously, every morning, for about 30 minutes. I come from an athletic family and had a very disciplined upbringing. I was born in Gentofte in Denmark and, as a kid, I wanted to become a tennis pro — I was one of the country's top 10 players. But when we moved to America I didn't even make the high-school tennis team and that just completely killed it for me.

We live just north of San Francisco, in Marin County. It's cool up there — we're on a hill, with a good view of the north bay and the Golden Gate Bridge. When the hippies grew up in the Seventies, they all moved out to Marin — it's where the hot-tub culture emerged. I do have a hot tub, but I don't sit around in it smoking ganja — that's definitely not part of my routine.

My three kids go to three different schools — high school, middle school and preschool. My fiancee, Jess, often takes the eldest, Myles, who's 15 — they listen to a lot of music together — and I drop off the two youngest; Layne, who's 13, and Bryce, the seven-year-old.

If the band is working, I'll then go straight to our HQ in Marin for about 9am, and we'll just start writing, or rehearsing, or whatever it is we're doing.

I think Metallica's survival is partly due to the fact that we all had kids at the same time. There was this point in the 1990s when Metallica became this giant machine that just kind of rolled across the land devouring everything. My escape from the band at the time was the art world, but I couldn't really talk to James Hetfield [Metallica's lead vocalist] about Jean-Michel Basquiat or Lucian

Freud. It's different now. We can sit and talk about our kids, because they're the main focus in our lives. In fact, as far as the band goes, I think it actually helps. It means Metallica's not so f****** serious and important any more.

I don't really eat lunch: I eat a lot while I'm moving — small amounts many times a day. These days, I look at Metallica as this little rock'n'roll band where we all go. It's our little place of fun, kind of like a man cave, away from all our family responsibilities. We can go play some shows, sweat a little bit, have a glass of wine, sit on the plane, read the papers, stay in a nice hotel. It's like, wow, this is fun!

The only meal I sit down for is dinner, and Jess makes it. We tend to eat a lot of chicken, turkey, fish and salad — I've some hereditary cholesterol issues, so I don't eat meat from four-legged animals. Danish food shows up, too, usually around the holidays. If we're on tour, though, I'll go back to the hotel with the rest of the band and maybe 20 or so guests after a show, and we'll take over a restaurant.

In the early days, I'd always get drunk way faster than the other guys. It's because I don't have a lot of body mass. In England, they call me "diminutive" — what the hell is "diminutive"? Anyway, I realised that if there was a little bit of cocaine involved I could stay up longer, instead of ending up face down in the corner passed out three hours before the party ended. I loved the social elements of cocaine. I loved the danger of it. It was a little bit "naughty", as they say in England.

Then about 10 years ago, I read an interview with Noel Gallagher, in which he said: "I just stopped doing cocaine." I thought that was really cool: it felt so fresh, so honest, so pure — I love that side of him. I've never had an addictive personality, so I woke up one day and said: "Enough." I haven't done it since.

For me, alcohol is now something that is associated with the end of the day, once all the work is done. If I have anything to drink at home, it's maybe only once every week or two, and it's always after the kids have gone to sleep — I don't like to drink around them.

At the moment I'm going through a bit of a vodka and soda phase; I'll have it at about 11.30pm as a nightcap. I often sit there with Jess and tell her that I should drink more. The only reason I don't is because I never have any f****** time to myself! And at this point in my life, that's the one thing that bugs me. **99**

Interview by James Palmer

The heavy metal band Metallica formed in 1981, headlined at Glastonbury in 2014 and has sold more than 125 million albums. In 2016 the band released an album called Hardwired... to Self Destruct. The band hasn't done so yet.

Bjorn Ulvaeus

MARCH 15, 2020

The ABBA singer-songwriter on new music and break-ups. Bjorn Ulvaeus, 74, was born in Gothenburg, Sweden. He began songwriting with Benny Andersson in 1966. Three years later he met his future wife Agnetha Faltskog, who along with Andersson's partner, Anni-Frid Lyngstad, joined them in the studio. Abba became household names after winning the Eurovision Song Contest in 1974, before splitting in 1982. They have sold 385 million records and spawned a successful musical and film franchise. Ulvaeus lives near Stockholm with his second wife, Lena.

 I wake up quite early and the first job is a coffee. I have up to 20 cups a day — black with a dash of milk. I don't start eating until noon. It's a way to keep trim and not put on too much weight, which is at my age very easy to do and really difficult to get rid of.

We live on a little island just north of Stockholm, so if the weather permits I'll start the day with a paddle on my surf ski. It's a form of kayak but your legs are out in the open. You're in total isolation, and that lends itself very well to thinking. But even then music creeps in. I'm constantly thinking about lines and melodies, so sometimes I get very excited and have to paddle home quickly.

Most days I'll write music or have business meetings. I listen to the radio and the latest pop hits, but it's like what Rod Stewart once said — it feels like you've seen and heard it all. When Benny and I started writing together, we were just two guys sitting in a room with a stand-up piano and a guitar writing the best songs we could, never imagining so many people would like them. Then we were just two couples who played and sang together and something magical happened.

Eventually Agnetha and I grew apart, like young couples do, and I think the same happened with Benny and Anni-Frid. It was an amicable divorce, we both knew it was time. And we both thought we have this platform to do wonderful things, so why break up the band?

We did some of our best songs like *Super Trouper* and *The Winner Takes It All* afterwards.

For lunch I'll grab a sandwich and some fruit. The afternoon might mean more meetings.

I still work because I get excited by new ideas, but I'm extremely cautious when it comes to anything about Abba. I said from the start with *Mamma Mia!*, if it ever felt wrong for the four of us or the songs, we'd put a stop to it. But that moment has never come and now we have a musical, two films and a party experience.

Will there be a third film? I didn't think there'd be a second, so who knows?

One of the reasons bands fall out is because they don't split up in time. We split in 1982. But we've actually recorded a couple of new songs, which will be out this year. There won't be a tour, though. That life never appealed to me.

My wife, Lena, is a really good chef so I leave dinner to her. She'll make something like my favourite, gravlax. Several nights a week, one of my daughters and her family will join us. My older grandkids are briefly impressed by my career, but then I'm just Grandpa again, which is perfect.

After dinner I'll use the gym in our basement for an hour. I have a sweet tooth for ice cream and chocolate so I need the exercise. There's a huge screen so I'll look at a movie while I run. Good action films like the Bourne trilogy work the best. Before bed, I'll have a final coffee and I go to sleep around 10pm.

I often dream about situations where I don't have control, but in dreams, like reality, you have to be ready to grab something good when it comes along. It's incredibly humbling when somebody says how much our music means to them. It happens very often, but I never get used to it. It still blows my mind all these years on. I hope it always will.

Interview by Emma Broomfield

The new ABBA songs mentioned in this interview did not, in the end, appear in 2020. But in May 2021, there were renewed reports that the band would release new music, the first for decades. Bjorn Ulvaeus was quoted as saying: "It's not a case anymore of it might happen, it will happen".

WORDS OF WISDOM	**BEST ADVICE I WAS GIVEN**	**ADVICE I'D GIVE**	**WHAT I WISH I'D KNOWN**
	Slow down, look at every situation and see it for what it is	Don't be scared of getting old	That I would feel as relaxed and free as I do at my age

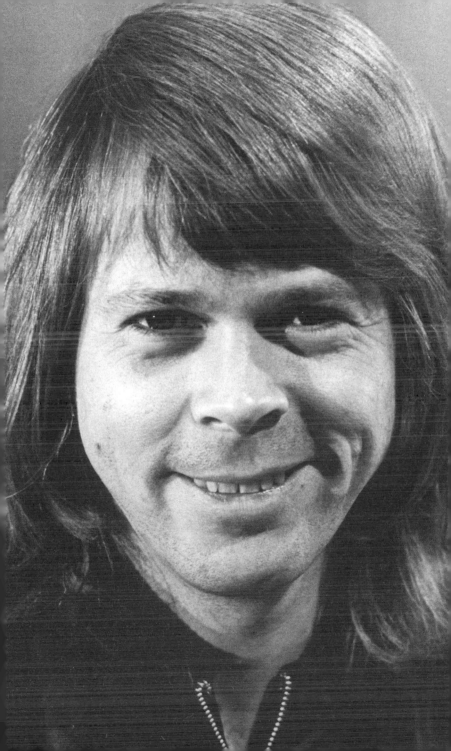

Yanis Varoufakis

NOVEMBER 26, 2017

The Greek economist on weightlifting, dog-biting and his mission to change politics. Born in 1961 in Athens, Yanis Varoufakis, 56, served in Greece's government as the minister of finance during the 2015 bailout crisis, before resigning in protest over austerity measures. He has a flat in Athens and a villa on the island of Aegina, which he shares with his wife, Danae Stratou, an artist, and her two children. Varoufakis has a daughter with his first wife. He is the author of several books on the global economy.

"Rising early is the only way I can work. I wake at 5.30am and put the coffee machine on. By the time it's ready, I've finished my press-ups: three sets of 80. I've been doing them for 50 years.

Before I get to my desk, my Labrador, Mowgli, and I have a big hug. I bite him, he bites me.

Then, for two or three hours, I'll write intensively, the equivalent of a whole day's work. In my most recent book, I wrote to my 12-year-old daughter about capitalism. My personal tragedy is I've never lived with Xenia. She lives in Australia with her mother, and so the clock's always ticking: counting down when we're together, or until we're together. As a child, she would fall asleep as I read her bedtime stories on Skype, but this book brought me closer to her without a ticking clock.

After I finish writing at 10am, my wife, Danae, and I have breakfast: tea and Greek yoghurt with chopped-up fruit. This is a special part of my day. Every time, it feels like a first date.

Before I actually knew Danae, I'd fallen in love with her work. I came across an exhibit in Athens and assumed she was a 90-year-old woman — it was a mature piece of art and the name sounded old-fashioned. Then I met her and thought: "Now I'm in trouble!"

Nothing happened because we were both married, but two years later, we met by chance in a London restaurant. The rest is history.

My big project at the moment is the Democracy in Europe Movement [DiEM25]. Our aim is to spread a new politics through the democracy-free zone that is the EU. It will probably fail, but we don't give a damn. It's fun trying. For the European elections, we're putting up transnational candidates: Greeks in Germany, Italians in France. I'll probably have to stand. I'm dumbfounded by career politicians, though, and think anyone keen to be a minister should be disqualified.

At 1pm, I'll have lunch. Danae and I have something cold: our latest craze is black lentils with Greek white goat's cheese, cherry tomatoes and salad. I used to cook, but my time in government ended that. I lost the luxury of time.

Reflecting on that period, I'd say my relationship with Alexis Tsipras [the Greek prime minister from 2015–19] is beyond repair. To justify his U-turn [over the EU's austerity package], he has to tell himself stories that, deep down, he knows are false.

I'm not enthusiastic about the EU, but my view remains that, instead of leaving, one should stay and veto the hell out of everything until we can have a serious conversation about reform.

[Jeremy] Corbyn and I are very close and I'm pleased he's come to my original position: that in terms of Brexit, Britain should have a long transition period and give itself a chance to prepare. Then you can leave but maintain good links, and potentially come back in if the EU shows it's transformed itself.

After an afternoon of reading and writing, I'll go to the gym at 7pm. If I don't go, my back starts to hurt. I used to bench-press 150kg. Now I can't do more than 90.

Two or three nights a week, we'll go out with friends, whether it's the theatre or a film or to eat.

For dinner, we're keen on simple grills with meat or fish and a big salad with balsamic and figs and tomatoes. Danae has a glass of wine. I enjoy a shot or three of raki.

At the end of the evening — and that can be anywhere from 9pm to 3am — we crash on the sofa, listen to music and fall asleep.

Interview by Gabriel Pogrund

In 2018 Yanis Varoufakis founded a left-wing political party in Greece called MeRA25, which is aligned with the Democracy in Europe Movement 2025, known as DiEM25. In 2019, nine MeRA25 candidates, including Varoufakis, won seats in the Greek parliament.

WORDS OF WISDOM	BEST ADVICE I WAS GIVEN	ADVICE I'D GIVE	WHAT I WISH I'D KNOWN
	A statistics professor told me: "Say what will happen or when it will happen. Never predict both as you'll end up with egg on your face"	To be moderate, you have to constantly subvert the dominant paradigm	That the worst enemy lies within your own camp

Jimmy Wales

MARCH 12, 2017

The Wikipedia co-founder, 50, on fake news and why he doesn't mind not being a billionaire. Born in Alabama, Jimmy Wales, a former financier, co-founded Wikipedia, the free online encyclopaedia that is the world's fifth most popular website. Listed by Time in 2006 as one of the 100 most influential people in the world, he takes no salary from the website, founded in 2001. He lives in west London with his third wife, Kate Garvey, a former aide to Tony Blair, and daughters Ada, 5, and Jemima, 3. Kira, 16, his daughter with his second wife, lives in Florida.

Home is a rented house in Notting Hill. I get up at 6.25am, make myself a coffee, check news headlines, then start chivvying Ada to get ready. She has Weetabix, I have Greek yoghurt with blueberries and hibiscus tea — at the weekend I cook omelettes and pancakes for everyone. If possible I take Ada to school, but as Kate and I both work, we also have a nanny.

Kate runs Project Everyone, which promotes the UN's goals for sustainable development. We met at a piano bar in Davos while she was working for Tony Blair. We got married in 2012 — Tony was at our wedding, as was Alastair Campbell, who played the bagpipes.

I like to walk to my office. It's in Marylebone, a good couple of miles away, but it's my main exercise. I don't own a car, I just rent one when I need to.

My role these days is fundraising for Wikipedia, giving talks, dealing with governments. I don't like being a chief executive, I'm more of a collaborator than a boss, so we employ someone else to do that. I also don't have a bank of computers; I work on a laptop and a phone and have an assistant to help me organise things.

My goal for every person on the planet to have free access to all human knowledge was quite a grand vision. I thought that if we did our job well, we might end up among the top 100 websites.

I never dreamt Wikipedia would become the biggest encyclopaedia in the world. I think its success is because it's not for

profit. Anyone can contribute. We have 70,000 volunteers producing roughly 7,000 articles a day in 295 languages.

The fact that it's free engenders a giving spirit. The kind of stuff that gets passed around endlessly on Facebook wouldn't make it past our editors. Fake news has had almost zero impact on Wikipedia.

I don't regret that I'm not a billionaire like Mark Zuckerberg or Bill Gates. I know and admire them, but I'm not that motivated by money. Besides, I make plenty of money doing corporate speaking gigs and tech conferences. My days are super interesting and I meet lots of extraordinary people.

For lunch I buy vegetables from Waitrose and steam them in the office, maybe a bit of salmon too. I try to keep off carbs. In the course of a year, I'll do a lot of travelling, but it's a big change for me because I didn't leave the US until I was 37.

I grew up in Alabama, where my mother and grandmother ran a house of learning. My three siblings and I also went to school there. I was very influenced by a set of World Book Encyclopaedias my mother got from a door-to-door salesman. Every year the company would send out stickers to update the pages, and I would be the one to put them in. Later, I graduated to the Britannicas. At the same time, my uncle ran the local computer store, and he taught me basic programming. I became hooked.

I've taught my oldest daughter, Kira, programming and code. She is 16 and pretty good with technology. I visit her at least once a month and we speak every day. My little ones have iPads, but their favourite game is jumping off the couch with me.

I came to London because of Kate, and I'm happy living here. The range of people we know is so much more diverse than if we lived in Silicon Valley. In the evening we go to events and dinners, but if we're at home, we tend to cook healthy Mediterranean dishes.

To do anything creative you need a crystal-clear mind, so I'm a big advocate of sleep. I'm also a pathological optimist. I always think everything will be great.

Interview by Michèle Jaffé-Pearce

The English version of Wikipedia contains more than 6.3 million articles – at least, that was according to Wikipedia in August 2021. In 2019, Jimmy Wales became a British citizen.

WORDS OF WISDOM	BEST ADVICE I WAS GIVEN	ADVICE I'D GIVE	WHAT I WISH I'D KNOWN
	My uncle advised me to learn to program computers	Fail fast – go ahead and try things now. The time is never perfect	That Apple stock would go through the roof for years on end

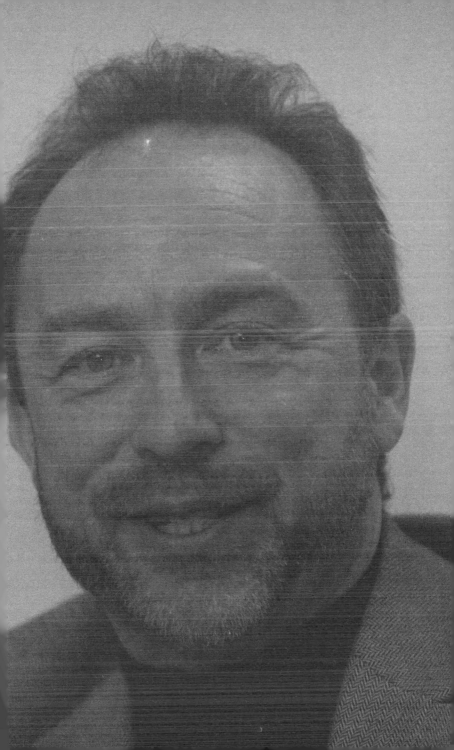

Nicola Walker

JULY 29, 2018

The British actress on her East End roots, being a terrible cook and marrying a joker. Nicola Walker, 48, is best known for her roles in television dramas such as Unforgotten, The Split and Spooks. In 2013 she won an Olivier for her performance in The Curious Incident of the Dog in the Night-Time. She studied English at Cambridge, and lives in Oxfordshire with her husband, the actor Barnaby Kay, and their 11-year-old son, Harry.

66 If I'm filming, a car might pick me up from home as early as 5.15am. I can be ready to leave in five minutes, but I have to move like a ninja so that I don't wake my husband, Barnaby, and our son, Harry.

We used to live in London, but we moved to Oxfordshire six years ago. We have more green space now, plus room for our dog and two cats. The cats are rescues, and they arrived so covered in fleas that we couldn't touch them. They're beautiful now, but they're also murderers — they went through a phase of bringing in dead rabbits and eating only their backsides. It was really peculiar.

I'm not a breakfast person, but I'm aware I should be. I have a love-hate relationship with porridge. My husband does all the cooking — I'm terrible at it. I made something for Harry recently and he had two spoonfuls, then burst into tears and said: "I can't eat it, I can't eat it. It's so horrible."

My family is from the East End of London. It's now terribly glamorous, but in the 1970s it wasn't a great place to live. My dad was a scrap-metal dealer, and his father before him, and so on. My mum did up houses. I remember phoning my dad a decade ago to tell him that there was a Planet Organic shop near where we used to live and he just didn't believe it.

No one in my family had been to university, but I had a brilliant teacher who said I should go to Cambridge. It hit me like a wave. On the first day, I met Sue Perkins [the comedian and presenter]. I thought I looked great — I was wearing what I considered to be a very trendy red jacket and black trousers. Sue

always says I looked as though I was going fox hunting. But we got on straightaway.

If I'm working, I'll eat lunch at about 1pm in my caravan on set. It will be some amazing thing covered in tin foil. If I'm not working and Barnaby is at home, he'll make something delicious.

I decided to be an actor when I was very young. I think it was liking imaginary games that did it. My older brother was also into acting, which probably helped. My first job after Cambridge was [playing a hippie singer] in Four Weddings and a Funeral. It was just the loveliest experience.

Barnaby and I met when I was 24. We were doing The Libertine at the Royal Court together. He played a trick on me — we were standing in the wings and he said: "You're on!" So I ran on stage holding a chair, then saw him gasp because I wasn't on at all. He was just being funny.

I wasn't bothered about getting married, but we've both had deaths in the family and we wanted to bring up Harry in a secure environment in which there would be no question about where he'd go if one of us died. So we got married. Isn't that morbid?

I really love what I do, though fallow periods between jobs are difficult. It's strange being married to an actor — when my husband did A Streetcar Named Desire at the Donmar, I'd send him off to work knowing that he was going to very passionately kiss Rachel Weisz six nights a week.

If I'm filming, I might get home at half eight, in time to talk to my son and put him to bed. I should go to sleep after dinner, but I don't— that's always been my problem. I sit at the kitchen table talking to my husband. Often I'll be in bed at half past midnight. Fortunately, my character, Cassie, [in the TV drama Unforgotten] is not meant to look hugely glamorous — it keeps saying in the script how tired she looks.

Interview by Leaf Arbuthnot

Nicola Walker starred in four series of Unforgotten, which was first broadcast on ITV, received critical acclaim and became a hit on Netflix. Though a fifth series is planned, it will not feature Walker: her character died after a car crash at the end of the last season.

WORDS OF WISDOM	BEST ADVICE I WAS GIVEN	ADVICE I'D GIVE	WHAT I WISH I'D KNOWN
	My nan told me when I was a teenager, "You can't ride two horses with one arse," because I was trying to do too many things. It still makes me laugh	Don't give advice, listen	How much I'd miss London when I left

Ruby Wax

NOVEMBER 12, 1989

Ruby Wax, 36, actress and comedienne, grew up in Chicago
and has degrees in psychology and drama. She and her
husband, the TV director Ed Bye, live in Notting Hill, with their
son, Max, 1.

❝ Those people who start their day with some lemon juice,
muesli and bran – who are they? They're not part of my
world. Neither is 6.15am. I have no idea what 6.15am
looks like, but I could recognise 9.30am.

This morning was typical. I got up a few times before the
real thing. It's what I call kick starts. The major disturbance was a
nightmare at 5am. I often have nightmares, which makes me feel as if
I'm having a heart attack. The only thing which calms me down is TV,
particularly *Donahue*, an American chat show, but I can't always time
my panics to wake up when it's on. I watch TV in bed while the bran
and muesli people are fast asleep. Ed's usually asleep too and I'm
afraid it's just tough if the TV wakes him. He's used to it. If I wasn't so
exhausted from filming, I would go joyfully to the typewriter at 2am
and write 5,000 words. I haven't been near it for six months.

Eventually, when I get up permanently, I crawl to the phone
and give hell to plumbers, decorators – anybody I can think of who is
connected to the house and not doing their bit properly. I'm
obsessive about fixing things – the drains, washers on taps, loos that
don't flush properly – and I wouldn't like to be the person on the
receiving end of my phone calls. Before work, my mornings are for
seeking lost earrings, remembering that the pillow cases are still at
the cleaners, and for Max.

I have to get the practicality of living out of the way as
quickly as possible so that all my energy can be directed into work.
Thank God I can afford a cleaning lady and a nanny. After my
experience interviewing people on TV, when it came to interviewing
nannies, I was able to pick out the goodies first time. As soon as Julia
arrived I tore up her return ticket to New Zealand.

Julia organises Max's day. He thinks we're both his mother. He laughs all the time and when I'm around it doesn't take much to get him into a frenzy of excitement. Walks in the park or mother and toddler groups aren't for me. Yesterday I had Max to myself and by the end of the day I was a wreck. All I'd done was taken him to a fish shop, a vegetable shop and a swimming pool. In the evening, over dinner, I told Ed I was glad I'd got to the fish shop before it closed. That was all I had to talk about.

Currently my life is all about meeting interesting people. It doesn't matter what they do, just that they're interesting. When it happens, I lose track of everything else and know that if it happened when I was out with Max I'd forget he was there. That's why he's much better off with Julia. She brings order and calmness into his life. As I don't have to work from nine until five, at least what little he has from me is quality time. I get to feed him – although I feel rejected when he spits it in my face. I bath him and play with him, but there's no way I could do it for a long time. Ed's much better at parenting than I am. If I didn't work, and if I hadn't become someone by now, I'd definitely have been locked up.

This house used to belong to the writer Carla Lane. She had a mina bird, 40 rabbits, an Irish setter, tortoises and a whole lot of other things which she took with her to a bigger house. I turned the main room, which looked like a scene from *Bambi*, into my fantasy of early America. Instead of Laura Ashley wallpaper, I've got tomahawks and totem poles on the wall. It isn't finished. I have to find recordings of mosquitoes to add some authentic background noise to my New Mexico jungle effect.

Breakfast is a piece of toast in the car, while I put on make-up. Doing it at home is such a waste of energy. I hate wasting energy, because I like to be 30 seconds ahead of schedule. I enjoy driving myself around; I even drive to my exercise class, which is 30 seconds from home. Whenever I go there, the studio is full of incredibly famous people, like Joan Collins and Lynn Seymour. Nobody ever recognises me. On TV I look like I look in real life, which is nothing special, so nobody comes up to me in shops or restaurants. If a programme has a budget, I might get to wear something great, by the designer Rifat Ozbek, who I love, but it's extremely rare.

During the day I have a need to go somewhere – a film location, an office or a meeting. It doesn't matter where, as long as I'm working. I don't enjoy days with nothing to do. There's no purpose to them, which scares me. My favourite workplace is the

lobby of the Hilton Hotel which smells like America and has terrific Club sandwiches. I often have meetings there. With so much excitement going on in our lives, I try to spend quiet evenings with Ed. We usually go to restaurants, where I eavesdrop on other people's conversations. Ed talks to me and I sit there grinning at him.

At home, I throw things on the stove in the hope that they are related, and usually find potatoes in the oven which have been in there three days. I don't give dinner parties and we don't go to them.

Apart from sleep, there's nothing much that's regular about my days. I clean my teeth in the morning and last thing at night, and only shave my legs if I'm going to have sex. There has to be a reason for everything I do. Always, in the back of my mind, is the typewriter, reminding me that I have still got a book and a one-woman show to write.

I'm usually so exhausted by the chaos of the day that I simply pass out and stay that way until it's time for another nightmare.

Interview by Sue Fox

Ruby Wax found fame as a comedian, actor and presenter, with some of her shows drawing on her experience of depression. She later studied for a Master's degree in mindfulness-based cognitive therapy and is the author of several books, including Sane New World and How To Be Human. In 2015 she was awarded an OBE for services to mental health.



Life

However, I am used to being watched. I grew up in a communist society and, when I was a baby, my family was blacklisted because my father was a poet. We were watched by neighbours and my classmates. Until I was 10, I grew up in a labour camp in Xinjiang. I accept my conditions now, but if my family is with me — especially my four-year-old son, Ai Lao — I get angry if people follow us. Animal instinct takes over. Once I grabbed their camera and took the memory card. It had photos of my rooms, the places I go to, my son's pram…

At midday or 1pm, we stop for lunch. My chef prepares vegetables and meat. I'm not fussy. I have tea, not so much alcohol, as it affects my blood pressure. After lunch, my driver takes me to a park for my hour-long walk. I've been doing it for five years, as I need to keep fit.

Then at 3.30pm, I pick up Ai Lao from school. His name is what my mother called my father when he was old. It translates as "Old Ai".

He goes to an international school. It's expensive, but he cannot go to a local Chinese school as he doesn't have a *hukou* [official registration] — he was not born "legally", in Chinese terms [he was the child of an affair]. My son's mother is a lovely girl, a film director, but I don't have feelings for her now.

Ai Lao is a curious boy. He is also articulate. He'll say: "Why should I fear death if dead people can't feel anything?" When I was in detention, the one lie I was told that hurt me was I wouldn't see him for years. His mother told him I was doing an exhibition in London, so when I saw him again, he said: "Don't go back to Britain!" If it weren't for him, I know I would take bigger risks politically.

If the city pollution is bad we stay indoors, walking around a shopping centre, and eat at one of our favourite Japanese restaurants. I then take him back to his mother's. They live in an apartment close to the American embassy, and he will run to the lift and shout, "Bye!" That used to be hard for me. Now it is just strange. I'm back in my office by about 9pm and it can be 2am when I finally finish my work. I tend to shower and, once in bed, I'm out in seconds.

I'm living through an interesting chapter in Chinese history, and I, too, have faced dramatic situations. It has made my life rich, but the fight for free speech is far from over.

Interview by Clio Williams

In 2011, Ai Wewei was arrested in Beijing for what the authorities called economic crimes. He was released after several months and allowed to leave China in 2015. He moved to Germany and then Cambridge in Britain. He currently lives in Portugal, but retains a base in Cambridge. Among his many works are Forever Bicycles, involving more than 1,000 bikes, and Sunflower Seeds, a sculpture made up of millions of individually carved pieces.

Jonny
Wilkinson

AUGUST 12, 2018

**The England rugby hero on coaching, chanting and walking
very slowly. Jonny Wilkinson, 39, played for the England
rugby team in four World Cups and holds the national-team
record for points scored. He is lauded as the hero of the 2003
World Cup final in Sydney, where he scored 15 of England's
20 points, including a last-minute drop goal. He retired in 2014
and lives with his wife, Shelley, in west London.**

The first thing I do in the morning is take a moment to
reconnect with how I'm feeling physically. As I open
my eyes, I feel gratitude for another day full of
opportunities, then my mind turns to what I'm excited about in the
hours ahead.

From there it's straight into getting dressed and breakfast.
When I was a player I'd be up and out of the house in 10 minutes.
But even if it means getting up earlier, a nice long breakfast sets the
mood for my day. Shelley and I prepare a lot of our food pretty
much from scratch, even if it's porridge.

After breakfast I head over to the England rugby facility in
Bagshot. I coach the seniors — the guys playing now. It's all about
skill work, which is the physical element behind the sport, but I also
incorporate mind work. I try to get the two elements working
together. That way, even on a bad day, you can still perform.

For a long time rugby was the only part of my identity I
felt comfortable with. When the team went for dinner after a match,
everyone else would be relaxed, but I would be thinking about the
last game, the next game, questioning whether I'd done enough
training. I didn't know who I was.

When I was out of the game for four years due to injury, I had an identity crisis. Even though there was nothing I could do, I'd still worry about my team. Part of me wanted them to win, and another part worried that if they did win, then that meant they didn't need me any more. I didn't know how to take my rugby kit off. My life has changed a lot since then, and if I can continue the metaphor, I don't feel like I have a kit any more.

Lunch tends to be the biggest meal of the day for me. I'll often have meat, perhaps a roast. The rest of the afternoon is spent working on the business element of things. At the moment I'm working with Sainsbury's on my brand of kombucha [fermented tea]. I also spend time working with my mental health charity, the Jonny Wilkinson Foundation.

One thing Shelley and I do every day is go for a walk. It's a key part of my day. I naturally become quiet and move slowly — like, ludicrously slowly, to the extent that everything else starts overtaking me. We live near Windsor Great Park and I love going out as it's getting dark. The wildlife comes out and there are deer everywhere. It's a grounding experience.

I still like to challenge myself physically as well as mentally. I've got a gym in our garage and do weight training. I don't have many goals — I'm not training for a triathlon or anything — I just enjoy it. Good health can lead to great fitness, but great fitness doesn't necessarily lead to good health. But I admit that every now and then, with a friend, I say sod it and we'll hit the weights hard.

After that it's back home for a light dinner. I like to slow down the pace before bedtime. When I was playing, I used to put off going to bed because as soon as you fell asleep the next day would come and it always held so much pressure. Now I usually read novels — I like Lee Child, Michael Connelly and Harlan Coben — or watch a TV series. I've also started experimenting with things like mantras and chants. It means just sitting quietly and repeating, whether it be a mantra or simply noises. Sometimes I only sit there and think, pondering the mechanics of the mind. I find that when I go to bed now, I just fall asleep.

Interview by Robbie Harb

Since retiring as a player, Jonny Wilkinson has developed business interests and a second career as a TV rugby pundit.

WORDS OF WISDOM	BEST ADVICE I WAS GIVEN	ADVICE I'D GIVE	WHAT I WISH I'D KNOWN
	Listen to life around you	You're exactly where you're meant to be	Nothing. You're only supposed to know what you know

Oprah Winfrey

SEPTEMBER 8, 1991

Oprah Winfrey, the television chat-show host, was born on January 29, 1954, in Kosciusko, Mississippi. She was illegitimate and was brought up by her grandmother until she was six, when she moved to Milwaukee to live with her mother. At the age of 13 she went to live with her father in Nashville. She attended Tennessee State University and began her television career in Nashville. In 1984 she moved to Chicago to host a morning talk show. It was so successful that in less than a year the show was expanded and renamed The Oprah Winfrey Show, and is now syndicated to 13 countries. Ms Winfrey owns and produces The Oprah Winfrey Show and is head of her own studio, Harpo Productions Inc. It is estimated that she earned nearly $40 million last year. In 1985 she was nominated for an Academy Award for Best Supporting Actress in the film The Color Purple.

I am up at 5.45am. I never close my curtains and the sun rises into my room so I never need an alarm clock. I set the alarm every day but I always try to beat it. My home in Chicago from Monday to Thursday is an apartment on one of the top floors of a downtown high-rise near Lake Michigan. I leave for Harpo at six, looking like I just woke up, hoping nobody in the elevator talks to me. I work out at the studio gym for an hour and I hate it, really hate it, every day of my life. Until recently I had a personal trainer but now I feel I can accomplish more by myself. When it's over there's a feeling of achievement. It's a tight schedule in the morning because I have to be in the make-up chair by 7.30am to be ready to record my first show of the day at nine.

When I meet the guests in the studio I've already been briefed on them by the producer. I have a good memory; I don't use notes or cue-cards but rely on my producer to guide me through my earpiece when I'm in the studio. I've recorded 220 shows a year since 1986. I never get tired of it and I don't see a time when I won't be doing it. There's a message in every show, but the continuing theme is about taking responsibility for your own life.

At 11am I record a second show. In the hour in between I change clothes, read some more research and talk with the producer. I feel people talk to me on the show because they know I have problems just like them – celebrity doesn't change that. After the show I shake hands with each member of the audience as they leave.

The show which altered me and made me confront the anger and shame I'd carried with me since I was a child was one of my early ones dealing with sexual abuse. I was raped when I was nine and abused for years by members of my family and their friends. By the time I was 13 I'd run away from home and was sexually promiscuous as a direct effect of being abused. During the show I suddenly realised I'd been carrying that emotional damage with me for years. I broke down and couldn't stop crying. I said 'Please stop the tape,' but they didn't and I released all the pain which had built up. I realised what had happened wasn't my fault and I could stop feeling guilty. I still see my parents. I don't blame them any more.

Just after noon I take off my false eyelashes and high heels and change into more relaxed clothes. I eat lunch in the studio canteen. Hot dishes are sometimes sent in from my restaurant, The Eccentric, or there's a salad bar. Right now I'm 60 pounds overweight. Being thin was wonderful and I vowed I'd never gain weight again. But I've always been a compulsive eater. I love to eat junk food, any time of the day or night. I've tried every crash, cranky, harm-your-body diet in the world. Now I believe I'm on the edge of conquering my weight problem because I believe it's an outward sign of fear – part of me wants to hold back from being all I can be. Now I eat healthy food, I never weigh myself and I'll never go on another diet. When I have time I do enjoy cooking and find it relaxing.

The afternoon is devoted to corporate work: I'm trying to build a fully fledged production company. My ambition is to both produce and act in more movies. I've bought the screen rights to three books so I go to a lot of screen meetings.

The Academy Award nomination for my role in *The Color Purple* was one of the finest moments of my life. The part of Sofia was my first acting job. I'd read the book and so admired what the author, Alice Walker, had to say about the experience of being black in the South. I knew I wanted to be part of the film but I didn't have the guts to call Quincy Jones or Steven Spielberg. I thought, 'They don't know me so why should they take my call?' Then Quincy Jones

saw my show and offered me Sofia. I can only say it was divine intervention.

I read the newspapers in the afternoon to stay in form for the show and to get ideas, although some of the most powerful subjects I've dealt with, like battered women or alcoholism in families, have been generated by the two and a half thousand viewers' letters I get every week.

I feel a responsibility towards combating racism in this country so I devote time and resources to helping several charities which work in this field. I've given $1 million to a fund to educate black men in Atlanta. At least women can work as domestics, but there are very few jobs for unskilled black men. I also support a rape treatment centre.

Since 1976 I've talked every day on the phone to my best girlfriend, Gayle, in Connecticut. We talk for hours about nothing of any significance to anyone on this planet. I'm not a very social person. If I have to entertain I take guests to my restaurant.

Marriage is not a major concern of mine right now. I've been with my boyfriend, Stedman Graham, for five years. He has a PR company here in Chicago. I do love him but if you're starting a movie company and doing six or eight shows a week you need a lot of focus and energy, and marriage is just not compatible with that right now.

On Friday nights Stedman and I drive to my farm in Indiana for the weekend. I was born in the country so that's where my roots are. On the 200 acres I have sheep, cattle, horses and four dogs. I collect Shaker furniture for the house. Bill Cosby introduced me to it and I love the simplicity of it and what the Shakers stood for.

Only very special people in my life are asked to the farm, like my wisest friend, the writer, Maya Angelou. I have problem-solving sessions with Maya, when she spoon-feeds me knowledge and helps me make sense of my life.

During the week, if Stedman's out of town, I often sleep at the studio on a futon on the floor. Late at night is often the best time to do some creative thinking and read up the research for the next day's shows.

I'm basically a Christian and I believe absolutely in life after death. I've kept a diary since I was 15. Sometimes a day will have been so wonderful that at night before I go to sleep I just write 'Great day'.

Interview by Vyvyan Mackeson

In March 2021, Oprah Winfrey's interview with Prince Harry and his wife Meghan drew an audience of 50 million across numerous countries, according to the Associated Press. Forbes estimated Winfrey's wealth in mid-2021 at $2.7 billion.

Kate Winslet

MARCH 22, 1998

The actress, 22, won her first Oscar nomination for her role in Sense and Sensibility and a second for Titanic. She lives in a flat in north London.

I never set an alarm, but I wake up naturally between 7 and 8am. The moment my eyes are open, I jump out of bed. I've driven people potty with that in the past, but I can't lie in because it would be wasting the day. I have a wee, clean my teeth, have a cup of tea and my first roll-up. I deserve to have the skin of a monkey's bottom, I smoke so much.

I throw on a sweater and jogging shorts and go for a swim in the local public baths. I do a mile each morning. This is my exercise for the day, apart from about 200 sit-ups later on, which takes about five minutes. Then it's back to my flat for a shower.

Breakfast is usually bran flakes with skimmed milk and a piece of fruit. Everything I do in the morning seems to be at a pace. I often go out with my hair still wet, and there's no way I can sit in front of a mirror putting on make-up. It takes about five mad minutes, standing. It's the same with dressing. I use one bedroom as a walk-in wardrobe. Racks and racks of clothes stare at me, with jumpers galore, but I often end up putting on exactly what I've worn the day before.

I'm still enjoying having all the space and luxury of my flat – it's my biggest treat to myself. I signed my mortgage papers at the age of 20, which is daft really, and I've hardly had any time to spend in it since. I was away for seven months on Titanic and then thought, "Great, I'll now have some time off." But then there were more trips between London and Los Angeles, and a reshoot, and visits to Berlin and New York.

I had these great intentions of painting the flat, but now it's a mess – piles of CDs on the floor, and God knows what else everywhere. But I love the place. It has French doors, balconies, two fireplaces and a fantastically well-equipped kitchen with a huge yellow fridge. I've shared places in the past and slept on friends'

floors after Sense and Sensibility, and I'd be lying if I said I didn't enjoy the independence of my own place.

I'll phone my mum Sally – every day, wherever I am. I was never happier than on Titanic, filming in Mexico, when she turned up, cooked me breakfast each morning and organised things. I try to get to see her and my dad, Roger, on a regular basis, and drive to our home in Reading in the late morning.

We'll go for a walk in the country and then have a late pub lunch. I love good country pubs that serve ploughman's lunches. My two vices in life are cigarettes and cheese.

My family are my rock. Dad's an actor, though he's never made it big. That's no reflection on his ability – he's absolutely brilliant – but a lesson that so much of this business is about simple good luck.

My mum's mum had six kids; Mum had four, and I want three or four. I know I'll feel distressed if I don't have one child during my 20s, though sometimes I try and fight it, saying to myself: "No, don't think like that. You have to be young: enjoy one-night stands and nightclubs." But it's just not me. I do want a settled life of togetherness and foreverness. And I won't be in a relationship if I don't feel it's going somewhere profound. I'm content to wait until that person walks into my life.

I had a very special relationship for four years with my first boyfriend, the scriptwriter Stephen Tredre, who died last year of cancer at 34. He taught me so much about life and gave me confidence. I was 13 stone at 15, and I was still plump when we met. I'm now around 9 stone for my 5ft 6½in. I'll never be thin – I don't want to be – and I have a very different kind of figure from Hollywood actresses. There were times when weight worry dominated my life, but now I just accept I have a womanly shape.

My idea of romance isn't someone sending me flowers and champagne with a note saying "I love you." I'd probably phone and say, "You complete idiot. What did you do that for?" But if they sent me a pair of their socks with a note saying, "Have a whiff of these," that, to me, is funny and romantic.

I'm not much of a going-out person at night. Maybe I'll go to a film, but I prefer to have people come over to the flat. The kitchen and lounge are linked, so friends can slob around on the sofa while I cook away. Around a quarter to one I light a candle and have a little bit of a chat with a god or something, though I'm not religious.

My sleeping partner is a little orange fluffy rabbit I've had since I was two, who's travelled with me around the world. Neither of us can believe what's happened so far.

Interview by Garth Pearce

Kate Winslet went on to live in the US as well as the UK, marry three times and have three children, one by each of her husbands. She has been nominated for the best actress Oscar four times, winning the award in 2008 for her starring role in the romantic drama The Reader.

Lucy Worsley

JULY 17, 2016

The TV historian on why she has no dignity, being frugal and what drives her bonkers. Lucy Worsley, 42, is best known for her series on the kings and queens of England, including the Tudors and the Georgians. She is also chief curator of the Historic Royal Palaces, based at Hampton Court. She is married to Mark Hines, an architect.

I'm up by 6.30am, and I usually just have eggs for breakfast. My husband, Mark, and I have a flat by the river, near Tate Modern. It's low-key and functional. People somehow expect me to live in a Georgian rectory, but I'm not particularly keen on housework.

When it comes to my wardrobe, I buy vintage clothes on Etsy, or in the John Lewis online sale. It's rare for me to go into an actual shop, except charity shops, which I haunt with enthusiasm. I'm very cost-conscious, so it would hurt me to wear a truly expensive dress. For TV, I have to wear brightly coloured clothes and I like to give them to my mum afterwards, only she'll say, "Oh, this is too bright for an old lady like me."

I'm based at Hampton Court Palace, and I have a special bunch of curators' keys that basically opens every door in the palace — and there are more than 1,000 rooms. My office is up a 51-step spiral staircase — a bit like Hogwarts — and is full of curiosities. I used to have a stuffed raven called Black Jack on my windowsill; he was from the Tower and was killed by the sound of cannon fire at the Duke of Wellington's funeral in 1852.

The first thing I do is get some tea down my throat, then we'll have meetings. There are 24 of us in the curators' team and we look after research, collections, displays and the palace itself.

For lunch, I might go to the Tiltyard restaurant and have lentil curry, then go outside to get some fresh air. I used to be quite shy and I'm still mildly introverted, so if I don't have a patch in the day to be on my own, I can go bonkers.

My interest in history started early. I used to love reading historical novels by authors such as Jean Plaidy. I have one brother, and I suppose we had quite a studious background — Dad's a geologist and Mum's an educationalist.

For the most part, we lived in Reading, in Berkshire — I went to St Bart's school in Newbury — but we also lived in Canada and Nottingham. My brother went on to study engineering; I did history at Oxford. Dad said I'd never get a job with my degree and would end up cleaning toilets, so it's good to be able to turn to him and say: "Ha-ha!"

Prancing around on TV isn't that different from being a museum curator, as we give tours, do sessions for kids and talk on local radio. I suppose I'm still doing what I did when I started out as a 21-year-old curator at Milton Manor, the Inigo Jones house in Oxfordshire.

Clothing really adds to people's understanding of history. It can tell you a lot about society's structure and hierarchy. The worst costume I ever wore was in my first proper series for BBC4, If Walls Could Talk. We didn't have a budget for actors to do reconstructions, so I said I'd do it myself and dressed as a medieval peasant. In effect, that meant wearing a sack. It poured down during filming and I didn't have the confidence to say, "Enough!" That was a notable low point, but I have no dignity — I'll do anything to get people interested in history.

If I'm at home in the evening, it's a pleasure to cook. We get a vegetable box delivered, so on a Monday night it's a stir-fry, and Friday is steak night. We might watch telly — we love Britain's Got Talent — but I'll read before bed. I'm back on speakers with my friend David Starkey [the pair ended a long-running spat over presentational styles and misogyny in 2014], and I'm reading his book on Henry VIII's wives. They'll always fascinate me.

Interview by Victoria Coleman-Smith

In 2021 Lucy Worsley is preparing Unsolved Histories, a new series for BBC Two that will investigate some of British history's biggest mysteries.

WORDS OF WISDOM	BEST ADVICE I WAS GIVEN	ADVICE I'D GIVE	WHAT I WISH I'D KNOWN
	Don't give up the day job — anyway, I love it	Work is not the opposite of play. It can be play	That the bookworm, too, shall go to the ball

Benjamin Zephaniah

JUNE 3, 2018

The poet, writer and musician on Windrush, Meghan's wedding and his remaining vice: chocolate. Raised in Birmingham, Zephaniah, 60, left school aged 13 and did not learn to read or write until he was 21. Now he is professor of poetry at Brunel University and has 16 honorary degrees. He lives near Spalding, Lincolnshire.

Birds outside my bedroom wake me up at 6.30am. I immediately do something physical — I'll go to the gym, run or cycle — and once I've pushed my body to the limit, I crave the opposite, so I meditate.

I was raised in Birmingham with my seven brothers and sisters. My mum was a nurse [originally from Jamaica] and my dad [originally from Barbados] worked for the post office — he started out as a cleaner, worked up to management and was finally buried in his post office suit.

I'm good in my own company and like living alone, partly because I spend so much time in front of crowds. After my workout, I go to my sauna, shower and have breakfast. I have muesli or porridge with soya milk. I'm a vegan and very particular about my [non-dairy] chocolate. When people come over, I tell them to make themselves at home — but then I show them my chocolate cupboard and I tell them: "Don't f*** with that."

Racism in this country has got better, but there are things to work on. When I was eight, a guy on a bike rode up behind me and cracked my head open with a brick, telling me to "go home, you black bastard". My mum had to explain to me that there were people who didn't want us here. We've all heard of people going

back to the Caribbean for a weekend and not being able to get back in. Hostile policies can make racists feel like MPs are on their side.

I'd not take an OBE — I don't want the word "Empire" attached to my name. I respect the royals as human beings, but I'm not keen on the monarchy as an institution. It's another opium of the people. I didn't pay much attention to the royal wedding. I'm not overly impressed by the fact that Meghan [Markle, now Duchess of Sussex] is mixed race — it gives people the fuzzy feeling that we're multicultural now, but we knew that anyway.

I don't really have lunch. Instead I do creative things — I write or record music. I'm obsessed with taking different approaches, so sometimes I start a poem with the rhythm, then fit the words around it.

I was popular at school because I was good at football and fighting, and could make up poems on the spot. At one point I had six girlfriends — they lined up in the playground and said I had to choose one.

I'm dyslexic, but when I was young nobody really knew about the condition. After being kicked out of school I got involved in pickpocketing. I became the leader of my gang and slept with a gun under my pillow for a while. Then, one day, I thought: "If my gang doesn't exist, it doesn't exist." So I just disbanded it.

I meet young people in gangs and see that they all have things in common. They need company. They feel that our society offers nothing for them. When I talk to them alone, they sometimes break down in tears.

I don't drink alcohol because I've never liked the taste or not being in control of myself. I don't smoke either. Once or twice a year I'll have sex.

I eat at about 6pm. I cook for myself and grow my own veg — peppers, sweet potatoes, cherry tomatoes. I might make a stew or a curry. After dinner I go back to work, but before bed I like to watch mindless TV — I love Take Me Out. I'll fall asleep at about 1am.

As a child I didn't have role models. I remember somebody asking me who I was trying to be, but I couldn't think of anyone at all. I always thought poetry was in me. Everyone doubted me, but I knew I could do it.

Interview by Leaf Arbuthnot

As well as writing poetry and novels, Benjamin Zephaniah has appeared in various films and television programmes, including 11 episodes of the series Peaky Blinders.

WORDS OF WISDOM	BEST ADVICE I WAS GIVEN	ADVICE I'D GIVE	WHAT I WISH I'D KNOWN
	Never eat anything with a face on it	Don't follow the crowd	I wish I'd known that it's good to know

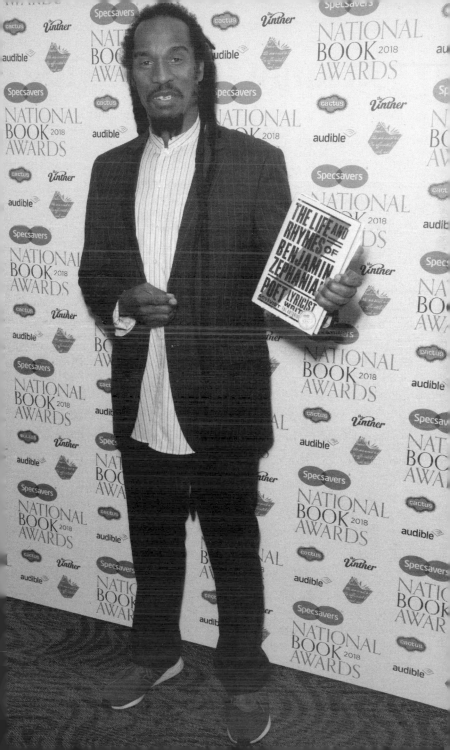

Acknowledgements

50 Cent, The Photo Access / Alamy Stock Photo
Muhammad Ali, PA Images / Alamy Stock Photo
Pamela Anderson, United Archives GmbH / Alamy Stock Photo
Ed Balls, Stills Press / Alamy Stock Photo
David Beckham, Andrea Raffin / Shutterstock.com
Ronald Biggs, Trinity Mirror / Mirrorpix / Alamy Stock Photo
Mary J Blige, Andrea Raffin / Shutterstock.com
Orlando Bloom, Andrea Raffin / Shutterstock.com
Richard Branson, Trinity Mirror / Mirrorpix / Alamy Stock Photo
Kelly Brook, WFPA / Alamy Stock Photo
Derren Brown, WENN Rights Ltd / Alamy Stock Photo
Frank Bruno, PA Images / Alamy Stock Photo
Simon Callow, Donald Cooper / Alamy Stock Photo
Roko Camaj, Sara Krulwich/The New York Times
Naomi Campbell, Ovidiu Hrubaru / Shutterstock.com
Eric Cantona, UPI / Alamy Stock Photo
Lee Child, ZUMA Press, Inc. / Alamy Stock Photo
Yvette Cooper, Allstar Picture Library Ltd / Alamy Stock Photo
Dalai Lama, Thomas Imo / Alamy Stock Photo
Nancy Dell'Olio, Peter Phillips / Alamy Stock Photo
Frankie Dettori, PA Images / Alamy Stock Photo
Julian Dunkerton, Jeff Gilbert / Alamy Stock Photo
Emily Eavis, CURLEYPAP / Alamy Stock Photo
Tracy Emin, PA Images / Alamy Stock Photo
Nigel Farage, PjrNews / Alamy Stock Photo
Mo Farah, Graham Eva / Alamy Stock Photo
Ralph Fiennes, Andrea Raffin / Shutterstock.com
Dawn French, Featureflash Photo Agency/ Shutterstock.com
Colonel Gaddafi, dpa picture alliance / Alamy Stock Photo
Kristalina Georgieva, Bebeto Matthews/AP/Shutterstock
Ricky Gevais, Sam Aronov/Shutterstock.com
Ann Glenconner, PA Images / Alamy Stock Photo
Dave Grohl, PA Images / Alamy Stock Photo

Bear Grylls, PA Images / Alamy Stock Photo
David Guetta, Everynight Images / Alamy Stock Photo
David Hasselhoff, Panther Media GmbH / Alamy Stock Photo
Hugh Hefner, ZUMA Press, Inc. / Alamy Stock Photo
Damien Hirst, London Entertainment / Alamy Stock Photo
Tom Hollander, Keith Morris / Hay Ffotos / Alamy Stock Photo
Jennifer Hudson, Ovidiu Hrubaru / Shutterstock.com
Mario Itoje, PA Images / Alamy Stock Photo
Michael Johnson, PCN Photography / Alamy Stock Photo
Kim Kardashian, INTERFOTO / Alamy Stock Photo
Imran Kahn, PA Images / Alamy Stock Photo
Marie Kondo, ZUMA Press, Inc. / Alamy Stock Photo
Joanna Lumley, Everett Collection Inc / Alamy Stock Photo
John Lydon, PA Images / Alamy Stock Photo
Charlie Mackesy, David Loftus
Paul McCartney, Keystone Press / Alamy Stock Photo
Malcolm McLaren, Trinity Mirror / Mirrorpix / Alamy Stock Photo
Captain Tom Moore, Xinhua / Alamy Stock Photo
Olivia Newton-John, Keystone Press / Alamy Stock Photo
Paddington Bear, Ian Macpherson London / Alamy Stock Photo
Elliot Page, Irvin Rivera/Contour by Getty Images
Luciano Pavarotti, Concert Photos / Alamy Stock Photo
Zara Phillips, Paul Marriott / Alamy Stock Photo
Gordon Ramsay, EDB Image Archive / Alamy Stock Photo
Esther Rantzen, Trinity Mirror / Mirrorpix / Alamy Stock Photo
Nile Rodgers, Joe Bird / Alamy Stock Photo
Joe Root, Sarah Ansell / Alamy Stock Photo
Jennifer Saunders, Vibrant Pictures / Alamy Stock Photo
Seal, MusicLive / Alamy Stock Photo
Delia Smith, PA Images / Alamy Stock Photo
Patti Smith, Pictorial Press Ltd / Alamy Stock Photo
Philippe Starck, Hemis / Alamy Stock Photo
Raheem Sterling, Allstar Picture Library Ltd / Alamy Stock Photo
Tanya Streeter, Buzz Pictures / Alamy Stock Photo
Daley Thompson, PA Images / Alamy Stock Photo
Donald Trump, Abaca Press / Alamy Stock Photo
Kathleen Turner, Photo 12 / Alamy Stock Photo
Bjorn Ulvaeus, roger tillberg / Alamy Stock Photo
Yanis Varoufakis, Ververidis Vasilis/Shutterstock.com
Jimmy Wales, 3777190317/ Shutterstock.com